D0379902

SPEED TRIBES

SPEED TRIBES

DAYS AND NIGHTS WITH JAPAN'S NEXT GENERATION

KARL TARO GREENFELD

HarperPerennial

A Division of HarperCollins*Publishers*

Portions of this book have appeared in various forms and at various times in *Arena, Details, FHM, The Face, The Los Angeles Times* magazine, *The Nation,* and *Wired.*

A hardcover edition of this book was published in 1994 by HarperCollins Publishers.

First HarperPerennial edition published 1995.

Designed by Nancy Singer

The Library of Congress has catalogued the hardcover edition as follows:

Greenfeld, Karl Taro, 1964– .
 Speed tribes: days and nights with Japan's next generation / Karl Taro Greenfeld. — 1st ed.
 p. cm.
 ISBN 0-06-017039-5
 1. Youth—Japan—Case studies. 2. Subculture—Japan—Case studies. 3. Japan—Social conditions—Case studies. I. Title.
HQ799.J3G74 1994
305.23'5'0952—dc20 94-6865

ISBN 0-06-092655-1 (pbk.)
95 96 97 98 99 ❖/RRD 10 9 8 7 6 5 4 3 2 1

FOR FOUMI AND JOSH

CONTENTS

PROLOGUE

I was born in Kobe, Japan, of an American-Jewish father and a Japanese mother. I grew up in Los Angeles and went to college in New York. In 1988, when I was twenty-three, I returned to Japan and landed a job covering trade agreements and visiting dignitaries for the English-language spin-off of Tokyo's leading daily newspaper. I wound up staying in Tokyo for five years, moving from reporter to managing editor of a monthly city magazine and then finally free-lance writer.

This was the era of the "bubble economy."

Tokyo from 1985 to 1991 saw what some believe was the greatest concentration of wealth in the history of the world. Between 1985 and 1989, Japan's GNP grew 30 percent; the value of Japan's assets increased 80 percent. The real estate value of Tokyo, the received wisdom had it, was greater than the real estate value of the entire United States *plus* the asset value of every company listed on the New York Stock Exchange. The value of the Imperial Palace alone, about ten acres in downtown Tokyo, was

greater than that of the entire state of California. Spurred by the overcentralizing of government bureaucracies and buildings in Tokyo and the city's strict tenants' rights laws, prices in good neighborhoods doubled every three years—every two years in the prime Marunouchi or Akasaka neighborhoods, if you were lucky enough to find someone willing to sell. A three-bedroom house on a twentieth of an acre an hour's ride from Tokyo, which sold for $100,000 in 1979, sold for $1.5 million in 1989. A one-bedroom condominium in the tony Hiroo section of town with a view, parking space, and all mod cons: $2.5 million.

As real estate soared, investors took out cheap loans, using the endlessly escalating values of their properties as collateral, and bought into the rising stock market. Capital thus generated blew back into the real estate market. The *baburu* (bubble) inflated. With asset appreciation spreading like crabs in a whorehouse, anyone who went into the "bubble days" with some capital and an IQ over six was flush by the late eighties. "Only idiots and foreigners didn't get rich during the bubble," an equity warrants salesman for Japan's largest securities house once confided to me.

Designer boutiques flourished, nouvelle cuisine restaurants opened daily, jewelry and gold vendors couldn't keep up with demand. There was money everywhere and it had to be spent. Between 1985 and 1990, about $700 billion flowed abroad in exchange for Louis Vuitton steamer trunks and Rolex Oyster Perpetual watches bought in Paris or Geneva—or for flagship buildings and movie studios purchased in New York or Los Angeles.

You saw the money in the streets of Tokyo, glimpsed it in the rows of chauffeur-driven, double-parked black Lexuses, Benzes, BMWs, and Bentleys idling outside of posh Ginza or Roppongi watering holes. Felt it in the crush of consumers jockeying for position at the Tiffany counter in the Mitsukoshi department store. Heard about it from bar hostesses who described their customers taking them out for thousand-dollar, seven-course dinners. I remember watching a videotape of an NFL play-off game a friend had sent me from the United States.

At one point there was a slick commercial in which a silver, gull-wing Mercedes sports car from the fifties rotated on a pedestal while an auctioneer took bids, photographers snapped pictures, and potential buyers oohed and aahed at the fine piece of machinery on display. The gist of the commercial was that Mercedes-Benz made very exquisite, very expensive cars, which eventually, if you kept them for forty years, became objets d'art that were highly sought after by collectors. In the lot across the street from my cramped Tokyo apartment, three of those gull-winged collector's items were parked.

In December 1989, the Tokyo Stock Exchange's Nikkei Index peaked at 38,915.87. In less than two and a half years it would be down 60 percent, with trading volume off close to 80 percent. Real estate plummeted as much as 50 percent. If you could find a bidder. In other words, everything in the country was suddenly worth half of what it had been two years earlier. And by 1993 the market hadn't yet recovered. Scandals also frightened investors away. Nomura Securities, Japan's largest brokerage house, was caught compensating preferred clients for stock losses and engaging in other chicanery.

In addition, the highly publicized Japanese purchases in America, such as Mitsubishi Estate's acquisition of Rockefeller Center, in which it overpaid by as much as $400 million, were certified disasters. "The thing about the Rockefeller Center situation is that it's one case out of dozens. There are too many to mention," a Mitsubishi Estate executive told me.

The bubble had burst.

In 1991 I was dating a twenty-year-old English woman. Nina had short, cropped, blond hair and the pale, blemish-free skin Japanese men were supposed to be very fond of. For five hours a night, six nights a week she poured drinks for, batted eyelashes at, and made small talk with Japanese businessmen at a popular Roppongi hostess bar. Occasionally, she would have dinner with a customer. For her services as a hostess she was paid handsomely, ¥7,000 ($64) an hour, plus whatever she could coax in tips from her clients, usually about $200 a night.

Nina made over $10,000 a month. I saw her late at night, at the earliest around one, usually later: two, three, or four in the morning. Sometimes she would keep me waiting until dawn at El Macombo or Deja Vu or Gas Panic or any of the other dingy bars where hostesses went after work. I knew this going into the relationship: if our affair was to work, no jealousy was allowed.

But then I saw the new four-carat diamond pendant dangling from her neck sparkling brightly in the streetlight's white light. It was two A.M. and I was standing just inside the saloon doors of Sunset Strip, a bar on Roppongi Dori between Nishi Azabu and Roppongi Crossing in central Tokyo. We had arranged to meet there after she finished her night's work. As Nina climbed from the tan leather seats of a dark blue Bentley convertible, the pompadoured owner, in a yellow-and-green tropical print shirt, and I exchanged glances, his laced with contempt and mine with jealousy. The smirking owner was three years younger than his twenty-two-year-old, black-suited driver. The driver was three years younger than me.

When I saw that four-karat diamond—big and hard enough to cut glass, flesh, soul, or whatever you put in its path—I felt a pang of jealousy and anger and resentment first toward the smug, Bentley-owning, real estate-dealing, expense account–wielding Japanese guy who had given it to her and then toward Nina herself. When she entered the bar I told her I wanted to leave and she shrugged and said, "Fine," perhaps sensing my bad mood but unaware that I was about to break the unspoken no-jealousy-allowed rule.

Six-lane Roppongi Dori stank of fruity and fishy garbage that had been cooking and fermenting in the tropical July heat. The two-tiered elevated expressway that divides central Tokyo loomed overhead, the whir and rush of traffic audible from where we stood seventy feet below. The surface streets were empty save the occasional taxi cruising for a fare.

Nina walked ahead of me. She was wearing a tight, short black dress made from some kind of cotton, probably with a little polyester or Lycra spandex woven in for elasticity. Moschino?

Alaia? Gaultier? She was in, as usual, flat shoes; she didn't want to appear taller than her Japanese customers. She wore a Cartier tank watch with a black lizard band (another gift from a wealthy customer) and carried a small black purse barely capacious enough for a lipstick.

We passed a shuttered vegetable shop, a small business hotel, and a convenience store before she turned to me and said, in her Cockney accent, "And what the fuck's wrong with you?"

And in the nanosecond before we were going to have it out—fight? break up? slap each other? go back to my place and make love? or just realize we didn't like each other very much— a loud, throaty chorus of engine growls, like chain saws through megaphones, came up behind me. A motorcycle gang of twenty-five Japanese kids with tightly curled, permed hair and mirrored sunglasses, dressed in the green aviator suits of kamikaze pilots, roared past. From their bikes flew Rising Sun flags.

The gang rode slow and loud, taking up all three west-bound lanes of Roppongi Dori. Their small-engine bikes had been modified beyond recognition with chrome handlebars, decorative mirrors, fiberglass packing, and triple-header tail pipes that increased exhaust noise to ear-splitting volume. They looked at Nina, in her short, sexy skirt, and me and revved their motors, waved their flags, hit their four-trumpet horns, swerved from side to side and made sparks by striking the pavement with their kickstands. A few of the bikers cat-called or gave us the finger. Most of them just stared impassively and gunned their fantastically loud machines. One, a well-muscled youth with impressive tattoos of intertwining dragons and snakes, rode shirtless, and when he looked at me he grinned. A gold tooth flashed.

They were *bosozoku* out for a Saturday night run. On the backs of their kamikaze uniforms were ancient Chinese characters of a style I had never seen before.

At that moment, with the cycles roaring and the hostess beside me, I realized that the Japan I had been writing about as

a reporter and magazine editor had nothing to do with the Japan I was living, breathing, smelling, and seeing firsthand. In the flurry of having to bat out stories about microchip dumping, trade disputes, or twenty-dollar cups of coffee, I had overlooked the gritty, sexy, real Japan: the dazzling variety of new youth subcultures and rich pop cultures emerging as a result of the bubble economy prosperity. "Speed tribes," a literal translation of *bosozoku,* is the term I have come to use in referring to all these new subcultures. They are not the Japan that a foreign journalist riding an expense account uncovers when interviewing a deputy minister of finance. Nor are they the quaint picture-postcard Japan of tea ceremonies, sumo wrestlers, rock gardens, and Kabuki. The twenty-five million Japanese between the ages of fifteen and thirty bear little resemblance to the twelve-hour-day salarymen or kimono-clad geisha familiar to westerners; they are a far cry from their generational predecessors, the *shinjinrui,* the Japanese baby-boomers. The speed tribes, the children of the industrialists, executives, and laborers who built Japan, Inc., are as accustomed to hamburgers as *onigiri* (rice balls), to Guns N' Roses as *ikebana* (flower arranging), and are often more adept at folding a bindle of cocaine or heroin than creasing an origami crane.

Standing there, with the pretty blond hostess frowning at me and the motorcycle gang giving me the finger, I decided my Japan would be life in the bars, at the nightclubs, and on the streets. I had never read about this Japan in *Time, Fortune,* or the *Wall Street Journal.* I would hang out with these kids and write their stories.

Nina and I didn't break up that night. Our particular bubble burst a few weeks later, and when we split up the reason wasn't expensive gifts from rich Japanese guys or my jealousy or the debilitating late hours we kept. What finally did us in was an argument about money. I borrowed fifty thousand yen, about four hundred dollars at the time, and was a little slow paying her back. That annoyed her so she dumped me.

And began dating the guy in the Bentley.

Alaia? Gaultier? She was in, as usual, flat shoes; she didn't want to appear taller than her Japanese customers. She wore a Cartier tank watch with a black lizard band (another gift from a wealthy customer) and carried a small black purse barely capacious enough for a lipstick.

We passed a shuttered vegetable shop, a small business hotel, and a convenience store before she turned to me and said, in her Cockney accent, "And what the fuck's wrong with you?"

And in the nanosecond before we were going to have it out—fight? break up? slap each other? go back to my place and make love? or just realize we didn't like each other very much—a loud, throaty chorus of engine growls, like chain saws through megaphones, came up behind me. A motorcycle gang of twenty-five Japanese kids with tightly curled, permed hair and mirrored sunglasses, dressed in the green aviator suits of kamikaze pilots, roared past. From their bikes flew Rising Sun flags.

The gang rode slow and loud, taking up all three westbound lanes of Roppongi Dori. Their small-engine bikes had been modified beyond recognition with chrome handlebars, decorative mirrors, fiberglass packing, and triple-header tail pipes that increased exhaust noise to ear-splitting volume. They looked at Nina, in her short, sexy skirt, and me and revved their motors, waved their flags, hit their four-trumpet horns, swerved from side to side and made sparks by striking the pavement with their kickstands. A few of the bikers cat-called or gave us the finger. Most of them just stared impassively and gunned their fantastically loud machines. One, a well-muscled youth with impressive tattoos of intertwining dragons and snakes, rode shirtless, and when he looked at me he grinned. A gold tooth flashed.

They were *bosozoku* out for a Saturday night run. On the backs of their kamikaze uniforms were ancient Chinese characters of a style I had never seen before.

At that moment, with the cycles roaring and the hostess beside me, I realized that the Japan I had been writing about as

a reporter and magazine editor had nothing to do with the Japan I was living, breathing, smelling, and seeing firsthand. In the flurry of having to bat out stories about microchip dumping, trade disputes, or twenty-dollar cups of coffee, I had overlooked the gritty, sexy, real Japan: the dazzling variety of new youth subcultures and rich pop cultures emerging as a result of the bubble economy prosperity. "Speed tribes," a literal translation of *bosozoku*, is the term I have come to use in referring to all these new subcultures. They are not the Japan that a foreign journalist riding an expense account uncovers when interviewing a deputy minister of finance. Nor are they the quaint picture-postcard Japan of tea ceremonies, sumo wrestlers, rock gardens, and Kabuki. The twenty-five million Japanese between the ages of fifteen and thirty bear little resemblance to the twelve-hour-day salarymen or kimono-clad geisha familiar to westerners; they are a far cry from their generational predecessors, the *shinjinrui*, the Japanese baby-boomers. The speed tribes, the children of the industrialists, executives, and laborers who built Japan, Inc., are as accustomed to hamburgers as *onigiri* (rice balls), to Guns N' Roses as *ikebana* (flower arranging), and are often more adept at folding a bindle of cocaine or heroin than creasing an origami crane.

Standing there, with the pretty blond hostess frowning at me and the motorcycle gang giving me the finger, I decided my Japan would be life in the bars, at the nightclubs, and on the streets. I had never read about this Japan in *Time, Fortune,* or the *Wall Street Journal*. I would hang out with these kids and write their stories.

Nina and I didn't break up that night. Our particular bubble burst a few weeks later, and when we split up the reason wasn't expensive gifts from rich Japanese guys or my jealousy or the debilitating late hours we kept. What finally did us in was an argument about money. I borrowed fifty thousand yen, about four hundred dollars at the time, and was a little slow paying her back. That annoyed her so she dumped me.

And began dating the guy in the Bentley.

I

IZUMI

THE MONEY-
DRINKERS

Mitsunori Izumi, twenty-nine, sat on an imitation leather chair in the Wakao Wrecking Crew offices, sipping Bron brand cough syrup from a brown bottle and trying not to stare at the big, square Hino Truck Company clock on the wall directly opposite him. He had caught a cold five days ago when he fell asleep in the front seat of his air-conditioned Nissan Sylvia while parked outside a Shimbashi mah-jongg parlor waiting for his *kumi-cho* (gang boss) to finish gambling and drinking. When Izumi awakened at seven that morning Kumi-cho had already gone; he hadn't even bothered to wake Izumi and dismiss him.

The cold became a bad cough and he read in the papers about something going around called the Korean Flu. He bought the codeine-laced cough syrup so he wouldn't have to give up smoking for even a day. And the codeine soothed his nerves.

The seventy-eight-year-old grandmother of the proprietor of the Wakao Wrecking Crew brought in a pot of green tea and a dish of sweet bean cakes. Izumi smiled up at her, his crooked teeth showing beneath thick lips and a twice-broken nose. Over his narrow, dark eyes his black hair was cut close to his scalp. He thanked the old lady profusely and nibbled one of the bean cakes out of politeness.

Outside the offices, an '87 Honda with a bashed-in front end made a crunching sound as Wakao let it drop from the tow winch. The small parking area around the office was crowded with battered, rusting auto hulks hauled there by Wakao or one of the *tsukaiipa* (errand boys). If no one claimed the wreck for two months it would be chopped and sold for parts.

Izumi, dressed in tan golf pants, a no-name polo shirt, and imitation Gucci loafers, took another slug of the cough syrup, shivering slightly as the heavy, brown fluid slid down his throat. He was waiting for an errand boy to come back with a rental car. One of his girlfriends had taken his BMW, another was driving his Nissan Sylvia up to Saitama to visit her mother. He couldn't rent a car himself because he had left his licenses and credit cards—all forgeries—in the Nissan. He had an impor-

tant meeting across town with his *kumi-cho* and didn't want to be late.

He capped the cough syrup bottle and dug a pack of cigarettes from his jacket pocket. He lit one with his gold Dunhill lighter and snapped it shut with a click.

Wakao entered, wearing a dirty green jumpsuit.

"Where's the punk?" Izumi asked.

Wakao shrugged and lit a cigarette. "He'll be back," he said, exhaling.

Izumi looked up at the red-and-blue Hino clock. Four-thirty.

In another two hours, maybe three, he would be back in the trenches threatening to bust heads collecting money for his *gumi*—Yakuza gang. The thought of it all—or was it the codeine in the cough syrup?—nauseated him.

Tokyo, a metropolitan area with a population of over twenty-five million, is the richest market in the world for young entrepreneurs eager to interest the public in new consumer goods and equally rich for hustlers eager to bilk the public through games of chance, drugs, or extortion. Mitsunori Izumi is a rank-and-file soldier in the sixty-member Kobayashi-kai, an organized crime "family" directly under the Tsuguta-kumi, a two-thousand-member Yakuza syndicate, one of the nine reputed to control Tokyo rackets. Izumi runs three off-track betting operations called *Nomu-kaypa* (money-drinkers). His setup is little more than a few telephones and account books in three small Fukagawa apartments in Tokyo's old downtown. His income largely comes from his percentage of what the money-drinkers can imbibe. Izumi's three money-drinkers man the phones all day Monday through Sunday, taking bets on races at any of ten major racetracks scattered throughout Japan.

Izumi's accounts, like most Yakuza-run money-drinkers, are based on a point system. A gambler sets up an account via a face-to-face meeting with Izumi, often referred by higher-ups in the family. Izumi awards the gambler twenty points a day with which to wager. Each point has a different value, depending on

the bettor. Some gamblers have ¥20,000 ($182) points, others ¥2,000 ($18) points. Only the bettor and Izumi know how much each point is worth. It's a polite way of setting limits—and of simultaneously making the bookmaking process smoother for insiders and inscrutable to authorities. Before each race, Izumi's three money-drinkers fax him lists of bettors and the points they have put down. (After faxing the bets, the money-drinkers burn the original slips. They use very delicate paper, much like toilet paper in consistency, so that it can be swallowed if the police start banging on the door.) Izumi then figures whether he can cover the bets himself or if he will need to lay some off through his *kumi-cho* at headquarters. For that service, among others, Izumi pays 20 percent of his earnings in tribute.

But money-drinkers and horse players comprise only a fraction of the Yakuza's $35 billion annual income.

The name *Yakuza* means eight-nine-three, a losing hand in an old card game. The traditional Yakuza businesses, besides gambling, are extortion, narcotics trafficking, prostitution, and protection. (Izumi also runs drugs for the family, small amounts of *shabu*—methamphetamine—and marijuana.) One of their well-known extortion rackets is the *sokaiya*; hoods buy one share of blue-chip stock and announce their intention to attend that company's annual shareholders meeting and ask embarrassing questions or create a disturbance. This tactic deliberately plays on the Japanese distaste for confrontation. Corporate boards will buy off *sokaiya* and even pay them protection money to ward off other *sokaiya*. According to a recent National Police Agency survey, nearly one-third of two thousand companies that responded admitted they still pay *sokaiya* annual amounts of up to ¥100 million ($910,000).

However, in recent years the Yakuza have taken their own seats on the boards of major corporations. During the time of the bubble economy, no one could resist the easy money to be made in real estate and stock market speculation and gang bosses became major shareholders in legitimate corporations. At the time of his death, Susumu Ishii, former chairman of the

Inagawa-kai, one of Japan's leading crime syndicates, owned 2.9 million shares of Tokyu Corporation, 1.85 million shares of Nippon Steel, 1 million shares of Mitsui Kinzoku, and .5 million shares of Nomura Securities. Reportedly, he had his sights set on a takeover bid of the Tokyu Corporation, a major department store–railway conglomerate. The value of Ishii's shares was well into the billions of dollars.

"This is the ultimate type of intellectual violence practiced by the Yakuza," says a spokesman for the National Police Agency. "The money made illegally through traditional methods—gambling and protection—can now be legitimized through buying shares on the stock exchange."

Despite new laws intended to curb the Yakuza by declaring their very organizations, not just their criminal activities, illegal, organized crime continues to thrive in Japan. Japanese politicians have traditionally been reluctant to crack down on the Yakuza because of the clout they wield in running labor unions and delivering votes. A seat in the lower house of Japan's Diet, the primary legislative body in Japan, can be decided by a few thousand votes. And in those districts where the Yakuza are known to have a heavy interest, large numbers of suspicious, timely absentee ballots have swayed elections. In 1986, an unusual surge in the number of absentee ballots cast in the No. 1 district of Ehime Prefecture decided the fate of that election; 23,500 absentee ballots were cast, 18,000 more than in the previous election. Absentee ballots accounted for 10 percent of the total turnout. Says a former Dietman of the 1986 ballot, "Several thousand yen were paid to the gangsters for each vote. The strategy was very effective."

Yakuza connections with the *uyoku*, fanatic ultra-rightist fringe parties, are another instrument for exploiting and intimidating Japanese politicians. A U.S. Embassy official in Tokyo described the right-wing movements as "so intertwined with organized crime it's hard to take them seriously as political movements." Yet no member of the Liberal Democratic Party, Japan's powerful conservative party, would deliberately risk alienating the *uyoku*. Even Shin Kanemaru, a conservative

politician with a long history of anti-Communist rhetoric and legislation, was stabbed by a right-wing fanatic who was irate after Kanemaru's talk of normalizing ties with North Korea. Even more ominous was the 1989 shooting of Nagasaki Mayor Hitoshi Motoshima by Seiki Juku, a right-wing organization with Yakuza ties. That group had said they found Motoshima's criticism of the emperor as "a grave problem. He had to be stopped."

Yakuza influence extends to the highest reaches of Japanese government through billionaire kingmakers like Ryoichi Sasakawa, a former war criminal who runs Japan's jet-boat racing industry—one of the most lucrative gambling rackets in Japan. Sasakawa has bragged publicly that he was a drinking partner of Kazuo Taoka, the head of the Yamaguchi-gumi, Japan's largest crime syndicate. He was also instrumental in bringing to power Prime Minister Nobusuke Kishi in 1957, nine years after Kishi was imprisoned for war crimes. The youngest member of the Kishi cabinet was Yasuhiro Nakasone, who would later become prime minster with the support of Sasakawa and fellow ultra-rightist Yoshio Kodama, who did time with Sasakawa in Sugamo prison after World War II. (Sasakawa has also proclaimed himself "the world's richest fascist.")

Such activities—fixing elections, assassinating politicians, or taking over corporations—take place in the stratosphere of the criminal world. But on the streets, where Izumi hustles, the Yakuza rule by direct threat, violence, and a fierce sense of loyalty that is drilled into each gang member the same way a master teaches a dog where not to piss: by smacking the mutt around.

"Most of these kids," Izumi explains of young, would-be gangsters, "are morons. Practically the dumbest of society. High school dropouts. You give them money, they'll lose it gambling. You give them a job, they'll screw it up. You give them a woman, they'll knock her up. Of every ten who come to me wanting to join, only one has a chance of making it."

The Yakuza world is fiercely hierarchical. Above Izumi is Kenzo Araki, his *kumi-cho* who left him asleep in his car last

weekend, one of eight capos in the Kobayashi-kai. At the top of Kobayashi-kai is the *oyabun* (godfather) Ryunosuke Okada, a slender fifty-eight-year-old who made his reputation beating up Communists and radicals in the fifties and then running strike-breaking crews in the sixties. Izumi meets his *kumi-cho* two or three times a week. Izumi meets his *oyabun* at least twice a year: on New Year's and again on Respect for the Aged Day. On both occasions he presents envelopes bulging with ¥10,000 ($90) notes; these "gifts" do not constitute part of his regular 20 percent obligation. He also sees his *oyabun* at Yakuza funerals, immensely profitable affairs where each mourner gives money to the widow, who then shares the windfall with her husband's gang.

Above the *oyabun* is a chubby man Izumi only met once who represents the Tsuguta-kumi, the syndicate of which Kobayashi-kai is just one component.

And above Tsuguta-kumi are the gods. Izumi once saw an exquisitely engraved chart of the Yamaguchi-gumi printed on a parchment scroll. His *oyabun* and *kumi-cho* were listed as one of the subfamilies of Tsuguta-kumi. Above them had been only the name of a powerful capo of the Yamaguchi-gumi, whom Izumi has heard of but never met personally.

Beneath Izumi are his crew, Wakao and Tanaka, and then the money-drinkers and below them the errand boys. At the bottom of the formal hierarchy are the *chimpira* (literal translation: little pricks), punks who hang around the Wakao Wrecking Crew office, which doubles as Izumi's office, or the coffee shop across the street, where Izumi sometimes spends the afternoon watching the televised horse races from Fukushima and Nakayama. The kids wear their hair in the tight-curl style popularized by the Yakuza and sport imitation gold jewelry and knockoff Rolex watches. They sometimes ask Izumi to show them his tattoos, the Chinese-style lion on his chest or the ornate geisha on his back. (The painful ritual of body-tattooing is a rite of initiation aspired to by *chimpira*. A full-body, six-color, intricate tattoo with the gang *kanji*—the Japanese character—on the chest will take a year of installments that feel,

according to Izumi, like "being whipped slowly." The tattoos, along with the chopping off of the pinky finger as an act of atonement, are perhaps the two most widely recognized Yakuza trademarks.)

Giving paid work to *chimpira* and other social outcasts is perhaps the Yakuza's greatest social service. "If we didn't pay these guys," Izumi says of the Yakuza's role as a kind of criminal welfare system, "who knows what trouble they would be making for everyone?"

It is ironic that in the Yakuza—which professes to the same values of racial "purity" as its allied right-wing groups—Koreans, Chinese, and *burakumin* (Japan's untouchable class) all have risen to greater heights than is generally possible in the legit world. Hisayuki Machii, a Japanese national of Korean descent, reigned as one of the most powerful gangsters in Japan, running the lucrative Tokyo docks for much of the sixties.

Izumi himself started as a motorcycle gang delinquent. By the time he was sixteen he had done four months at a youth detention facility in Saitama for stealing car stereos. He made his connection with the Yakuza by selling off equalizers, amplifiers, compact disc players, and LED car televisions to Yakuza members who then resold them to secondhand-electronics dealers.

When he was twenty-one the police arrested Izumi for car theft and detained him for eighteen days. Under the Japanese criminal justice system, police are allowed to hold a suspect for twenty-one days before pressing charges or letting him confer with a lawyer.

Izumi actually broke down during interrogation, a rough process in police hands, and confessed everything he knew. The judge gave Izumi six months, and when he was released, Kumi-cho was there, waiting at the Kosuge Prison gates. But rather than threatening him, the Kobayashi-kai asked him to join.

"When they have you in for questioning," Izumi says of his interrogation, "the toughest guy in the world is going to talk to the police. Everybody knows that. It's like the Yakuza's dirty lit-

tle secret." And the secret of the police is that they rarely act on the information they get.

Izumi, for the past two years, has spent most of his working hours counting, adding, and making sure his money-drinkers are covered. And making sure, even after 20 percent goes to the organization, he could still pay the rent on four apartments, float Wakao and Tanaka, and keep his three girlfriends comfortable.

Forget tough guys. Izumi liked money-drinkers. Quiet. Steady. Reliable. Good earners. Tough guys were like the punk he had sent to get the rental car. Sometimes they just didn't come back.

Izumi and Wakao rode in the tow truck through east Tokyo, known as the Low City. This is the Tokyo of narrow alleys and dilapidated wood-frame buildings, where old women in kimonos and wooden sandals still clop down cobblestone streets, far from hilly west Tokyo, the High City of skyscrapers and designer boutiques, of French restaurants and modeling agencies, of BMWs and art galleries—in other words, the city journalists describe when they write about Tokyo as the richest city in the world.

Fukagawa, Izumi's old neighborhood, is the center of the Shitamachi, what had been Edo during the time of the shoguns. According to their own legends, the Yakuza evolved in the seventeenth century from marauding, samurai Robin Hoods who stole from corrupt *daimyo* (feudal barons) while giving succor to the peasants. This code, of never doing harm to the *katagi* (ordinary people) is frequently repeated by Yakuza soldiers and bosses. "Never hurt the *katagi*," says Takashi Tsunoi, a soldier of the Inagawa-kai. "Because we honor the *katagi*, we feel the *katagi* should honor us. They shouldn't pass insulting laws which harm our prospects."

It was late afternoon, nearing rush hour. The tow truck's wench clanged behind them in the stop-and-go traffic. As Izumi surveyed the crowds of commuters, he scoffed at the notion that the Yakuza never harm the working man. "If the working

man wasn't terrified of us," he said as he rolled the bottle of cough syrup between his palms, "you think we would ever be able to collect from him?"

All over Tokyo "ordinary people" incur debts to the Yakuza. Some are gamblers, others have borrowed from loan sharks. No matter how the debts are incurred, one rule always holds firm: All debts must be paid. Izumi's *kumi-cho* repeated this like a mantra.

The logistics of collection are always complicated. Rival gangs have sit-downs to allow safe passage into other territories, as quid pro quos for their own collection missions. Or collection contracts are sold to other gangs for 30 percent of the remittance. Standard procedure calls for the crew actually doing the collection to take 20 percent of the remittance to share among themselves, the rest going back to the *oyabun* or whoever has contracted the *tori-han* (collection). But, in practice, collections are dirty business, requiring the threat of brutal, sudden violence to be effective.

The thought of collecting made Izumi wince in revulsion. Collecting was like a costume play. Izumi even owned a wide-lapelled pin-striped suit, white necktie, gold-rimmed sunglasses, and thick gold rings just for collections. He wore the costume because it helped him to look like a Yakuza; it intimidated "ordinary people." Wakao had a samurai sword he would wave around to really scare the shit out of the *katagi*. These devices could make collecting easier. But Izumi despised collections when the money wasn't forthcoming. The vulgarity of slapping around a fifty- or sixty-year-old man. Of watching him weep. Of kneeing an old man in the groin.

"That's the worst," Izumi explained, "beating up someone old enough to be your father."

Before he was bank-rolled to open his string of money-drinkers, Izumi had worked collections for two years for his *kumi-cho* as a fast way to raise capital.

And after the fifth race on Saturday at Fukushima, Izumi was in need of capital. Miho Brown, the number 8 horse and a

42 to 1 longshot, had won on a sloppy track. The race had merited banner headlines in all the papers because Miho Brown was the first horse of an exacta combination that had paid an astounding 2,403.3 to 1. Izumi could have handled one exacta payoff, even one that big; there had been enough action earlier in the day to pay off some heavy, late bets. But eight other high rollers had put down big points on Miho Brown to win. So besides his exacta payoff, Izumi had to cover eight ten-point bets that paid 42 to 1. What the hell had been with everybody on Saturday? All day the action had been at Kaiba, a local Tokyo track, and then suddenly, in the afternoon, all his high rollers had a hunch on the same longshot out at Fukushima. It didn't make any sense. Of course, Izumi hadn't had the time to cover that much action. But with the horse at 42 to 1, he took his chances. He had watched on the coffee shop television as the five-year-old stallion took the slow field—and Izumi—by surprise.

Now his money-drinkers were clamoring to square their accounts, and Izumi had to come up with about ¥50 million ($455,000) within a week, or he would be out of business. There was only one place he could turn for that kind of money.

Kumi-cho hadn't sounded surprised to hear from him. Everybody knew about Miho Brown. Every money-drinker in the city was shaking his head and bitching and draining his accounts to make his payments. Only the shrewdest or most powerful money-drinkers had been able to cover the damage.

Kumi-cho and Izumi arranged a meet at Kobayashi-kai headquarters.

The Kobayashi-kai's formal turf is Koto-ku, back in the Low City. But the Kobayashi-kai offices are in Meguro, near the heart of the High City, far from the money-drinkers and riffraff of the Low City. (They had cut a deal with a rival family to secure this prime, and valuable, office space.) Here, the BMWs and Mercedes-Benzes favored by the capos fit right in. And it was a good business move to stay as far from Koto-ku as possible. Politicians and businessmen who have to drop in on the

Kobayashi-kai find the trip to Meguro much more pleasant, and easier to explain, than a trip to Koto-ku.

Kobayashi-kai's headquarters are the fourth and fifth floors of a perfectly ordinary, black-plate-glass office building. An insurance company rents the bottom three floors. Only the *kanji* for *kobayashi* (small forest) on the building directory reveal the true nature of the offices on the fourth and fifth floors.

Izumi told Wakao to wait in the double-parked tow truck. Izumi checked his hair in the tow-truck's rearview mirror before entering the building. He buzzed his *kumi-cho*, who told him to wait as he was coming down anyway.

Kenzo Araki, Izumi's *kumi-cho*, was forty-eight and thin. His suits fit him like tarps, hanging over his bony shoulders and wiry wrists. They took a walk down the street from the headquarters, Kumi-cho grinning as Izumi waved to the tow truck for Wakao to park farther down the block to avoid attention.

"Nice car," commented Kumi-cho sarcastically.

They sat down in a warm coffee shop. The table they hunched over was actually a flat-display video game where the player pilots a spaceship whose mission is to blast through a complicated network of defenses. Idly, Izumi wondered which gang controlled the 50 percent take on this particular video game.

"Miho Brown," Kumi-cho said and smiled, removing his thick-frame sunglasses. They ordered iced coffees. "The horse that ruined July."

Izumi explained his predicament: he needed the money fast or he would have to close down.

Kumi-cho nodded. He would slake Izumi's parched money-drinkers, and then Izumi would have to pay him back at the discount *sarakin* (loan shark) rate of 15 percent a month.

But Izumi would have to do something for Kumi-cho: collections. He handed Izumi a list of ten names, with addresses and phone numbers.

All debts must be paid.

* * *

He explained the situation to Wakao during the drive back. They figured they could do all ten collections in three days if they started tonight.

Back in the office, Izumi read through the faxes from the money-drinkers. He had already sent word that the payoffs on Miho Brown would be made tomorrow. He would deliver the money personally, and, after inspecting the account books and double-checking the points, he would leave the money in decorative gift envelopes for the gamblers to collect.

Izumi thought it was odd that the high rollers had wanted their payoffs in cash. Most players usually took their payoffs in points, being the compulsive gamblers that they are. But with Miho Brown everybody wanted cash, so Izumi stuffed the five thousand ¥10,000 notes into envelopes and then wrapped, sealed, and wrote the gambler's name on each.

He lit a cigarette and inhaled. The thick smoke made him a little dizzy. His cold was getting worse. He uncapped the cough syrup and drank the remaining third of the bottle.

The first collection turned out to be a salaryman for a renowned company who hadn't yet made the move from Koto-ku to better digs in the High City. He owed ¥1 million ($9,100) to some rival gang's money-drinkers. Credit points, Izumi guessed, which the guy had never been able to cover. Poor salaryman.

Izumi and his crew had crowded into the narrow doorway on the sixth floor of the dingy apartment block the salaryman shared with about two thousand other unlucky Tokyoites. Izumi could imagine the inside, probably a one-room, six-tatami-mat apartment. The salaryman opened the door and upon seeing the crew immediately began crying. A baseball game could be heard on a television in the background. Izumi was dressed in the pin-striped polyester suit he had brought back from Korea. He had unbuttoned his silk shirt to allow the green and orange of his body tattoo to show—all he was missing for the full gangster effect was a scar or a twelve-inch cigar.

When Izumi began shouting, his voice echoed down the halls. Neighbors peeked out from behind their doors, and then, seeing who was there, quickly slammed them shut again. The salaryman was clearly on his own. Izumi was surprised by his own anger. As he poked an index finger practically up the guy's nose, he found himself berating him loudly enough to embarrass him in front of his neighbors. Sometimes that was all it took, a little shouting.

Then he let the welsher have it, smacking him in the face and demanding whatever money he had.

The salaryman promised he would come up with at least half by tomorrow. He was due a summer bonus. He would ask his boss for an early payment.

Izumi hit him again and pushed him out of the doorway, back into the room. The salaryman's tears disgusted him. Why did the punk have to cry? Why couldn't he just pay when he was supposed to? Why did he make Izumi come on a collection?

All of Izumi's anger and frustration, at Kumi-cho, at his girlfriends, at the punk who had never come back with the ¥20,000 (Wakao had beat the crap out of him in front of a video arcade), and even at that impossible 42:1 Miho Brown were all welling up inside him. Izumi found himself relishing his role.

"All debts must be paid," he shouted at the salaryman. "Don't you know that?"

He slapped him again for being so naive.

After the collections, as he sat in his Wrecking Crew office smoking cigarettes and waiting for the errand boy with the Band-Aid over his eyebrow and the fat lip to return with another bottle of cough syrup, Izumi recounted the envelopes for the gamblers and marveled momentarily at the amount of money they contained. This was the biggest payoff he had ever made. He was grateful Kumi-cho had been there to cover him.

Then another thought flashed: Why does everyone want cash?

Izumi knew some races were fixed. But information about

fixed races only went to *oyabuns* and other high-ranking Yakuza. There is no way Kumi-cho could have known.

But what if Kumi-cho had known, and he had burned Izumi by sending some of the sucker longshot action his way?

Even if it were true, there was nothing Izumi could do about it. That debt would never be paid.

II

TATS

THE SPEED
TRIBES

From the side, front, even from above, as far as he could tell in the full-length mirror, it was perfect. Then he leaned closer and checked the three-quarter view and detected a flaw, a tiny imperfection, a lock of hair out of place above his ear, and with a sigh he started over. Tatsuhiro squeezed another palmful of Stiff hair gel from the tube and tried once again to get his hair just right.

It was 12:30 on a Friday afternoon, and Tatsuhiro Nobutani—Tats—was just starting his day. This was a personal, contemplative time for him and he made it clear to his mother that he was not to be disturbed during his morning routine: a half-hour devoted exclusively to his hair. And if it didn't come out just right he would spend another half-hour. When he was finally satisfied, having inspected the back with a hand mirror and checked the gaudy, swooping ducktail for bounce and hold, he went downstairs to where his mom was watching samurai dramas and had his usual breakfast of cigarettes and iced coffee while guys in wigs sliced each other up on TV.

He finished his own pack, then bummed a menthol from his mom and waited for Small Second Son to chop up Red Mask. Right when the hero had worked his way through about a dozen evil underlings and had the black-kimono-clad Red Mask backed up, the phone rang. Tats's mom shouted at him to get it because she didn't want to miss the ending.

He picked up the phone. "Yeah?"

"What the fuck are you doing at home?" said Yamada.

"I got caught up in something," Tats said, hoping Yamada couldn't hear the television as Small Second Son stabbed Red Mask, who let out an agonizing, ear-piercing screech, and then Red Mask ripped off his mask and turned out to be Small Second Son's long-lost older brother.

"You fucking a cat over there?"

"What?" Tats asked. "Nah, my mom's watching samurai shows."

"Listen," Yamada told him. "Go over to Kimpo's on Ameyoko and tell that faggot to give you the package, you follow?"

Tats grunted. He looked at the tattoo above his elbow of a kamikaze pilot riding a sword and flexed his skinny arm. He wondered how his hair was holding up. Yamada was talking again but Tats missed what he said.

"You follow?"

Tats didn't grunt. He heard Yamada's breath against the phone and thought maybe Yamada was getting pissed off, but so what, what was Yamada going to do from jail?

"Take the package over to Miki out in Juban, you know the place?"

"Yeah."

"Give him the package and tell him it's from me and that I'll call him and that he shouldn't do anything until he hears from me, you following me here?"

Tats grunted again. Maybe he would get another tattoo, one on his chest, maybe a hawk or a heron, some kind of bird, swooping—no—diving.

"How's it going in there?" Tats asked.

"What the fuck do you think? I'm bored. Do what I said for me."

Tats promised he would and then hung up and after checking his hair in the hallway mirror went to find his mom to bum another menthol. She refused and told him to get a job.

Nineteen-year-old Tats hadn't had any kind of job since he paid off his car two months ago. He used to drive a truck, but now he was unemployed and hadn't exactly been scanning the want ads. Actually, since Yamada had gotten three-to-five in Fukushima Prison for sticking a knife through the trachea of a welsher who had had about a dozen bad months at the track, Tats hadn't done much of anything but run errands for his former boss who called him every day from jail.

Yamada, now twenty-six, had headed the Tokyo chapter of the Midnight Angels motorcycle and hot-rod gang until three years ago when he rose to become an associate of the organized crime group Sumiyoshi Rengo. Now he planned and executed numerous little scams, most of them having to do with

loan collecting and occasionally some drug peddling. He had worked with a few other, older guys until he was sent up when his partners testified against him to save themselves. Tats had taken over the Midnight Angels from Yamada. He didn't like running Yamada's errands for him but felt he didn't have any choice: it was Yamada who had taken him into the Midnight Angels four years ago.

Tats stepped out into the bright sunlight and removed the gray canvas cover from his white 1989 Nissan Skyline, folding it carefully before placing it in the trunk. He opened the driver's side door and climbed in to rummage around beneath the seat and in the glove compartment for a cigarette. He found one in the pouch next to the seat and lit it and sat in the car, listening to the radio, some new song by Hikaru Nishida, until he had smoked the cigarette down to the butt. He opened the door, dropped the butt in the dirt, then stepped out of the car, shutting the door behind him. He was on his way back inside to get a pair of sunglasses when he realized—fuck—he'd locked his keys in the car. He wouldn't be able to drive anywhere—but it was a nice day for a walk anyway.

Tats was dressed casually in a gray zoot suit over a black T-shirt and traditional *geta* sandals. He strolled through Arakawa Ward, in the heart of east Tokyo's Low City, where shabby wooden houses and run-down ferroconcrete apartment blocks lined the narrow roads. During the U.S. occupation of Japan immediately after World War II, the Ameyoko Market streets had been where black-market goods, misdirected from the American PX, were sold to Tokyoites. Now dried fish, uncensored porn videos, and Japanese Bart Simpson T-shirts were hawked beside endless stores of "designer" clothes. Brand names such as Paris Tailor, Hi-Touch Fashun, and Running Dapper Man were Japan's answer to Members Only.

Tats walked among the tile-roofed houses, pachinko parlors, convenience marts, and liquor stores. He waved at the kid with the bad acne behind the counter at the 7-Eleven and courteously bowed to a gray-kimono-clad friend of his mother's, and he checked his hair in a store window.

Arakawa Ward was one of the poorest of Tokyo's twenty-three wards, and here the Japanese family values of unity, cohesion, and diligence were cracking right down the middle. This was not the land of Sony and Mitsubishi. Here, Tats would tell you, *bosozoku* ruled.

The *bosozoku*—speed tribes—are Japan's discontented youth. A little under half of them come from broken homes. They revel in noise and spectacle and disturbing the quiet, orderly operation of Japanese society. But they are more than gangs of delinquents. They are also proving grounds for the Yakuza. *Bosozoku* gang members perm their hair, dress like wise guys, and drive flashy cars and motorcycles without mufflers, hoping to be noticed by the local *gumi*, or Yakuza family.

Maybe a Yakuza lieutenant needs a young tough to hold a shipment of methamphetamine, the drug of choice for Japan's half-million speed addicts, or, like Yamada, a messenger to run a hot pistol out to a fellow gangster holed up in a Juban flat. A Yakuza always needs a good *chimpira* (little prick) who's cool, tough, and can keep his mouth shut.

The *bosozoku* have been around since Japan's rebirth as an industrial power after World War II. The Tokyo Metropolitan Police Department's first record of the existence of the *bosozoku*—or *kaminari* (thunder tribes), as they used to be called—dates from September 4, 1959, when fifty-five "juvenile delinquents" on motorcycles gathered at Tokyo's Meiji Shrine.

Now there are hundreds of different gangs, including Medusa, Fascist, Black Emperor, Cats, Kill Everybody, and the Devils, many loosely federated. They've adopted an eclectic array of styles and symbols, from traditional samurai to *The Wild Ones*. The Midnight Angels dress in red-and-black jackets—their colors—with gold Chinese characters on the back. Many wear tiny, almost effeminate slippers and roll *haramaki* (stomach wraps) around their chests. These last are all Yakuza affectations. A veteran police department observer estimates the percentage of *bosozoku* who go on to become Yakuza at 40 percent.

Tats was Yamada's little prick. For eighteen months before going to jail Yamada had been on a streak where he could turn shit into yen. Everything he touched, every venture he tried, was making money. He was generous with Tats and his former cronies in the Midnight Angels. Yamada remembered where he was from, and just because he was making more money in a week working with his new friends than he ever made in the motorcycle gang didn't mean he turned his back on his old posse. He still showed up at the Skylark family-style restaurant where Tats and his friends played cards and mah-jongg. Yamada picked up checks, lost a bundle on the tiles, and then slipped Tats and his friends a few big bills and maybe some new clothes or free brandy or whatever swag had come his way. He treated Tats and his friends like princes, and he reminded them of this constantly. "Remember what I do for you," he would say from behind the wheel of his Mitsubishi GTO before peeling out, "you follow?"

He asked for a few favors, which were no problem for Tats. Yamada got him the job driving the truck and arranged for Tats's tiny down payment for the Nissan Skyline that was Tats's pride and joy.

At first Tats didn't mind doing favors for his mentor, like stashing a 9-mm. Beretta pistol beneath his bed for six weeks or delivering a van loaded with pirated *Bluce* [sic] *Springsteen Greatest Hits* cassettes to a drop-off point in Shinjuku Ward. Tats, however, tired of the little—and not so little—favors. He had begun to dislike answering the phone every morning and getting his daily itinerary from Yamada. All this running around for Yamada was taking up too much of his time. The Midnight Angels were still his main priority and Yamada, having once been a member himself, should have known that.

Yamada had presided over perhaps the greatest era in Midnight Angels history. When Tats was fifteen, he was sniffing a lot of glue and barely attending Kokushikan High School—a high school that in its entire history had never sent anyone on to college. He was what his teachers described as learning-impaired: he had a short attention span. He had shown even

less aptitude in shop classes than in academic classes, and neither department wanted him anyway. He dropped out of school. He had seen the Midnight Angels around and was dazzled by their loud motorcycles, gaudy cars, and kamikaze outfits; as they rode around Arakawa Ward they reminded him of the kind of delinquents who were the heros in *Akira,* his favorite comic book. So Tats joined.

For the initiation, a few older members, Yamada included, jumped him. He emerged bloodied, with a black eye and several broken fingers, but unbowed. "That's our only rule: you have to be able to fight," Yamada told Tats after the initiation.

That summer, Tats went on his first run with the Midnight Angels, down to Shonan Beach in Kanagawa. Nearly four hundred Midnight Angels from Tokyo, Yokohama, Chiba, Ibaraki, and Kanagawa were there as the gangs took over the beach near Enoshima Island and turned the half-acre parking lot and boardwalk into a two-day debauchery reported in local newspapers as the "*Bosozoku* Nightmare." Tats had ridden down in an older member's car, waving a Rising Sun flag, drinking Ozeki One Cup sake, and sniffing glue as they crawled down the Tokaido Highway at just ten miles an hour, intentionally blocking traffic and scaring the hell out of everyone else on the road. That had been a glorious time, the hundreds of cars with aftermarket tail fins, airfoils, skirts, and flashing lights strewn around the parking lot terrifying the local summer vacationers as the gang made a leather- and kamikaze-jumpsuit-clad spectacle of themselves on the dirty, polluted beach.

The night after they arrived they built bonfires as the older members passed out beer and brandy and some members raced motorcycles back and forth. By then the local population had come out and was watching in awe from across the coast highway as the Midnight Angels seemed to be working themselves into a frenzy. The locals shook their heads but couldn't do anything because the police were hesitant about moving in—they didn't want a riot on their hands, and they still hoped the Midnight Angels would honor an order to disperse by morning.

That night, amid the flames and roaring engines, the stench of motor oil, the radios playing traditional *enka* music, and the frequent sound of breaking glass, Tats was utterly thrilled. He followed Yamada and watched him as he talked with other chapter heads and decided Yamada was one cool *bancho* (gang leader). Yamada was wearing a black jumpsuit zipped down to his chest to reveal a tattoo of a fiery pair of crossed swords with dragons intertwined around them. His hair was cut short and slicked back with a combination of hair gel, sweat, and axle grease, and all the guys that were there seemed to want to know him and all the girls seemed to want to fuck him.

When the sun rose over the Pacific Tats was still awake, still excited. As the beach gradually brightened—the sand turning from gray to tan to white and then to white with specks where the beach was strewn with garbage—he saw a figure dressed in black, like a TV samurai villain, riding along the wet sand near the water, and around the black human form was a white glow like a lunar eclipse as the morning sun made a silhouette of him. Tats wondered for a second if he was really seeing the guy on the motorcycle. The bike turned, spinning out a little as the rider had some trouble keeping control in the dry sand, but he made it, and just before the bike reached the boardwalk where Tats was sitting with his arms around his own knees, Tats saw it was Yamada. He had a few chicken sandwiches and deep-fried fish he had bought at some greasy shack down the beach and he gave the bag to Tats, who had forgotten how hungry he was. Tats thanked him and ate the food with his fingers and washed it down with warm beer and it all tasted so fucking good he felt like laughing.

He went to sleep on the beach, while behind him the Midnight Angels entertained local newspaper reporters by riding their motorcycles in circles standing on the seats of their bikes. The reporters, in their eagerness to give their readers the story of a motorcycle gang terrorizing a beach town, incited the Midnight Angels to more outrageous behavior, at one point even paying a Midnight Angel's girlfriend to pose topless as a few members poured beer over her breasts.

It was blazing hot by the time Tats woke up. The sun was three quarters of the way across the sky; there was no ocean breeze. A Chiba Midnight Angel handed Tats a beer and Tats wandered around the parking lot searching for Yamada. A few other *bosozoku* gangs had arrived, the Hit and Runners, a few chapters of Black Emperor. Some OBs (Old Boys, the phrase used for older, retired members) had also shown up with more beer, sake, and brandy. Their cars were like American lowriders, all shag carpeting, fuzzy dice, deep bucket seats, and graphic equalizers emitting waves of lights. In one of the OB's cars Tats saw something he had never seen before: people sticking hypodermic needles into their legs or tattooed arms. A few of the OBs had brought speed with them and were selling injections of methamphetamine for ¥2,500 which, Tats overheard, was a pretty good price. The guys who had taken the injections had faces like cartoon dogs when they're shown a big bone: eyes bulging and their tongues practically wagging.

Meanwhile, the composition of the crowd of locals milling across the highway had changed: before there had been women and children watching curiously from behind the guardrail; now there were only men in casual clothes, some carrying golf clubs and a few with baseball bats. Tats noticed they looked angry and barely budged when an empty beer bottle was hurled across the highway at them. A few squad cars lined the highway as tourists continued to drive past to have a look at the scene on the beach.

As the sun began to set Tats found some of his friends from Arakawa and drank with them. He'd drunk so much the alcohol wasn't doing anything to him anymore, just making him piss, but he kept drinking because everyone else was drinking. He climbed onto the hood of a Toyota Crown and surveyed the scene. The *bosozoku* were scattered in small groups all over the parking lot. He had either overestimated how many there were or a few hundred had already taken off; he now counted maybe a hundred and fifty. Those who remained were a sweaty, greasy mass of drunken delinquents: tattooed limbs, curvaceous pompadours, kamikaze jackets with obscenities stitched on the

back, inebriated girls draped like hood ornaments across cars whose airfoils and spoilers and unmuffled engines and obscured license plates were all against the law. With the engine noise and the loud chatter and frequent amphetamine-driven shouts, it sounded as if there were a thousand kids in the lot and on the beach.

He also noticed that more police cars were arriving. Tats wondered if they were there to keep the Midnight Angels in check or to keep the agitated locals from assaulting the Midnight Angels.

Then Yamada walked up to Tats. He was holding a beer and had that wide-eyed look so many of the older guys had. The bonfires were going again and Tats could see the fire reflected in Yamada's eyes. "You gotta try this stuff," Yamada was saying.

"What?"

Yamada took him by the arm and led him over to a Toyota station wagon where a guy in a pin-striped suit and a punch perm—the short, tight curls popular with the Yakuza—was counting money and stuffing the bills into his *haramaki*. He smiled at Yamada and nodded.

"Let's get loaded," Yamada said and handed the punch-permed money-counter a five-thousand-yen note. The money-counter removed a crumpled brown paper bag from beneath the bucket seat and told Yamada and Tats to climb aboard. He shook out two syrettes of Philopon methamphetamine and then pulled the caps off the syrettes. The Philopon was pharmaceutical amphetamine, the kind of speed Japanese soldiers used to shoot during World War II and that Japanese factory workers and taxi drivers still preferred over smokable speed.

Tats cringed a little when he saw the short needles. Yamada clapped his hands together and bobbed his head up and down and slapped Tats's thigh. "In the leg," he laughed, "put it in the leg. You follow?"

He rolled up the cuffs on his black jumpsuit and threw his leg between the bucket seats, resting his calf on the emergency brake handle. The money-counter grabbed his leg and twisted it forty-five degrees so that the fleshy back of his calf was facing

him and then jabbed in one of the syrettes. Yamada flinched and sucked air through his teeth and then rocked back as the speedy rush of the skin-pop gradually circulated through his body, up his neck, to his brain. He shook his head, said, "Wow."

Tats's cuffs were too tight to roll up so he had to slip off his pants, and by the time he had been injected Yamada was out of the car and telling anyone who'd listen, "It's going to go off tonight."

As soon as the needle hit his skin Tats tasted the bitter amphetamine in the back of his throat—and pulled up his pants so fast he almost caught his dick in the fly. Then he was out of the car and trying to keep up with Yamada who was jogging from group to group, shouting greetings, bowing, back-slapping, taking swigs of brandy and sake, bumming cigarettes, showing off his tattoos. "It's going to go off, boys, it's going to go off."

Tats's heart was palpitating and his head was spinning, not in a drunken way but in a clear way that enabled him to see everything around him—360 degrees simultaneously, the world at a glance. Bonfires, bikers in black leather, unconscious girls with their tits hanging out of their tops, Yamada with a bottle of Hennessey going vertical in his mouth. And above it all a full moon shining bright and casting dull, white, vicious light over the whole scene. He felt like telling Yamada what he was see-ing, how clear it all was, what a fucking great time he was hav-ing, but then he couldn't find Yamada. He had been there a moment ago, slap fighting with some guys from Yokohama, but now he was gone. On his motorcycle? With some girl? Tats was on his own, wandering around between cars and staring open-mouthed at the distorted faces that bobbed toward him out of the chaos. He didn't recognize anybody. These weren't Mid-night Angels—this was some other gang: Black Emperor or the Hit and Runners.

Tats heard popping, like the sound champagne corks made in movies, and saw white plumes of smoke rising from between cars and something metallic came skittering past him along the hood of a black Mazda sedan trailing a gray gash of smoke. Someone pushed him aside and ran to the smoking canister

and threw it back where it had come from. Smoke stung his eyes and a terrible burning sensation stuck in his throat; he couldn't breathe and he instinctively backed away from where the canister had been, even though there was nothing there now but a brown stain on the pavement.

"Tear gas!" someone screamed.

"They're coming!" shouted someone else. Engines were starting everywhere, guys were running to their cars and bikes and peeling out, but the police had already blocked off the parking lot. Nobody was getting out.

And the popping noises continued as more canisters were shot into the parking lot. Tats found an old T-shirt on the pavement and held it over his nose and mouth as he ran toward the parking lot exit. But traffic was stuck; police were letting out one car at a time and then pulling the drivers from the cars, making arrests, and tearing off aftermarket parts from the vehicles. The result was a huge traffic jam with screams coming from the sprawling lines of cars.

A few motorcycle riders tried to slip out by riding over the boardwalk or the beach. They were clotheslined by locals wielding bats and golf clubs. Tats watched as a fellow Midnight Angel was smacked clean off his bike when a chubby local with a bandana wrapped around his head tagged him with a graphite driver.

It came down to a choice between being arrested by cops or beaten up by locals, with tear gas in between; two hells with a hellish purgatory in the middle. Then the police stopped firing the tear gas canisters, which meant the locals could start closing in, forcing those *bosozoku* who had managed to survive the gas to choose between an arrest or a beating. Tats started looking for a ride out; he had decided on arrest over beating. The police weren't arresting everyone anyway, and Tats figured that those who didn't have criminal records, like him, would be free to go.

But the speed Tats had taken two hours ago was now making him nervous—all his confident energy had turned to anxiety and panic. He wished he were anywhere but there. He saw

the locals massing in small clusters on the sand, their golf clubs and aluminum bats shining in the moonlight. A car nearby had caught fire—the tongues of a bonfire having ignited a polyurethane airfoil. Flames were now consuming the back end, and the owner desperately tried to put it out by patting it down with his leather jacket.

"Give me a ride," Tats asked him.

The guy looked at him and shook his head. "In what?" The car was now a flaming hulk.

Tats was still crying because of the gas, his tears stinging his flesh as they rolled down his cheeks. The crowd of locals was closing in, seeking stragglers and working them over. Tats ducked between cars, searching for a familiar face, looking for a way out. Where was the confidence that had intoxicated the *bosozoku* earlier? Why was everyone suddenly bolting?

He emerged from between a silver Toyota Corolla and a Nissan Fairlady and then some middle-aged, angry salaryman type with a tennis racket—a tennis racket?—took a swing at him. The strings caught him squarely on the side of the head and then bounced off; the wood of the racket had missed completely. Tats took a two-handed swing that caught the older man in the chest. He stumbled backward, pivoted, and ran.

From behind the windows of those cars nearest Tats other *bosozoku* were cheering his small victory. He smoothed back his hair, reveling in the moment before he would get his ass kicked.

A motorcycle rolled up from between two bonfires.

"Get on," Yamada ordered.

Tats climbed on the back, grabbed Yamada's sweat-soaked jumpsuit and held on as he spun a half-donut on the pavement and screamed out of the parking lot.

"Duck!" Yamada shouted back.

They did and a baseball bat whizzed over their heads, brushing the top of Tats's pompadour.

Yamada steered the bike over the sand, the weight of two people and the sand's now damp hardness giving the bike better traction than had been possible during the day. Yamada

maneuvered the bike down near the water to the firmest sand where they rode for about a kilometer. They passed resorts, where piles of beach chairs were chained up, and crowded oceanfront bars and cafes where the patrons looked curiously at the motorcycle speeding by on the beach. Then they hit the highway and Yamada drove them back to Arakawa.

The next night, back at the Skylark in Arakawa, Yamada told them that eleven Midnight Angels from their chapter had been arrested and two had been hospitalized, but that two guys had lost their virginity. Six cars and five motorcycles had been impounded. Police had announced a new crackdown on the *bosozoku*.

But despite those setbacks, the mood of those who had made it through the Shonan Run, as it came to be known, was of elation at having taken part in the epic *bosozoku* event of all time.

Yamada was particularly pleased with Tats. He had seen Tats fight off the guy with the tennis racket.

"You're my *kohai*," he told Tats, using the word that implied protegé, assistant, apprentice, and sidekick all in one. "You're going to be the head when I retire. You follow?"

But now, while Yamada played mah-jongg, placed bets over the prison phone, and depended on his *kohai* to take care of illicit business, Tats had spent half the day in bed and an hour standing in front of a mirror blow-drying his hair into a shining, swooping ducktail while listening to a tape, not of Bruce Springsteen, but of car and motorcycle engines at full throttle.

In the stuffy storeroom of a small shop on Ameyoko Street, Tats found his buddy Kaoru Takagi, nineteen, known in the Tokyo Midnight Angels as "The Joker." The Joker was working, unloading cheap, knockoff, made-in-Thailand Sansabelt-style slacks from a panel truck and sorting them by size and color. The job paid ¥20,000 ($180) for the day.

The Joker sat on a pile of lemon-yellow slacks and lit a cigarette. He wore sunglasses, a bright red T-shirt, and tight black pants. His hair was done in a punch perm. The Joker had

attended high school for just three days. "I didn't like the teachers," he had explained to Tats, "and they didn't like me. They didn't like my clothing, my hair, nothing about me."

Tats rubbed the synthetic fabric of the citrus-colored pants between his thumb and ringed forefinger. He took pride in sussing out the crap from the real crap in the poly-blend genre. "Bangkok bullshit," he said, disgusted, and lit one of the Joker's Seven Stars with his own Zippo lighter.

"No smoking," Kimpo—a wiry, sunglasses-wearing, gold-chain-flaunting associate of Yamada—told Joker and Tats when he walked in. "Those pants are highly flammable." He himself was puffing away on a brown cigarillo.

Joker snuffed out his cigarette on the concrete floor. "Whatever you say, boss."

Tats kept on smoking. "You got something for Yamada?"

Kimpo looked him over. "Wait here."

As soon as he walked away Joker lit up again.

Tats and Joker had *bosozoku* business to discuss, something about another big run. Hell-raising needed to be organized, Tats knew, so they had to meet tonight. "Big fucking run," he told Joker, "biggest yet, like the Shonan Run. Bigger, even."

Joker smiled. He hadn't been at the legendary Shonan Run.

Kimpo came back and handed Tats a brown-paper-wrapped package that weighed about a pound. "Don't lose it," Kimpo said. Tats pretended not to hear him. Who the fuck was this guy to be treating him like a punk?

Kimpo stood chewing the plastic tip of his cigarillo, sizing Tats up. Kimpo broke into a wide grin around the cigarillo. "You want some pants?" Kimpo asked. "We've got about six hundred pairs. They go out front for a thousand each."

Tats shook his head. "I wouldn't *steal* those pants."

Instead of taking the package straight out to Miki in Juban, as Yamada had instructed, Tats carried it home with him. His keys were locked in his car and Tats figured he'd drive the package out to Juban once he took care of that.

In his room, surrounded by posters of motorcycles, cars, and girls; stickers advertising car parts stores; traditional wood-block prints of sword-wielding samurai; and a big Midnight Angels banner, he unwrapped the package. Inside the folds of crumpled, heavy brown paper and oily plastic bubble wrap was a Ruger P-89 9-mm. pistol with two clips and thirty loose rounds in a small cardboard box. He removed the handgun and held it by the hard graphite grip. He flipped the safety to what he thought was the "S" position and pulled the slide back and held the gun up to the light to see if a round had been chambered. It wasn't loaded. (Yamada had taught him the rudiments of how to handle a pistol, though Tats had never fired one. He'd once shot a hunting rifle.) The magazine was also empty. He slid a clip into the handgrip of the pistol and flipped the safety off; some oil from the clip rubbed off on his hands. He wiped his hands on the towel he used for cleaning up after working on his car engine.

Standing in front of a full-length mirror, he tossed the pistol from hand to hand and posed with it, looking at his reflection as he sighted down the barrel at himself. He held the pistol in various poses, from the hip, at shoulder height, at a forty-five-degree angle, pointing down at the ground as if he were being casual. He spun the gun around on his finger and it slid off, making a loud thump against the tatami-mat floor. He kneeled down to pick it up and rolled over, as if he were dodging bullets, and aimed back at the mirror. He had bumped into a stack of porn and motorcycle magazines and they came tumbling down on him; this heightened the illusion he was really being shot at. He began pulling the trigger and listening to the solid clicks of the firing pin against the empty chamber. (He knew he wasn't supposed to do that. Firing against an empty chamber is bad for the firing pin.) He unbuttoned his jacket and slipped the gun into his pants, buttoning the jacket over it and then checking to see if there was any bulge.

It felt cool to have a gun, especially a nice gun like this, not some Russian piece of crap like a Tokalef or Makharov. This was the real thing, like an American gangster would use. Tats

figured Yamada would get about a ¥1 million ($9,100), maybe more, for this. (In the United States the same pistol retailed for $350.) Handguns were illegal in Japan and even hunting shotguns were strictly controlled. Only police and the military were allowed to possess handguns; no ordinary citizens were legally entitled to carry them. Yet in 1991 police had seized over a thousand guns, most of them from racketeers and gangsters. Yamada had sold plenty of Tokalefs and Makharovs, shoddy, Russian-made pistols brought over by Russian seamen and sold for bargain prices. Russian guns went for about ¥200,000 ($1,800).

American small-caliber rifles sold for about the same while Russian rifles were the cheapest, sometimes going for less than a hundred thousand yen. Machine guns were expensive: Uzis, Mac-10s, or even Russian-made RPKs; Yamada had never had one, at least that Tats knew about, but he had once told Tats they went for up to ¥4 million ($36,400). Guns were big business, and when there was a gang war on, prices would go through the roof. Bullets alone could sell for ¥5,000 ($45) each.

The penalty for being caught with a handgun was stiff: five-year sentences were typical for Yakuza members. But for Tats, who had already done a month at Gunma Prefecture's juvenile detention center for possession of Yamada's Beretta, the penalty would be much less severe. At nineteen, he was still legally a minor.

The Ruger would have to be delivered to Miki out in Juban, and then, once he had checked it out, Yamada would call Miki and tell him to deposit a million or so into his bank account. Tats knew the system—he'd delivered everything from guns to crotchless panties all over Tokyo as Yamada wheeled and dealed from the prison canteen.

Tats drew the gun as fast as he could, like a cowboy, and pointed it at his reflection. "Bang," he said. He noticed his hair was a little messed up and tossed the gun on the bed so he could tend to his do.

* * *

"Check this out," Tats said, holding up the Ruger.

Chiharu Sato, seventeen, rolled her eyes. She'd seen guns before.

"This isn't some Russian-made piece of shit. This is a real American pistol." He flipped it over in his hand and held it out to her by the barrel. "Like in 'Yokohama Vice.'"

Chiharu had stopped off on her way home from Bunkyo High School. She sat on Tats's single bed and smoked one of Tats's mom's cigarettes. She blew smoke at the gun.

Tats swung around, aiming at himself in the mirror, and then swung the barrel back around so that he was pointing it at Chiharu. She still wasn't impressed.

Losing interest himself, he dropped the gun on the bed and plopped down beside her. Chiharu wore a pink dress and was heavily made up with purple eye shadow and matching lipstick. She walked and talked with exaggerated femininity, like one of the Japanese girl-idol singers on television, all curtsies, bows, and giggles. But behind all that excessive politeness was a lack of interest in anything that wasn't of immediate benefit to her. And the gun, obviously one of Tats's innumerable errands, didn't concern her. Chiharu was the head of the female auxiliary of the Tokyo Midnight Angels, a loosely federated group of girlfriends and hangers-on called the Lady Bombers. Yamada had been before her time; when she and Tats started going out Yamada was already in jail and the Shonan Run was ancient history, something that had happened in the distant past, like Pearl Harbor or astronauts walking on the moon.

"We're going on a big run," Tats said, picking up the pistol and sliding it into his pants. "Biggest run of the year."

Chiharu nodded. "Great. Let's go to the Skylark."

On their way downstairs, Tats remembered he had locked his keys in his car. He wondered if Chiharu wouldn't mind walking to the Skylark, about a mile away.

"It's a nice evening," Tats said as Chiharu fastened her high heels and he slipped on his *geta*. "Why don't we stroll there?"

Chiharu looked at him as if he was crazy.

"Okay, wait here." Tats slid off his sandals and went upstairs.

He came back down with a wire coat hanger, which he undid and twisted into a tight loop. But when he went outside and tried to slide it around the window glass he realized it would never work on his car: the door locks were down around the inside handle and didn't protrude at all.

"What are you thinking?" Chiharu said, clearly annoyed.

Tats shook his head. "You're right, this won't work."

"Call someone," Chiharu said. "I don't want to stand here all night." She went back inside, took off her shoes, and sat at the kitchen table with Tats's mom. Mom gave Chiharu cigarettes, Tats noticed, but she wouldn't give him any. Tats stood in the doorway a moment and played with the useless coat hanger. He'd call Joker. Joker had one of those flat metal car-door jimmies.

He phoned Kimpo's down on Ameyoko Street.

"You drop off the package?" Kimpo asked when he heard it was Tats.

"I'm on my way," Tats said. "Car trouble."

"Car trouble?" Kimpo sounded pissed off. "Don't fuck around. That package is worth more than your whole fucking car."

"I'm not fucking around," Tats explained. "That's why I'm calling Joker, I really got car trouble."

Tats didn't want to have to explain he had locked his keys in his car.

Kimpo laughed. "You got trouble and you call this punk?" He called Joker to the phone.

Tats told Joker his problem. Joker laughed.

"Don't tell Kimpo about it," Tats begged him.

"What's in it for me?" asked Joker.

"I'll let you check out the gun."

"Russian?"

"American. Ruger."

Joker demanded to see it as soon as he arrived on his Suzuki GXR 400. Tats lifted up his jacket and revealed the black handgrip.

"Do the car first and I'll let you check it out," Tats insisted. They were standing on the narrow street before Tats's small house.

Joker pretended to inspect the Nissan's door. He felt around the rubber molding and reached into his black pants for the metal jimmy.

"This is a hard door to pick," he said, shaking his head. "Don't know if I can do it."

"Come on," Tats begged.

"Can we shoot the gun?" Joker asked.

"What?" Tats said. "No way. They'll know. You can tell if a gun's been fired by the way it smells."

Joker smiled. He was missing one front tooth and had a gold cap on one of his canines. "Then you better call a mechanic or someone to unlock this." He walked over to his motorcycle and threw a leg over it.

Tats sighed. "Okay, one shot."

Joker climbed off his bike. He was twisting the jimmy in his hands, bending the malleable steel back and forth. He rubbed the flat rod against his pant leg to warm it, bent it again, and slid it between the bottom window gasket and the glass. It took him just three tries to pop the lock.

"I can do it in one," Joker boasted. "Let's shoot it after the meet tonight, at the tire yard."

Tats watched Joker roar off up the street. He slipped his keys out of the ignition and closed the door.

When he went inside to get Chiharu, she was watching game shows with his mom and smoking more of his mom's cigarettes. They looked so happy sitting there on the tatami, cups of tea, small plates of sponge cake, and a carton of Caravel Menthols on the table before them.

When Tats reached for a pack his mom told him to get a job. And a haircut.

Chiharu laughed.

The tire yard was enclosed by a chain-link fence and had once been a furniture factory's dirt parking lot. Now the factory

was closed and there was nothing there but thousands of old tires and abandoned household junk: worn-out couches, broken televisions, trashed refrigerators.

Tats had spelled out to everyone the details and agenda of tomorrow's run up to the Moriya Exchange, a highway rest stop in a small Ibaraki Prefecture town, so named because it was where the Joban Expressway intersected with several smaller highways. The plan, as it had been laid out to him in a phone call from the Yokohama chapter leader, was for the four main chapters of the Midnight Angels to head up the Chuo Expressway and rendezvous at 1:30 A.M. at the Minowa exit.

Around midnight, while the gang passed around a bottle of Hennessey brandy, Tats had excitedly described the run to the thirty-five members present; he told the boys that this could be another Shonan Run. (Of all the active Tokyo Midnight Angels, only one other member had taken part in that legendary event.) This was the high point of Tats's year. To him, the endless petty errands for Yamada were less important than *bosozoku* business. Yamada, of all people, should have known that.

Now Tats, Chiharu, and the Joker stood alone in front of Tats's Nissan Skyline. Tats had pulled the gun from his pants, removed the clip, and was sliding 9-mm. parabellum SWC shells into the magazine. Joker raptly watched him. Chiharu walked around the car and climbed in the passenger seat, playing with the radio.

Tats told her to keep it down; they didn't want anyone to hear them.

"You're shooting a gun," Chiharu pointed out. "Everyone's going to hear you."

"Just shut up," Tats told her. He concentrated on sliding the rounds into the spring-loaded magazine. He loaded four rounds, popped the clip, and pulled the slide.

"We'll shoot at the tires." Tats pointed to the mass of black rubber forty feet away that was taller than he was.

He pointed the gun, closed his eyes, and squeezed the trigger. Nothing happened. He lowered the gun and examined it carefully.

"Safety's on," he said.

Tats flipped the safety and fired off a round. The recoil was less than he'd expected, and when the hot, spent shell casing flew from the gun and bounced off the Nissan next to Joker, Tats began laughing hysterically. The paint on his car had been chipped, but so what? He squeezed off another round, and another and another. The shell casings nicked his car's paint job each time, but he didn't care. Even Chiharu had been excited by the noise and damp, sulphuric smell of gunpowder and cordite; she'd stepped out of the passenger door and was now standing behind Tats.

"My turn," Joker demanded.

Tats flipped the safety and released the magazine, setting the gun on the roof of his car after he did so. He only had four more bullets in his pocket; suddenly he wished he had brought the whole box with him. All thirty rounds. He hurriedly pushed the shells into the clip. He was elated to be shooting a real pistol and was looking forward to tomorrow's run. Fuck Yamada and Kimpo and all these errands. He was Tats, president of the Tokyo chapter of the Midnight Angels. He slammed the magazine back into the Ruger, flipped the safety, and fired again.

"Fuck all of you!" he shouted.

Then he gave the gun to Joker.

"You okay?" asked Joker.

Tats nodded.

Joker shrugged and gripped the pistol carefully in his right hand. He wrapped his left hand around the right and shot once, twice, three times, and then he kept pulling the trigger and saying, "Bam, bam, bam," until Tats wrestled the gun away from him.

After he dropped Joker off at the Skylark, Tats drove Chiharu home and she let him sneak up to her room with her. Because they had to stay silent the sex wasn't as boisterous as Tats liked but it was still a great way to wrap up an excellent evening.

At home, he removed the Ruger from his pants and smelled the barrel. It stank of powder and he could see black marks

around the firing pin and some kind of brown streaking at the edge of the barrel. The gun had to be cleaned before it could be delivered anywhere. Fuck Yamada—he would drop off the gun when he was ready, clean or dirty, who cared. He slipped the gun under his bed. As he was hanging up his jacket, he changed his mind. After all Yamada had done for him, he couldn't let him down by dropping off a dirty pistol.

Sitting in his underwear, a can of spray-on metal cleaner that he used to clean his car radio antenna and a soft, metallic-fiber scrub pad arrayed beside him on a newspaper, he turned the gun over in his hands. He depressed the slide-release and pulled on it to see if it would give at all. To his surprise it pulled out without much resistance. The barrel and slide assembly then slid back easily off the frame. Tats grinned at how easy it was. The recoil spring and guide were quickly detached from the frame, and then the barrel could be removed. He held the short barrel up to the light. It was ingenious, he decided, simple yet brilliant. The whole pistol stripped down to just eight parts. He carefully rubbed the firing pin and then the barrel with cleaning solution, scrubbing them till they smelled like metal and oil. He scrubbed the rest of the gun as well and enjoyed feeling the metal parts in his hands, cool and greasy, each with a satisfying heaviness, like rolls of hundred-yen coins.

When he determined the pistol was clean, he commenced to reassemble it. But the parts that had disassembled so effortlessly suddenly didn't seem to fit together; it was like a badly designed puzzle. He found no way to manipulate the barrel, recoil spring, and guide so that the slide would fit on top. He couldn't do a thing with the slide release; fitting that piece back under the slide seemed against the laws of physics. He played with the pieces of the pistol, trying every combination of parts, forcing, pushing, sliding, and jerking; the closest he could come to a reassembled gun was if he left the recoil spring out completely. Tats gave up at three A.M.; he would try again in the morning.

*　　*　　*

His mother was shouting that Yamada was on the phone. When Tats picked up the phone, Yamada was furious with his young protegé for having disrespected him.

"What the fuck are you doing, you little prick?" Yamada demanded. "Where the fuck is that package?"

Tats shuddered as he remembered the mass of pistol parts scattered on the newspaper beneath his bed. "I got it. I had car trouble."

"I don't care if you have to crawl out to Juban," Yamada growled, "you get that package to Miki, you follow?"

"Yeah, yeah," Tats said. He thought about the big run tonight; it was going to be epic—five hundred *bosozoku* all in one rest stop. They were going to rule that place.

"You do what I tell you, you little prick," Yamada shouted, "You follow?"

Tats didn't say anything. He'd had enough of being a "little prick," of being ordered around. Tats was nineteen, he was a man and Yamada should treat him like one.

"I'll do it," Tats said in a low, cool voice. "Just shut up."

Yamada shouted, "Deliver the package. You've got big problems, you little prick, bigger than you could ever imagine."

When Yamada hung up, Tats felt a rush of elation. He didn't need Yamada, he didn't need anyone but his buddies and the big run. He popped in a tape of some car engines, this a recording of his own Nissan Skyline's unmuffled 244 power plant, and did his hair.

Fuck Yamada. The pistol could wait, forever, as far as Tats was concerned. Today was the day of the Moriya Run, and it promised to be as exciting as the Shonan Run. As he did his hair and regarded himself in the mirror, he concluded this was what he was, a *bosozoku atama* (headman) not some errand boy for a washed-up, incarcerated ex-*bosozoku*. Let the pistol, Yamada, Kimpo, Miki out in Juban, let the whole fucking world wait; Tats had *bosozoku* business to attend to.

He met with the other Tokyo Midnight Angels on a deserted shopping street. Tats wore black pants and a red jacket with

Chinese characters on the back that read, "We do what we want. We don't care what you say. We don't care about you."

A little after midnight he received bad news from Yokohama. Police roadblocks at the border of Kawasaki and Tokyo had stopped the Yokohama chapter. The Midnight Angels discussed the bad news and the light rain as they put the finishing touches on their cars and motorcycles. Before they pulled out of the lot, the Joker sounded his motorcycle's new customized horn. It played "La Cucaracha."

Tats's white Nissan Skyline, with its fins, airfoils, and skirts, took the lead. He and several other Midnight Angels mounted flashing purple imitation police lights in their rear windows and removed their license plates to avoid identification. They rode two or three to a car, driving slowly, a waltz of lane-changing and jockeying. The Joker's horn blared. They drove at five miles an hour down the Chuo Expressway, jubilantly shaking fists, their voices drowned out by engine noise. Tats remained at the head of the column, swinging his Nissan back and forth across four lanes of highway.

"I love the noise," shouted the Joker from his motorcycle, "I love driving people crazy. It's like yelling 'This is who we are, and if you don't like it, what the fuck are you going to do about it?'"

Over the surreal parade flew several Rising Sun flags. As the traffic piled up behind them, the Midnight Angels began smiling, beaming, and gunning their engines. Tats completely forgot about the pistol and Yamada. He wasn't even thinking about his hair. He gunned his engine, spun his car around in a 180-degree slide and stopped for a moment, watching the ragged column of Midnight Angels advance toward him. He swigged from a bottle of Hennessey. This was great, and it was only going to get better.

Elevated over northwest Tokyo, the highway wound through Adachi Ward, over the Sumida River, and then the suburbs. The expressway was bright with white light and the pavement was slick, making it easy for Tats and the rest of the Midnight Angels to spin 360s or 180s and drive in reverse. A few

Midnight Angels climbed up and stood on the hoods of their cars or sat back on the roofs, smoking cigarettes, waving flags, and pumping their fists.

A flurry of excitement rose from the rear of the column as more *bosozoku* joined. A few members of the Yokohama chapter had managed to run the roadblocks and brave the elements, and they were there, gunning their motors and shouting greetings.

The Chiba chapter waited alongside the road near Misato. Ten more cars and ten more motorcycles. A pretty girl with long black hair whipping in the breeze of passing cars and exhaust raised her fist exultantly and pumped the air, cheering on the boys. She climbed onto the roof of one of the Chiba cars—a white, barbed monster of a Toyota—and the Chiba chapter got rolling, falling in behind Tokyo and Yokohama.

When the Ibaraki chapter came aboard near Kashiwa, two hours since Tats and the Tokyo chapter had massed on their home turf, the Midnight Angels were at full strength, over a hundred cars and sixty motorcycles. The highway sputtered with the sounds of combustion and a kaleidoscope of flashing red and purple lights and fluttering Rising Suns sparkled. Occasionally, the Midnight Angels came to a complete stop, halting traffic to set off fireworks or attend to car trouble. They had backed up traffic for over twenty miles, the line of cars and trucks stretching to Tokyo over the giant arc of the elevated expressway. If angry drivers leaned on their horns, Tats couldn't hear them.

Overhead a gigantic traffic advisory sign flashed four-foot high yellow letters reading, TRAFFIC JAM: FROM KIBA 10 KILOMETERS.

In front of Tats was nothing but open road. He owned the highway.

As the morning sun broke through scattered clouds and for a confusing instant it drizzled and was sunny simultaneously, the Midnight Angels rolled into the Moriya Exchange. About fifty other *bosozoku* were already gathered there, their cars and

bikes parked near the curb in front of a small curry snack shop and restroom complex and an out-of-business gas station. The waitresses and cooks from the curry joint stared through the plate-glass windows as the Midnight Angels pulled to a stop amid the scorching smell of racing tires and exhaust and burning motor oil.

Tats was a little disappointed by the turnout but within minutes more motorcycles and cars rumbled in. The Edokko Racers arrived, as did the Crazies, the Kanto Warriors, and Imprisoned for Life a few minutes later. And there were more girls than Tats had ever seen at a *bosozoku* rally; good thing he'd left Chiharu at home. (She'd become angry when she found out he hadn't delivered the package. She told Tats he was irresponsible and immature, that he never did anything but play with his car and his hair.) Tats, as one of the oldest *bosozoku atama* there, was treated to deep bows by other *bosozoku* leaders.

The president of the Eddoko Racers asked Tats how Yamada was doing.

"Who cares?" Tats said and chugged the rest of his beer.

The Hit and Runners were also there, Tats noticed, leaning on their horns and accelerators. So were the Top Ladies—a gang of girl *bosozoku* who wore their purple satin uniforms seductively hanging off their pale shoulders. There was no shortage of boys leaning against their violet convertible, where two of the hottest girls sat straddling the vinyl headrests of the backseat, smoking Vogue-brand cigarettes.

One biker with a white-tanked Yamaha 400 entertained a small audience of his own. Tats briefly joined the circle around him and listened while he gunned his unmuffled engine, making it play the first notes of Beethoven's Fifth at earth-shaking volume.

The Midnight Angels, with about three hundred members present, was the largest of the gangs. Tats and his friends had brought up plenty of brandy, beer, and sake. This was going to be a fun few days, Tats figured, at least until the police broke it up.

Tats and Joker passed a bottle of brandy back and forth as the rain recommenced, drenching the boys' jackets and saturating the girls' tops.

"Is this great or what?" Tats announced as he wiped his lips with his sleeve.

Joker didn't answer. He was sitting on his motorcycle, checking out the scene. "I want to get me a girl, some country girl," he said, looking over the prospects. "Going to get me a country girl and take her back to the city." He kick-started his bike and rode off between parked cars, leaving Tats holding the pint of Hennessey.

Tats wandered among the huddles of kids, joining a clique of Ibaraki Midnight Angels and passing around his bottle of brandy. He listened as they excitedly recounted the ride up and explained why they had chosen, for example, the Hotline BMT shifter instead of the Moma, or the Tokiko suspension coil instead of the Nayaba, or why a *Zetto* (Nissan 280-Z) was better than a *Suka G* (Nissan Skyline GT).

The car talk bored Tats. He wanted to tell them all about the Shonan Run, about the tear gas and methamphetamine and newspaper reporters, about the locals wielding baseball bats and—he suddenly remembered Yamada, riding out of the rising sun on his motorcycle, and shivered. He didn't want to think about Yamada. He didn't want to think about the pistol. Instead, he yawned as some pimple-faced punk talked at length about his new Yoshimura header pipes.

Who cares? He wanted to ask. Who gives a shit? Then he remembered he used to love talking cars and car parts; just yesterday he had been listening to a cassette of his car engine.

Then the kid stopped talking cars and seemed to be listening to something. Sirens. Tats craned his neck to see six flashing squad cars and twenty cops in light-blue riot gear sweep into the rest stop. *Bosozoku* were laughing and yelling and running and clawing at the doors of their cars. Bikes were peeling out, heading toward the far side of the lot. Drivers hit their horns. Tats watched as a couple of kids were grabbed while desperately trying to kick-start their water-logged bikes. A gang

who had come in a lowrider got nabbed because their leader locked his keys in the car. Two Midnight Angels were collared walking out of the men's room. Tats knew whoever got busted would be dragged into the station, grilled, fined, released in the custody of his parents, or, if he was old enough, arraigned. His car would be stripped by the cops.

"Don't go," Tats shouted as he screwed the cap back onto the brandy. "It's not over."

In the chaos, two hot-rodders spun taunting 360s around a cop. A couple of bikers feigned surrender, then high-tailed it over the grassy embankment and onto the highway, leaving the cops standing there with their batons and ticket books. Everyone was pulling out, even Tats's Tokyo Midnight Angels. The early morning air was pierced by a wheezy high-pitched "La Cucaracha." Tats turned just in time to see Joker riding toward him, a fat girl in acid-washed denim perched on the bike behind him.

"I'm gone," Joker shouted.

The rain had turned torrential.

Tats couldn't believe it: they'd just gotten there, nothing had happened, and these kids were already taking off.

Tats walked to his car. The run was over.

As he looked up at the sky and let the thick rain drops pelt his face and mess up his hair, he remembered he would somehow have to put that pistol back together again.

He had a package to deliver.

III

DAI

THE
MOTORCYCLE
THIEF

What made seventeen-year-old Daisuke Kato so jumpy was his father downstairs in the family sushi shop, cutting green onions in steady slices—chop, chop, chop—while singing, of all things, "Splish, splash, I was taking a bath . . ."

The chopping was rhythmic, constant, pausing only momentarily as Minoru Kato, thirty-seven, finished the green onions and began on the *daikon* (giant white radish).

Daisuke, known as Dai (pronounced "die"), stood at his battered old JVC turntable. He had turned off the Shinehead record so he could better hear his father at work downstairs. Sixteen-year-old Aye (pronounced "eye-ay") lay on Daisuke's sofa-futon, her heavy wool, blue school-uniform blouse in a heap on the tatami floor next to the futon. She wore a light-blue bra—Dai had seen it before—and a skirt made of the same coarse material as the blouse. When the chopping resumed, Dai turned his attention back to Aye.

Her eyes were closed.

He figured as long as he could hear the chopping he was fine. That meant his father was occupied preparing the restaurant for tonight's business while his mother was out shopping for vegetables. Not that his father would have been angry; Dai just wanted to avoid an embarrassing situation, like his father surprising them by bringing up a tray of Cokes or green tea.

Chop, chop, chop. He had heard that chopping thousands of times, as an out-of-sync percussion section to his reggae records, or as a reassuring reminder, when he woke from some afternoon nightmare, that he was home. Now, the hard thunk of knife-steel against cutting board sounded to Dai like a drum beat urging him to action.

Aye's eyes opened. She stared at him, smiling faintly, her crooked teeth making her look less innocent, more like an accomplice than a victim.

"I'm cold," she said.

Dai lunged for her.

His father kept chopping as Daisuke Kato lost his virginity.

* * *

Ohana-jaya, a sprawling suburban wasteland about an hour out of central Tokyo, is best known as a bedroom community of last resort for the armies of blue-collar and service sector employees who keep Tokyo fed, housed, clad, gassed-up, and on time. The suburb is also an industrial vassal community, where subcontractors and mechanics eke out livings from the scraps dispensed by world-famous manufacturing concerns such as Honda, Kawasaki, and Yamaha. The streets that extend outward from Ohana-jaya's Occupation-era train station are lined with motorcycle parts subcontractors and motorcycle repair shops. The shop interiors are twisted masses of bike frames, plastic body fairings, bulbous gas tanks, chrome forks, black handlebars, white rims, tires, electronic ignition systems, and carburetors dangling fuel lines. The men who work in these tiny factories are the foot soldiers of Japan's renowned just-in-time parts delivery network—the much-vaunted manufacturing system that enables large Japanese car and motorcycle manufacturers to keep down costs by understocking parts and calling on their subcontractors when they need, say, five hundred lower cowlings or twelve gross of regulator rectifiers. The substantial cost of keeping necessary parts in inventory is thus passed on to the small subcontractor, hired on a piecework basis by Honda or some other corporate giant. The subcontractor must come up with the parts as needed or risk being dumped by the manufacturer. When there's a boom, or bubble, the subcontractor doesn't share much of the windfall; when there's a recession, the subcontractor is hit hardest, as it is his inventory, not the big manufacturer's, that languishes on the shelf.

"We're sometimes given two days notice for orders of outrageous size," says a subcontractor who fills orders for a major motorcycle manufacturer. "They need the parts, and if we don't have them, they'll get them. So we make sure we have them, even if we have to buy from another contractor to make the order."

When the neighborhood was busier, the streets were a cacophony of clanging machinery and buzzing welders, as workers in gray jumpsuits rushed to fill orders. The scrap metal

dealers in the area also upped their workload during periods of heavy ordering, usually around the beginning of the year. It was in those good times that the run-down two-story houses, small empty shops, and numerous derelicts in the area could be ignored. In those booming times the myth of blue-collar Japan was alive and well.

But when it slowed down, as the inventory of windshields and cowlings and ignition cylinders sat on the shelves gathering dust, the neighborhood took on a different flavor. The thick smoke of scrap metal dealers melting down their stock filled the air. Bums and cough-syrup drinkers and butane sniffers and hookers suddenly seemed everywhere. The streets became a maze of broken-down cars that no one could afford to fix anymore and vandalized cigarette and beverage vending machines that had been looted by local kids who poured shampoo into the coin slots to coax the weight-sensitive coin counters into spitting out free change.

The police don't have much of a presence in Ohana-jaya. They do have their *koban* (small police station) near the train station and a squad car that wends its way through the neighborhood once in a while, but the police, like most outsiders in this community, can't find their way through the side streets that form an intricate warren of small shops, bike-part subcontractors, and tiny one- and two-family dwellings.

Last year, in Koto-ku, the ward that contains Ohana-jaya, there were 13,274 births, 12,996 deaths, 4 murders, 3 rapes, 87 cases of grand larceny automobile, and 1,284 cases of motorcycle theft.

Dai, holding a skateboard, bowed to Aye in front of the Kato Sushi Shop. A blue banner proclaiming the shop's name fluttered in the smoky late-afternoon breeze. Aye smiled at him, her black hair whipping up behind her. Dai's father shouted good-bye to Aye from inside the shop. He was washing the knives now, preparing the cutlery for tonight's business.

Dai winked at Aye. "I'll call you."

"Yes," Aye said. She hesitated a moment as a white van

drove down the narrow street. When it passed she stepped out. As Dai watched her walk, she turned back to him. "You have a nice room."

Dai smiled. "You've seen it before."

"Yes, I know," She transferred her book bag from one hand to the other. "But I like it more now." And she turned and walked up the street, the skirt of her blue school uniform rippling as she walked.

Dai dropped his deck and skated away. The hard Rat Bone wheels made a grinding sound that echoed off the houses and shops lining the narrow street. He ollied over a manhole cover and then slid to a stop when an old granny carrying some fruit wrapped in a brightly colored cloth stepped into the street just in front of him. He pumped over a short bridge spanning a stream that had long ago been confined to an artificial concrete bed. And he rode the wrong way down a one-way street of motorcycle parts manufacturers. The few workshops that were operating employed skeleton crews. Layoffs had affected the area hard, cutting into the earnings of, among other local merchants, the Kato Sushi Shop. Fortunately, the sixteen-seat restaurant did most of its trade with motormen and taxi drivers who worked in Tokyo and made their squalid homes in Ohanajaya. (Small, neighborhood sushi shops like the Kato Shop are common in Japan, some seating as few as six people.)

Dai gazed into the motorcycle parts operations, checking if anyone looked particularly busy. When he hit the intersection, he lost balance trying to ollie up a curb and had to pick up his skateboard and lay it down and begin pumping again, skating to the park.

Uemoto Park was a sandlot with a jungle gym, a swing set, public toilets, a pull-up bar, and a broken clock stuck at five past three. There was a ragged field too small for baseball where occasionally a few kids played catch. During the day, mothers brought their toddlers there to play on the swings while drunks and *furosha* (derelicts) skulked at the park's borders, sheltered in the shade of cherry trees during the summer and warming themselves in the bright sun during the winter. In

the early evening, around five o'clock on midwinter days, the mothers gathered their children and marched them home and the park became the domain of derelicts and Dai and his friends. The derelicts built fires of garbage and motor oil in the steel trash cans and drank codeine-laced cough syrup or sake. They wore shabby suits and wrapped themselves in old wool coats, blankets, and, for the more lucky among them, down jackets.

Dai and his friends had formed a loosely knit gang that they called the Straight Killers, though they had never killed anyone and rarely even fought. They had built a half-pipe of one-quarter-inch plywood at the park, where they could do skateboard tricks impossible to perform on flat pavement.

An uneasy truce existed between the bums and the Straight Killers. The toilets were neutral territory; the dirt field belonged to the boys and the line of barren cherry trees to the bums. Once in a while, a Straight Killer would have too much to drink or fall into a bad mood and go after one of the bums, spitting at him or pouring beer on him. The other derelicts would shuffle away, muttering to themselves as the Straight Killer kicked the bum. The derelicts were aware their broken-down bodies were no match for the sinewy sixteen- and seventeen-year-olds. The worst incident Dai could recall was when Naoya, a tall seventeen-year-old who hung out at the park, smashed in a derelict's teeth with the trucks of his friend's skateboard. Blood ran down the bristly lips and chin and shone purple in the flickering light of the garbage can fires.

But that was on a bad day. Most of the time at the park was spent skating, or smoking cigarettes, or, occasionally, sniffing some glue. The ramp was known as "Apurando," after a skateboard park in California called Upland. The Straight Killers owned the ramp and anyone who skated it without their permission did so at their own risk; this was made clear by the graffiti all over the ramp.

Naoya, the seventeen-year-old who had smashed in the derelict's teeth, greeted Dai as he rolled up. Both boys were

dressed in Pendleton shirts and chinos. Dai had Van sneakers while Naoya was in Dr. Martens nine-hole boots with steel-reinforced toes. Naoya wore a wool stocking cap. He also carried a blue canvas backpack.

Someone dropped in on the ramp and tried to bust a backside air but ended up shooting his skate into the tree line.

Dai grinned. On the way there he had been debating whether or not he should tell his friends about Aye. Unfortunately, he had already claimed to have slept with Aye, so he could hardly now say he had just *nama*'d her. (*Nama*, which translates to "bare penis," is also slang for intercourse.) He could maybe say something about how much he liked sex with Aye, but that wouldn't really communicate his joy over this particular day, certainly one of the high points of his life so far. He resigned himself to keeping this a secret—oddly, not even Aye had known this was his first time, so careful had he been to act as if sex was routine for him.

The other boys seated on the flat bottom of the half-pipe nodded to Dai or tilted their heads slightly toward him. Naoya waved Dai over to the restrooms.

He shook a cigarette from a pack of Caravel Menthols, and after lighting it, pulled down his skullcap. Compared to Dai's buzz-cut hair, sharp nose, and drawn cheeks flecked slightly with acne, Naoya looked like a child. He had white skin so pallid that his cheeks, where they weren't ruddy, appeared almost translucent. His eyes were wide and brown, and as he listened they widened even more and turned upward at the corners, so that if you were looking at his eyes, and not his mouth, you would imagine he was smiling.

Dai thought that Naoya, vaguely androgynous with his round, Western eyes, resembled Azuma, hero of the *Young Jump* comic book series.

Naoya could be cruel in the churlish, brutal manner of children, or, at times, he could be easily intimidated like a child. Because Naoya couldn't skateboard, he entertained himself by hassling bums. He considered it a kind of hobby, and an affirmation of his membership in the Straight Killers. Whenever the

derelicts saw him approaching, they gathered their blankets and bottles and sidled away.

"Do you want to go to Akihabara?" Naoya asked Dai.

Akihabara, Tokyo's famous electric town, was a source for Super Sega software or parts to repair their old stereo systems, but it wasn't much of a center for nighttime fun. There were only five game centers and very few kids around after dark.

"What's up?" Dai asked. "Does someone want something?"

"Sasaki," Naoya said.

Sasaki Manufacturing and Trading was a small motorcycle parts contractor that occasionally, for smaller orders from repair shops rather than manufacturers, didn't even bother to turn on their presses or heat their molding units. They bought parts from kids like Dai or Naoya. And where Dai or Naoya got bike parts was obvious, considering that whenever they filled an order it was by bringing in whole bikes. No one ever glanced at serial numbers before the bikes were chopped by the crew waiting on the workshop floor.

Dai and Naoya, like most local kids, had grown up watching the subcontractors and getting a feel for their business firsthand. Naoya's brothers worked for several subcontractors and Naoya himself had held an after-school and weekend job with a company that molded plastic body parts, the most sought-after replacement parts for Japanese motorcycles.

A seeming contradiction, that the cumulative parts of a motorcycle or scooter were more valuable than a new motorcycle or scooter, held true throughout the motorcycle part subcontracting industry. So, provided you knew people who could chop a bike, there were millions and millions of yen waiting to be claimed on the Tokyo streets, where seven million motorbikes were puttering around like so many undervalued assets.

The contractors knew it, and a few months ago Dai and Naoya had figured out that motorcycle theft was fast, easy, and profitable.

"How many?" Dai asked Naoya, who had put out his cigarette. "What kind?"

"Two," Naoya answered. "GSXR 750s."

Dai had intended to come hang out, skate for a while, and go home to the warmth of his parents' house. He also wanted to call Aye, just to talk to her and hear her voice. But his parents, busy as they were with the restaurant, wouldn't notice if he took off. (Aye's parents rarely let her out on school nights; she was studying for exams, preparing for college. Dai's parents hadn't even complained when he dropped out of high school.)

"I have the drill all charged up," Naoya said.

They walked back to the ramp. Dai skated as the sky darkened and the trash-can fires were started and a chill wind whipped through the barren branches, carrying with it bits of ash and soot. Dai lazily did kick turns and fakeys but wasn't pulling off any good tricks because he wasn't concentrating.

While America leads Japan in all types of juvenile crime, larceny is the one aspect of juvenile crime in which Japan is not running a substantial deficit.

The number of juvenile penal code offenders cleared by the Japanese police in 1991 was 177,097. Of these, 122,583 were arrested for larceny. By contrast, in the United States in 1992, the last year for which statistics are available, there were 1,943,138 cases disposed by juvenile courts, and of these 402,066 were cases of larceny of which 75,800 involved motor vehicle theft. Thus, while the rate of juvenile crime in Japan is one tenth the United States' rate of 47 per 100,000 youths between the ages of 10 and 17, larceny comprises a much higher percentage of recorded juvenile crime in Japan than it does in America—69 percent to 21 percent. Even measured in terms of crime rate per 100,000, larceny is the one area of crime in which Japanese youth can be compared to their American counterparts. (A mitigating factor here is that according to Japanese law, the definition of "juvenile" extends to nineteen-year-olds, while in the United States, juvenile courts clear only cases involving those under eighteen.) Still, theft among Japanese youth, while hardly of epidemic proportions, is possibly the gravest juvenile delinquency problem faced in Japan. At many "juvenile classification homes," as Japan's youth prisons

are called, over 50 percent of the inmates are incarcerated for larceny. "The exceptionally high rate of theft reflects a new morality among youth who no longer aspire to the traditional values of honesty and hard work," states Captain Sadaki Koyama of the Ministry of Justice Corrections Bureau.

Sherry Yamaguchi, creator of the popular movie series *Be-Bop High School*, which glorifies a gang of juvenile delinquents with hearts of gold, believes the bursting of Japan's economic bubble is another contributing factor to the high juvenile larceny rate. "The group hardest hit by the burst bubble economy are probably boys between fifteen and twenty-five. Traditionally, this age group has been given pocket money by their parents, but with bad times the amount has been cut or stopped completely. The boys are left to fend for themselves, which means that some will turn to stealing."

"Girls are less likely to commit crime anyway," she adds, in explaining why the recession increases the larcenous tendencies of males rather than females. "And that's a fact."

In rougher neighborhoods like Ohana-jaya, the supposedly strict Japanese morality that proscribes theft was never taken very seriously and, in hard times, has been abandoned almost completely. (At any rate, burglary and theft have always been common crimes in supposedly crime-free Japan.) While the bureaucrats and businessmen of Japan got rich through real estate and stock speculation during the bubble economy of the late eighties and early nineties, those who actually made things in Japan, like Ohana-jaya's subcontractors, never got to inhale the heady air of the bubble. Though they had steady work contracting for booming industrial concerns, they rarely shared in the immense profits. Local sentiment has it those profits were made off the backs of the hard-working, blue-collar stiffs of Ohana-jaya.

When asked whether he feels stealing is good or bad, Dai gives the matter some thought. His answer, in many ways, reflects the situational ethics typical of Confucian cultures. "I think if I knew the people whose bikes we took, I would feel guilty," he says. "Or I wouldn't even have done it. It's not an

act intended to hurt people. But I understand that it hurts people, at least people who didn't have insurance, and I think that's a large percentage of people."

Dai goes on to justify stealing motorcycles as a kind of protest against society, yet he has trouble articulating exactly what it is he is protesting against. His thinking is a muddle of borrowed Jamaican reggae rhetoric and punk rock's "skate tough or die" anarchy. "I think Japan is a very negative place, in terms of being an individual and in terms of being free," says Dai. "That's the problem I had with high school, with teachers. They restricted me. School tries to make you think a certain way. But if you just look around, you can get a different way of thinking."

"And once you're done with teachers there are cops." Dai shakes his head. "I hate cops. Hate them more than I thought was possible when I was a kid. Maybe that's why we take bikes. It's a way of saying I'm an individual and I'll find my own way, even if it's not the right way."

It was Naoya who actually discovered how easy it was to steal bikes. One night, as he was walking back from the train station, he saw a 50cc scooter with the ignition key in it. Impulsively, he jumped on it.

"I just rode it around the neighborhood and to school the next day," Naoya recalls. "I showed Dai and my friends. I figured I would ride it until it ran out of gas and then leave it."

Then Naoya's older brother told Naoya that the subcontractor he worked for would give him ¥20,000 for the gray plastic fairing, cowling, and the front wheel forks. Just like that, Naoya was in the bike business.

"That was a lot of money to me then." Naoya smiled. "And it was easy."

Naoya began hanging around the subcontractor, paying close attention to how ignition cylinders were assembled and operated. They were simple devices, just a few tumblers between you and the ignition switch. Once the ignition cylinder was out, any Japanese bike would start. (He learned that Harley-

Davidsons and BMWs were a different matter, with fork locks that made them more difficult to swipe.) The best targets were sport bikes between 125cc and 250cc with a lot of body plastic. These were the preferred motorcycles of delivery boys, whose high rate of accidents created considerable demand for replacement parts. For a Honda or Kawasaki 250cc, the contractors would pay up to ¥100,000 ($900).

The chop shops could break a bike down and resell the parts with clean paperwork to repair dealers for ten to twenty times what they paid Dai and Naoya. (The frames and engine casings were discarded because they carried serial numbers.) The repair shops, for the most part, never asked where the parts came from.

"When times are bad and a bike comes in to be chopped," laughs a fitter for a small subcontractor, "there isn't much quibbling about Japanese values."

Dai was playing the *Final Lap 3* racing game in Ueno's Pasela video game center. The graphics on the game were of a seaside racetrack in Monte Carlo complete with palisades, sailing ships, and bikini-clad spectators. Dai drove calmly, the fiberglass car chassis he sat in buckling as it mimicked the banked turns and chicanes he raced through on the three video monitors in front of him. He kept whipping through the chicanes cleanly and racking up extra time, picking up a best lap time of 46.38 seconds and leaving Naoya impatient and agitated as he surveyed the arcade.

Naoya still carried the blue canvas backpack. He clutched it close against his side.

"Come on, Dai," Naoya said, "no more games."

Dai, who had attracted the attention of a small group of junior high school boys, was enjoying himself. This was the best he had ever done at this game, and he wasn't about to stop now, not when the day's fastest lap time seemed within reach if he just kept cool, and if Naoya would shut up.

Dai had seen these graphics so many times they no longer

even looked like what they were supposed to represent. The cliffs were just fields of brown, the ships white, red, and blue triangles, the bikini-clad girls like skin-colored blobs.

"It's still early," Dai shouted to him.

Naoya conceded Dai was right and went upstairs to the slot machines and miniature mechanical horse racing games.

Dai found him a few minutes later, after having been unable to clock a faster lap than 45.11. He lit a cigarette and sat next to Naoya, who was depositing change into the coin slot of the mechanical horse race machine and picking losers. As the horses, three-inch-high slot-models with moving legs and bobbing jockeys' heads, made their way around a miniature turn on the track, Dai lost interest and took in the rest of the arcade.

The room was a mass of slot machines and Segas and bogus roulette tables and computerized blackjack machines. The air was smoky, but also smelled vaguely of machine oil and, somehow, like electricity, like the back of a television right after it's been turned off. The junior high and high school kids had shuffled out, back home to dinners and homework, or off to evening cram school. There were salarymen, cigarettes dangling out of their mouths, pupils dilated from caffeine, nicotine, and vitamin B12–laced energy drinks, mindlessly playing strip poker against animated, busty blonds. There were also a few tougher-looking kids, punks or motorcycle gang members, noisily clustered at one of the blackjack consoles drinking vending machine beer. In the corner, near the elevators, was a row of imitation motorcycle frames facing video monitors, part of a motorcycle riding simulation game called WGP-Real Race Feeling. Dai never liked motorcycle video games. They never struck him as very real.

The bike was a big monster of a Suzuki, a GSXR-750 sport bike with a white, red, and blue body. It wasn't a delivery boy's or student's bike, but a biking enthusiast's machine, the kind of motorcycle a salaryman might keep as a hobby, for riding in the mountains on the weekend or tooling around Harajuku on

Saturday afternoons. Big and muscled, it required the rider to hunch forward to shelter behind a tiny windshield. The speedometer went up to 400 kilometers per hour.

The motorcycle stood on a corner where an alley intersected a side street. The nearest business that looked like the type of place from which someone might emerge at any moment was a real estate office at the other end of the block. Dai walked up and felt the engine casing, then the handgrips, checking to see how warm the bike was. If the grips were warm and casing very hot, then the bike had just been left. If everything was cold, then the bike had been sitting for hours. If the grips were cold and the casing hot, then the bike had been sitting between a half-hour and an hour. Dai and Naoaya wouldn't take bikes that were still hot in both places, superstitiously assuming that the more recently a bike was left, the more likely the owner would return momentarily. They liked motorcycles that were a little warm, as it meant they definitely ran and would start fast.

The engine casing was lukewarm. Dai kneeled down and studied the forks to see if they were locked and to feel for an ignition kill switch hidden under the body. (Kill switches, used expressly to foil thieves, are more common in the United States than Japan.) He nodded to Naoya who had unzipped his canvas backpack, slid in his hand, and grasped the handle of a Makita power drill. Naoya cased the scene—the bike was well positioned just outside the cones of light cast by the street's two lamps—and jogged over to the bike. He pulled the drill from the bag and shoved the diamond bit into the keyhole. He hit the power on the drill, once, twice, and finally full torque, allowing the bit to rip into the locking mechanism until the bit had disappeared into the shiny chrome cylinder. He wrestled with the bit, pulling on the drill handle to see how far in he had gone, before working it in once more at full torque. The drill had been modified to increase the torque ratio, allowing the bit to spin faster and thus drill quicker. The higher torque ratio burned out the motors of the drills quickly and also necessi-

tated frequent bit changes. The cost of the diamond bit was equal to one-half the wholesale value of the bike they were now stealing.

He ripped the drill back out and dangling from the bit, like a beetle stuck on the end of a sharp stick, was the mangled, oily metal ignition cylinder that contained the locking mechanism. He reached a finger into the hole where the cylinder had been and flicked the ignition switch. He hurriedly put the drill, with the ignition cylinder, into his backpack and pulled out two helmets, giving one to Dai. They slid them on quickly and Dai hopped on the bike behind Naoya. Naoya turned the starter switch and then cranked down on the kick-starter. The starter engine turned, but the main engine didn't.

He kicked a second time and 750 cubic inches of Suzuki powerplant grumbled to life. He popped the kickstand and fired off down the sidewalk. Dai leaned forward against his friend.

The whole job had taken forty-seven seconds.

They swerved through traffic on busy Hongo Dori, beneath gigantic flickering signs and underneath expressways and train trestles. The night air was cold against their faces as they cut through the lines of traffic to be the first at the crosswalks.

The second bike, a 600cc rather than a 750cc, had been almost as easy as the first. As Dai had ridden away, he thought he heard someone shouting *"Dorobo!"* (thief), but he hadn't bothered to turn around and check. He found the purr of the Suzuki 600cc exhilarating. Behind his mask, as he waited for the light to change, he felt suddenly older and bigger than his seventeen years and 138 pounds. He wished Aye could see him now, on this big bike, weaving through traffic with the flashing lights and traffic jams of Akihabara receding behind him—or even better, to take her on a ride with him, away from the seediness of Ohana-jaya, to Harajuku or Shibuya or one of those legendary Tokyo environs where rich kids actually owned their own 600s and 750s and didn't even think twice about spending big yen for stolen parts.

He never used to think about getting out of Ohana-jaya.

But lately, when he was drunk or high from stealing bikes, he would imagine a different world, one where he didn't have to cautiously thread his way on a skateboard through sooty air between abandoned cars and old ladies but instead raced powerful motorcycles through crisp, clean air, the kind he had heard was in the mountains, to tall glass towers, such as those occupied by salarymen on TV vitamin-drink commercials. Skyscrapers where all the inhabitants had their own big bikes, their own 750s or even bigger 1100s and 1500s, not a measly Vespa like his or a Yamaha 50cc like Naoya's. He forgot for a moment that he wasn't legally old enough to be riding the bike he had stolen.

They rode the motorcycles to Sasaki Manufacturing where a foreman waited for them. The bikes were rolled through the workshop to a storage room overlooking the concrete streambed. The boys were given an envelope bulging with cash, which they couldn't count in the presence of the foreman—that would have been rude. They bowed and exited, thanking the foreman profusely as the foreman bowed and wished them a safe return journey and encouraged them to come back soon.

At Uemoto Park, huddling beside the half-pipe as a light drizzle began, they counted the twenty-five ¥10,000 notes and congratulated each other on the biggest score they had ever made for two bikes.

"Fantastic," Naoya shouted.

Dai told him to keep quiet, to restrain the celebration so that the derelicts at the tree line wouldn't overhear them, but Naoya let out a few cheers anyway and pumped the air with his fist.

As they walked home Naoya talked about bigger and bigger thefts, about how easy it had been and how they would get rich stealing bikes. Naoya planned to buy turntables, amplifiers, mixing boards, and a public address system—all the gear he would need to become a DJ—the career he dreamed of.

They turned the corner and were silent as a car drove toward them, its headlights blinding them. They fell into single file with Dai in front.

Again, for some reason, Dai wanted to tell about losing his virginity. Naoya, after all, with his baby face and stupid grin had never had a girlfriend, and when he boasted about all the times he had had sex the other Straight Killers just laughed at him.

"I really like Aye," Dai said.

Naoya didn't respond for a moment as they again walked side-by-side. Then he said, "There's nothing like *nikumanju*." He had used a deliberately vulgar word for woman, one that literally meant "meat pie." Somehow, this ridiculously obscene word choice was an implicit admission by Naoya that he wasn't in Dai's league sexually. The two boys laughed.

"What are you going to do with your money, besides buy equipment?" Dai asked.

"Maybe get a *josei*," Naoya said, using a much more polite, almost reverential, term for woman.

The next evening, as Dai waited with his skateboard for Aye outside of the six-story Sundai preparatory school, a branch of one of Japan's leading cram school corporations, two *bosozoku* members shuffled past in their trademark effeminate slippers and baggy trousers. From across the street, one of them jokingly shouted at Dai to "do some tricks."

Then they crossed the street and, their sunglasses reflecting the fluorescent street lights, insisted that Dai "show us some of your skateboard tricks."

Dai sat quietly, his feet resting on his skateboard, hoping the two bigger boys would lose interest in him and wander away. But the two, both sporting thick punch perms and wearing gold watches, apparently had nothing better to do.

"Spin around or something," one of them said.

The other one reached down and tried to pull at the Dog Town deck. Dai reached over, grabbed it, and held it to his chest.

One of them pulled at Dai's black bandana, which was knotted around his head. "What is this? A woman's kerchief?" he said. "Like an old woman."

He flicked Dai once on the ear, and the two walked away, laughing. Dai had tears in his eyes.

When he looked up, he saw Aye standing by the gated entrance to the cram school, staring at him.

In the hierarchy of Japanese crime and criminal groups, the Straight Killers fell somewhere beneath the lowest criminal gangs who show up on police blotters or Yakuza hierarchy charts. Bigger, more powerful organizations such as Yakuza families or even *bosozoku* motorcycle gangs could roll right through Ohana-jaya and even do business in town and never have to acknowledge the existence of the Straight Killers. Real gangsters didn't notice small-time juvenile gangs like the Straight Killers because the Straight Killers, in the strict Japanese sense, weren't a true criminal gang. Although Dai and Naoya were in the motorcycle business and once a few members had smoked some marijuana—purchased from real gangsters—the Straight Killers were primarily a bunch of kids who skateboarded and hung out in a park that the Yakuza didn't even know existed. The oldest Straight Killer was eighteen, and though one or two of the boys aspired to become Yakuza, most of them looked up to American skateboarders and punk bands as their main stylistic and lifestyle influences.

The Straight Killers tried to steer clear of Yakuza or *bosozoku* groups. The *bosozoku* gangs were generally comprised of a tougher, older breed of juvenile delinquent who often had access to handguns and swords and could be ruthless with opponents. They ran rackets, dealt drugs, and extorted money, often with the approval of Yakuza supervisors. With their extensive body tattooing and Yakuza-style outfits, the *bosozoku* were part of the underworld while the Straight Killers, for all their posturing, were not. Their milder reputation had an upside. Police never bothered them; their sneakers, work shirts, chinos, and bandanas didn't fit the serious criminal profile.

"At Tokyo Gakuin, my old high school, if you needed someone to threaten or beat up someone else, you could get a *boso-*

zoku member to do it," Dai says. "They were different, tougher than regular kids. And that was a very tough school."

Dai found himself as alienated from the underworld as he was from the straight world, and the hassling by the *bosozoku* confirmed this. Even his parents didn't see Dai's lifestyle as criminal, rather they saw him as a skateboard enthusiast who also loved strange music. And a girl like Aye would never have considered going out with Dai if he had been an overt delinquent such as a *bosozoku*.

While he could use his unique situation to his own ends, to commit petty and not-so-petty crime, he also had to face the fact that, just as he wasn't on track to become a salaryman, he wasn't on track to become a career criminal.

As Dai and Aye walked to catch the train back to Ohanajaya, Dai presented her with a new, gold-plated pen. He had wanted to get her something school-related, a book or notebook, but once he was in the bookstore he had quickly become confused by all the books and ended up flipping through motorcycle magazines. He had hastily opted for a gaudy black-and-gold Cartier pen, a gift whose obvious value would have to compensate for its lack of originality.

Now, as Aye unwrapped the pen, Dai felt stupid. The pen was a gift a teacher would give or something for a businessman. He wanted to take it back.

She opened it as she walked and turned it over in her hand.

"It was very expensive," Dai suddenly blurted out.

She looked at him curiously.

Then Dai suggested, "You can give it to your father as a present. Or to someone else." Dai was referring to a lower-class Japanese economizing measure of keeping gifts in their original wrapping and then recirculating them when another occasion arose for gift-giving. But the pen would never work in that context: it was too valuable.

"I'll use it," she said. "It's nice."

"I just wanted to give you something," Dai said. "It's hard choosing gifts."

She laughed. The two walked for a moment, finding their silence preferable to Dai's nervous chatter.

Dai was trying to scheme how to get Aye to come over before she went home. Once she was home for the night there was no chance of getting her to come out again. He also longed to tell her that she had been his first, but again, he imagined that would make him seem weak.

Later, upstairs in Dai's bedroom, Dai began boasting of how he and Naoya were going to become DJs. They weren't going to stay around Ohana-jaya, they would be spinning records in big Tokyo clubs.

"We almost have the money now," Dai explained, showing her the roll of ten-thousand-yen notes he still had from the previous evening. This was an immense amount of money for a seventeen-year-old to have, especially one who lived in Ohana-jaya.

"How do you get your money?" she asked.

"We're DJs." Dai insisted. "And when we have our company set up, our turntables and mixing boards, we'll be leaving here. You'll come, too. See, I don't need high school or college."

Or the Yakuza or *bosozoku*, Dai thought to himself. He caught sight of his own battered sound system, the old pair of JVC turntables, and the blown Sony speakers. "This stuff is all garbage," Dai said disdainfully. "We'll be getting our new equipment soon."

He folded up his money and slid it into his pocket.

Dai studied Aye as she looked at him. There were moments when he thought she was mocking him, when her eyes and the tilt of her head made it seem as though she was amused by him and nothing more. That Dai's depth of feeling wasn't shared by her, and that for her, Dai was a plaything, part of her childhood that she would leave behind when she went wherever it was she was going—bigger cram schools, college, corporation, and marriage. Dai, permanently off the track, wanted to make it seem as if he was going somewhere, that he would be some-

body, that, like Naoya, he had a dream: he would become a disc jockey, too.

But Dai wasn't even exactly sure what a disc jockey did. The idea that he would someday have to do something was a concept he had never taken seriously. He had dropped out of high school because he had found school "boring and useless. It was a trade school and I don't want to work in a factory." Tokyo Gakuin, the remedial school Dai had attended, occupied the lowest rung in the Japanese secondary school hierarchy. It produced the blue-collar workers who operated drill presses and lathes and the service-sector employees who manned cash registers and gas pumps. Dai's parents had always assumed that Dai would end up working in the Kato Sushi Shop. It was a steady business through good times and bad, and you didn't need to go to college to run it. You had to know how to open sake bottles and chop fish, and Dai had learned to do both as a child. But since dropping out of school Dai had lost interest in working at the sushi shop. Dai's father, who had been a wayward kid himself, attributed this to Dai's youth and assumed his disinterest would pass.

"They worry about me," Dai says of his parents, "and they want me to help around the shop. But I don't want to work on fish my whole life."

"My parents don't really know me," he continues. "They don't know about the bikes, about the Straight Killers, about my music. They are so busy at night that as long as I don't make any trouble, they don't really know what I'm doing."

That afternoon, when Dai and Aye had sex again, Dai found himself more nervous than he had been the day before. The circumstances had been similar: his father downstairs chopping, his mother out shopping. Aye on her back on the futon. But Dai had been awkward and bumbling, whereas the day before he thought he had been cool. While they were intimate today, Dai had knocked over a Coke bottle and the brown fluid had seeped into the tatami.

* * *

On windy days the gusts that screamed down the narrow alleys and streets would hit Uemoto Park and ricochet from the storefronts and concrete walls at the park's boundaries. Candy bar and potato chip wrappers tossed away by the Straight Killers and old newspapers and dirty scraps of clothing discarded by the bums were swept up along with ashes and dirt into swirls that raked noisily from swing set to sandbox to skateboard ramp. The garbage cyclones were constantly forming and unforming; old socks and cigarette butts, which a moment before had been weightless, would plunge earthward when the winds died. The clutter around a garbage can would vanish; a previously spotless bench would suddenly be littered.

As Dai spoke to Naoya, he shielded his eyes from the dirt and dust borne aloft in the trade winds.

The job was too confusing, Dai complained. First of all, there wasn't enough money: ¥10,000 each for four 50cc scooters. Second, he hated boosting 50cc scooters because they were more complicated than big bikes and much less profitable. (To take a 50cc you had to jimmy open the glove box without damaging the valuable body, clip all the wires, and then keep connecting wires until you found the right two wires of the four that would trip the ignition. This could take two or three minutes.) The third problem was that the job required riding slow 50cc scooters great distances over surface streets. (They had to catch the train into Tokyo to look for bikes; they didn't steal bikes around Ohana-jaya.) Fourth: storage. The contractor who wanted the bikes thought staying open late to receive scooters was too conspicuous. The boys would have to stash the scooters at an unlit lot in Ohana-jaya. In the morning Dai and Naoya would pick up the scooters and ride them over to the shop. In broad daylight.

And all this would have to be repeated for two consecutive nights; two people couldn't ride four scooters.

Naoya and Dai stood in the street next to Uemoto Park. A few boys were sitting on the flat of the ramp, huddling from the wind and talking in the loud, almost cackling manner popular

among young Japanese males. Although they were about thirty feet away their voices were carrying in the wind, and Dai could make out everything they said.

Visible over Naoya's left shoulder, sitting about fifteen feet away against the gray bark of a cherry tree, one of the derelicts was trying to snap shut his plastic shopping bag of possessions. He looked over toward Dai and Noaya periodically and blinked furiously, trying to keep the motes of dust from his eyes. Dai tried to remember if this was the guy Naoya had beaten up, but then, it didn't matter—Naoya had abused them all at one point or another.

Naoya wore his skullcap and was grinning wildly as he excitedly explained where they would put the bikes overnight: the parking lot next to a tenement complex near the station. The lot was always full of cars. No one driving by on the narrow street would be able to see the stolen scooters.

Dai listened as Naoya told him he had figured out which two wires they would need to connect to start a Yamaha scooter: red and white. And the glove compartment locks were so cheap they could be opened with a rough skeleton key.

"It's easy money," Naoya said.

Dai watched as the bum next to the tree sipped from a bottle of cheap sake.

Naoya suddenly turned around and made eye contact with the derelict. "What do you want?" Naoya shouted. He strode over to old man.

"Don't bother," Dai said, hoping Naoya wouldn't get violent.

The other Straight Killers stood up in anticipation of another of Naoya's tirades. The Straight Killers encouraged him. It had been a dull day. A beating might be fun.

But Naoya didn't swing at the old man whose long, bushy black-and-gray hair had formed into unwashed mats. He struggled to gather his plastic shopping bags and his sake bottle before Naoya reached him. Once Naoya was there, he stood over the bum, looking as though he would put a steel-toed boot into him.

"I'll kill you," Naoya said loudly so his friends could hear.

The old man began sliding back on his ass, propelling himself by pushing at the earth with his heels.

Naoya spit at him. "Why can't you get a job?" he shouted. "You're dirty. You're useless. Why do I have to look at you?"

Naoya spit again, the white foam riding the wind and missing the old man.

Misgivings aside, it went so smoothly Dai felt they could have stolen six, eight, or even a dozen scooters. They had so refined their system that even scooters had become easy. The first night, puttering home on two gray Honda 50ccs through mile after mile of Japanese urban sprawl, Dai realized he had been overly cautious before. They parked the scooters at the rear of the parking lot, in the lee of the six-story tenement. They stood for a moment, admiring their work in the dim light.

"Did you ever think that maybe these scooters have parts that we already once stole?" Naoya asked. "I mean, what if the people who own these already bought stolen parts once and now we're taking them again—"

"I doubt it," Dai cut him off. "Parts that old can't be sold as new."

The two new scooters, parked amid broken bottles and crushed cardboard boxes on pavement that stank of urine, seemed to shine. "These are perfect," Dai observed. "We should be able to get more for them."

Naoya nodded. "I told you. I told you it would be easy. We're professionals. Your father does sushi; we steal motorcycles."

All Dai's previous apprehensions about his future evaporated with Naoya's simple statement. We steal motorcycles. It was a future, a role, a niche in society. Dai had a place in this world, after all. Not as one of the glorified salarymen nor a vilified Yakuza and certainly not as a humble sushi chef. Dai was a motorcycle thief, and that's what he would be.

"The scooters were still there the next morning, parked where we left them. But when we walked up to get them, two

police cars rolled up to the parking lot and another cop came from nowhere—he must have been in the building. We were over near the scooters, and by the time we saw the police we were already trapped between the building and the corner of the lot. There was nothing we could do. I looked at Naoya, who was breathing really hard. He reached down and touched the handlebars of one of the scooters, twisted it a little, like he was giving it gas, and then one of the cops grabbed me from behind, pulled both my arms down to my side, and tugged me violently backward by the arms. It felt like my arms were being ripped out at the shoulders. The squad cars each had three or four cops in them—it's impossible to remember—and the police kept climbing out of them and they grabbed Naoya and smacked him cross the face, openhanded, I think. Like a slap more than a punch. They separated us, me over by one car and Naoya inside of the other squad car, and the cops started yelling, demanding answers, 'Whose are these?' I don't know, I said. 'Then why are you here?' One guy, a tall cop with really smooth, tan skin suddenly slapped me and shouted again and I started crying. I was saying that I had seen them and had just come over because I was curious and then the cop slapped me again.

"'You're a thief,' he shouts. And for some reason I wanted to say yes. I didn't, but I wanted to. And then suddenly it occurred to me, how had they known? They couldn't have just seen them, even though they were new—at the back of this parking lot they were practically invisible. Someone had told them.

"They pushed me into the backseat of one of the cars and we drove through Ohana-jaya, past the motorcycle repair shops and subcontractors and the old train station and then over the Arakawa River to a station closer to Ueno, one of the big police stations. The inside of the car smelled like coffee and cigarette breath, kind of sour. The whole time that same cop, the young one, keeps telling me how much trouble I'm in, that I'll go to jail for the rest of my life, that I'll be put in jail with Iranians and Yakuza and all the hardest prisoners because that's what

happens to motorcycle thieves. It's a shame I'm so young, he says. Too bad it's all over for me at such a young age. Right then was the worst time, as the car took us over the river and I left Ohana-jaya behind and realized that I was in so much trouble I would probably never be able to go back to my old life, to Aye and the Straight Killers and the park and that fun life of not having to worry about what I would do or who I would be. Maybe I had wanted to leave Ohana-jaya, but not in a squad car.

"At the station I was put in a private cage that was maybe two meters by two and a half meters. There were other prisoners in cages lined up in a row in a big, fluorescent-lit room, like a small gymnasium. I got a blanket. There was a squat toilet in the corner. I didn't have any visitors. Not my mother or father. Not Aye. Forget about a lawyer. No one. And I never saw Naoya. Once in a while the police captain, the same guy who had slapped me, would come down and ask me questions—about why I had stolen the bikes, how long I'd been doing it, about whether I was sorry about it. They said it like it was a fact, like they already knew I had done it, so I just went along, admitted I had taken the scooters. (Who told them? I kept wondering.) I had that terrible feeling you have when you realize that the world as you knew it was gone forever and now you were in a new phase, that the world had permanently changed. And then I began to feel like there really was something wrong with me, that I had been living all wrong before and I had to figure out a better way to live and behave. You're in there for two weeks, in pretrial observation where they can do whatever they want and they get you to sign piles of papers and these papers turn out to be what the judge reads when he decides whether to sentence you, release you, or authorize more detention. The papers they gave me were not just about stealing the scooters but also about being lazy, dishonorable, disrespectful, everything. They figured out everything that was wrong with me—from being a bad student to dropping out of high school to not helping my parents enough to sniffing glue—and made up these papers and gave them to me to sign. If I didn't sign they

would let me out of the cage and take me to a smaller, closed-off room that had a big mirror in the wall, a one-way mirror so someone sitting on the other side could see. They would tell me my mother or my father was over there and that if I signed they would be proud of me and know I was trying to become better. Or they would just tell me to sign and if I did or didn't it didn't matter because they would hit me anyway. They slapped a lot, the Tokyo police. Even though they're not supposed to, they hit you a lot when you're in there. That's how they make their case.

"They never turned off the lights in the room where the holding cells were and even though we weren't supposed to talk, the older guys were always talking, they weren't afraid of the police anymore. It was an older guy in the next cage who told me I was in big, big trouble. That they would send me to jail for years.

"But the funny thing about all the papers they make you sign is that some of them are for your own advantage, they make you seem like you're really trying to change yourself and become a better person. That since you've been arrested you've been trying to improve yourself. It's like the police want to make it seem like they've begun the rehabilitation process all by themselves, like they're doing a lot of good by keeping people in detention and knocking them around. And it's true that by the time I got to family court, after fourteen days, I was ready to admit anything and I really wanted to become a better person. I wanted to improve myself, maybe that's the point of the whole system, to make you look back on the past and think about how bad you were and then make you want to become a better person. I really wanted to become better. So I signed everything, a confession, a statement that Naoya and I worked together, a statement accusing some of the subcontractors of buying parts, a statement saying that I had convinced other kids to quit school. I really believed it was for everyone's own good that I was doing this. I sincerely wanted to change, that's what the observation system encourages. The longer you're in

there, the more you want to become a good person, a regular person.

"The best thing that can happen to you if you're arrested is fourteen-day or twenty-one-day observation and then release. But that happens like one time out of a hundred. If the cops have you they want to make sure you confess to whatever crime they picked you up for. The guy next to me, kind of a Yakuza guy, but not so scary, kept laughing at me. A long vacation, he said. Sayonara. He said when he was a kid he'd been picked up for a traffic violation and was given three years in Niigata Shonenin.

"When the guy from the Ministry of Justice came to talk about my future with me, I told him that I had seen that I was all wrong before, but that I wanted to become right, more normal. That's what I wanted. He asked me about school and I said I wanted to go back to school. I didn't know who was talking but I really believed suddenly that I wanted to become a better person.

"It was only when I was in court that I realized that the Ministry of Justice guy was both my prosecutor and my attorney. One of the documents I'd signed allowed for my case to be ruled on by a judge considering recommendations from the Ministry of Justice, the arresting officers, and the observing officers. The primary evidence were the confessions I'd signed. They would be the deciding factors, and it turned out they were devastating. I had admitted to everything a kid can do wrong. On paper, there was nothing good about me, and the thing was, after two weeks in the cage listening to a bunch of real criminals go on about how I was going to jail for a long, long time, I was ready to believe anything. Maybe I was a terrible criminal. People like me, people who didn't fit in, we were making problems for all the good people, the regular people in society, those salarymen in good suits in commercials guzzling energy drinks. I wasn't like them and the reason for that was I didn't know what I was doing.

"I want to change, I told the family court judge at my arraign-

ment. I want to become better, a good person—no more skate-boarding, I told him. No more drinking or motorcycle stealing. That was wrong. Wrong, wrong, wrong. I would change, I was changing, I had changed. I cried a lot then. Whenever I was out of the cage and away from the other prisoners I would start crying. While the police were questioning I would be crying, apologizing, tearfully explaining to them that I was sorry, terribly sorry, and that I was going to become a whole new person. In the family court I cried and told the judge that the time to think had been exactly what I needed.

"He agreed and gave me sixty days observation at Shonen Kembetsusho Boys Detention Center. We called it Nerima because that's where it was.

"When they took me back to my cage, while they were sending for the car to take me up to Nerima, I saw the captain again, the arresting officer, and I asked him, how did you catch us? How did you know?

"'The bums,' he said. 'One of the bums from the park came down to the police station and told us everything.'"

Shonen Kembetsusho Boys Detention Center, or Nerima, is an austere white-walled complex that, at any one time, houses over one hundred juvenile offenders in observation or awaiting transfer to tougher youth prisons in northern Japan. Dai's prescribed sixty days observation technically wasn't a sentence but a pre-hearing "psychological evaluation period." In reality it was like being put in jail without a trial, hearing, or sentencing. Due process, as defined in Article 37 of the Japanese Constitution, is considered by the Ministry of Justice to include extended pre-arraignment detention or pre-hearing observation. As long as Dai's arraignment took place within twenty-one days of his arrest, Article 37 had not been violated. (Article 36, which prohibits "cruel punishment" is also interpreted freely by the National Police Agency and Ministry of Justice.)

Due process Japanese-style was served because Dai had agreed—under coercion—to "psychological observation." The observation period meant, legally, that Dai had waived his right

to the "speedy trial" guaranteed in Article 37. Dai's behavior during the observation period would be the main criterion for a ruling by the family court judge on whether to release Dai or sentence him to a juvenile classification home; that is, a youth prison. If Dai was found to be unremorseful or disrespectful, it was possible, despite being a first offender, that he could get one to two years.

There are approximately 3,500 juveniles officially incarcerated in Japanese juvenile correctional facilities. However, at any given moment, there could be up to 100,000 more juveniles waiting for arraignment or waiting, like Dai, in pre-hearing observation. Post-arraignment, pre-hearing detention and observation for juveniles can extend up to ninety days. Obviously, Japanese prosecutors' loads are significantly reduced if a suspected juvenile offender can be made to serve an automatic ninety days without any real legal recourse. Only after the observation period is served and the presiding judge and the Ministry of Justice attorney decide further rehabilitation is required, will the offender be formally sentenced. Rarely does a case actually go to trial. In 1990, of 169,714 juvenile arrests, only 905 were referred to prosecutors; 900 of these trials resulted in conviction. Thus most juvenile jail time is technically "observation" and not incarceration.

"We always have the children's best interests in mind," explains Ministry of Justice official Kohji Omuro. "We really believe in rehabilitation, unlike the United States where there is more emphasis on punishment. The observation system we employ is primarily a rehabilitation system, not a prison system. It keeps the children from becoming lifelong criminals."

Observation at Nerima is, in Dai's words, "like living in a world run by high school physical education teachers."

The instructors—they are not called guards—wear track suits and sneakers. Their tone and bearing is somewhere between Strother Martin in *Cool Hand Luke* and Edward James Olmos in *Stand and Deliver*. But there is no algebra or grammar taught at Nerima. What the detention center emphasizes, above all else, is physical fitness.

"Endless push-ups, sit-ups, laps around the gymnasium. Boring exercises. Nothing fun, like it's on purpose that all the exercising is boring," Dai recalls. "And if you slow down or you can't keep doing the sit-ups, they really start yelling at you. They make you keep running until you vomit. And if you stop, collapse, or lie down, then you get a bad mark. Ten marks, people said, and you would go to jail. No marks and you went free after observation."

The rooms are tiny, about six feet by seven feet, with white concrete walls and no inner knob on each steel door. There is a squat toilet in one corner and each detainee is given a small, foldable sleeping pallet and a blanket. Meals consist of soy beans, miso soup, and brown rice. (In Japan, brown rice is considered subhuman fare.) The only books given to the detainees are history books and textbooks. Once a week, inspirational films about Japanese folk heroes or athletes are shown. Dai recalls one motivational film featuring track star Carl Lewis.

"We got out of our rooms once a day, at ten-thirty for our physical fitness," Dai remembers. "That was on weekdays. During the weekends we were locked down all day. Not even let out for physical fitness."

Letters were opened and read by the instructors, who were notoriously slow at censoring the incoming and outgoing mail. "They got in a bad mood if there was too much mail. They hated reading the mail," says Dai. "They would take it out on you by not giving you a pencil or anything to write on. All you could do was sit and think, or read a textbook."

Ministry of Justice official Omura says observation is intended as a contemplative period for the young delinquents. "They take the time to think and reflect on what they've done. They become healthy and strong in body and spirit, so they can see that they've behaved badly. Ninety percent of the time this is successful and we don't have to sentence the child to a juvenile classification home."

"You do think a lot in there," Dai reports of his observation. "You start thinking about the circumstances that led to getting caught. The quitting school, the bikes, the Straight Killers, hang-

ing around with Naoya, sniffing glue, drinking. And then about the bum telling the cops. Imagine that, some bum telling the cops about me. I wondered for a while which one did it, if it was the one Naoya had beat up or just one who didn't like him. And then I stopped caring. I was caught, and caught is caught. Nothing I could do about it. I missed Aye more than anything. There were rumors they put saltpeter in the food so we wouldn't get aggressive, and I think it's true because while you're in there you become pretty dull. Lifeless. You only get out once a day, and besides that you just think and think. It's meditative, that's what it is. A lot of reflecting—even more than in the cages. In observation, all I thought about is what I did wrong, how I did everything wrong. How, if I kept doing what I had been doing then I wasn't going anywhere—I was on no track. I wanted to become a better person."

Dai was fortunate that while in observation, Ministry of Justice caseworkers decided that contemplation had replaced youthful indiscretion. At his hearing the family court judge, at the request of the Ministry of Justice and with recommendations from the Shonen Kembetsusho Boys Detention Center instructors, sentenced Dai to one year probation and ordered him released to the custody of his parents.

Dai's partner, Naoya, it turned out, didn't take to observation. At an observation center in Chiba, just east of Tokyo, he exchanged blows with a fellow detainee during a lecture and repeatedly refused to participate in rope-climbing drills. (He didn't know how to climb ropes.) His instructors noted his anti-social behavior and Naoya, at his hearing, was given ten months at Ibaraki Juvenile Classification Home.

Ibaraki Juvenile is a sprawling concrete complex in the shadows of a giant statue of Buddha erected fifty years ago by the township of Ushiku. Ibaraki Juvenile's stated goal is to train its charges in agrarian skills; the convicted juveniles work in the fields most days, winter or summer, driving tractors, sowing carrots, potatoes, and rice, and shoveling fertilizer. They shave your head and put you in a black uniform and you aren't allowed

to speak unless spoken to by a guard. For a city kid like Naoya, who had never seen a farm before he got to Ibaraki Juvenile, adapting to driving tractors instead of motorcycles was traumatic.

New arrivals at Ibaraki Juvenile are stripped and searched. Their clothes and possessions are stored in gray plastic bins that will be sealed until the inmate is released. In a cold, tile-floored room furnished with only a bench, the new arrival changes into a prison black jacket and pants and leather work shoes. He goes through an extensive, day-long interview and orientation lecture that, according to one guard, "calms them down. They learn what is expected of them."

After the interview, each new arrival is locked into solitary confinement for five days.

Half the 125 detainees at Ibaraki Juvenile were there because of theft, 16 for aggravated assault, 13 for drugs. According to Ibaraki Juvenile Classification Home Deputy Superintendent Tsugio Noguchi, who dresses in a blue polyester suit and whose left eyelid flutters violently when he talks, "Eighty percent of our inmates have sniffed paint thinner, and maybe fifteen percent of them have used amphetamines.

"Despite the violent backgrounds of many of our charges," the Deputy Superintendent explains, "we don't have a violence problem. We keep them too busy to fight. They work. And if they aren't working in the fields then they are watching instructional videos or pursuing their studies. Sixty percent of each day is vocational. This is not a penal institution. This is a rehabilitative institution."

Each four-tatami-mat "dormitory room" is shared by four inmates, and the sleeping quarters are monitored by video cameras. Conceivably, during a stay at Ibaraki Juvenile, there is never a moment when the inmate is not being watched, either by one of the sixty-one staff members or on a video display terminal in monitoring stations off to the side of each dormitory. An inmate is allowed one visitor a month and that visit is limited to thirty minutes.

Ibaraki Juvenile at first glance appears a paradigm of modern rehabilitative theory; there is a well-kept soccer field, a baseball diamond, music classes, and even a sumo wrestling ring. The grounds are immaculately kept and the dormitory rooms are spotless. Peering into the classrooms, you see young boys working on their calligraphy or reading quietly. There are two guards to a room. Again, the boys are never allowed to speak.

Rather than shocking a visitor with unsanitary conditions or overcrowding, Ibaraki Juvenile numbs a visitor with antiseptic, institutional order. Nothing is out of place. No one utters a word. Beneath that giant statue of Buddha—who discarded speech once he had found spiritual enlightenment—is a whole complex dedicated to preventing speech and breaking the spirit through hard labor. The white walls, hard-tile floors, barred windows, and Spartan meals will knock the life out of even the most exuberant youth. Ibaraki Juvenile exists to break wild kids and remake them as worker drones in Japanese society. An inmate is drilled to quietly—silently—accept his lot in life.

It rained frequently the first spring Naoya was there. On rainy days, when the fields turned to mud, the inmates stayed indoors, shuttling from instructional videos to calligraphy to grammar to history to music classes. It was all busywork; the guards were more qualified in discipline than instruction. During the music classes, as twenty boys stood with their hands clasped behind their backs, Naoya mumbled along with the rest as a guard ordered them to sing, repeatedly, a popular Japanese folk song ("Haru Yo Koi") whose lyrics go:

Come Spring, please come soon,
The baby has just learned how to walk,
She has new red shoes,
She longs to go outside.

Ibaraki Juvenile has a 30 percent recidivism rate. Naoya was back there within a year.

* * *

Dai was out of the Straight Killers. He didn't want to know them anymore, and they didn't want to know him. While he was in observation the police had destroyed the skateboard ramp and questioned a few other members of the gang about marijuana smoking, and now the bums ruled the park, using the scraps of lumber left over from the skateboard ramp as fuel for garbage-can fires.

Aye, who Dai had been missing more than anyone and who had only written him one letter while he was in observation, was busy cramming for college entrance exams that were coming up soon. She was a very good student, it turned out, and her teachers said she had a chance to go to a four-year college. Her parents had called Dai's parents while he was in observation and told them they didn't want Aye to see Dai anymore. Dai's parents said they understood.

But Dai did see Aye one more time. Near the train station. Dai was stepping off the train, carrying two Styrofoam boxes of fish packed in ice from the Tsukiji fish market back to the sushi shop. He wore knee-high rubber work boots and had a white headband wrapped around his head rather than a bandana. When he saw her he froze for a moment.

Aye was boarding the train. She was wearing a simple white-and-blue dress rather than the school uniform familiar to Dai. She still carried the bulky leather book bag, but there was something else different about her. Her hair. She had cut it short and had it styled into some kind of permanent. It was a practical haircut, like an office lady or college student would have. Dai would have run over to her, but she was with someone, a guy Dai didn't recognize, who wore loafers, jeans, and a sweater. And the ice chests full of fish Dai carried were unwieldy, making it hard to run. Aye boarded the train, the doors closed, and she was gone. She hadn't even noticed him.

Dai wasn't allowed out at night anymore, under the terms of his probation. He was ordered to help around the sushi shop, which he did. Pouring drinks and serving fish to patrons

at night, emptying ashtrays, and rushing out to buy fish in the morning.

In the afternoons he would chop vegetables and fish against the wet cutting board with the sharp knife his father had always used.

IV

CHOCO BON-BON
AND EMI

THE PERFECT
TUNA

Choco Bon-Bon is five feet eight inches tall, weighs one hundred and twenty-eight pounds, and has a nine-and-a-half-inch-long penis. He was born on May 4, 1967—or Showa 42 by the Japanese calendar. His blood type is A. His hair color is black and his eyes are dark brown. His most recent address is the Hotel Queen DeGaulle. He got his stage name Choco Bon-Bon because his testicles show up surprisingly dark, or almost chocolate-colored, on videotape.

In pornographic films and videos, one sees more of a male actor's testicles than one does of his penis. The penis, in a typical AV (adult video), is buried in one of the female actor's orifices; the testicles—or *bon-bons* in the Japanese porno industry—will be on more prominent display, banging against the female lead's buttocks or knocking against her chin. Hence the high recognition factor of Choco Bon-Bon's testicles. He had become a star in the industry on the basis of them; he was one of the few male leads Japanese AV fans recognized. In just six months in the AV biz he had reached the A-list. He was hot, so much in demand, in fact, that one of the top AV talent management companies was putting him up at the Hotel Queen DeGaulle. Choco Bon-Bon himself didn't have to pay a yen for the smallish, two-room, track-lit suite. He could even order room service if he ever got hungry, which he never, ever, did.

Choco Bon-Bon shook a tiny shard of *shabu*—smokable crystal methamphetamine, the very potent form of amphetamine commonly known in the United States as ice—onto a piece of tinfoil and lit it from below with a cigarette lighter. In his clenched lips was a tightly rolled ten-thousand-yen note through which he sucked the thick, white plumes of smoke rising from the foil as the speed liquified, turned brown, and ran down the foil. He released the red butane lighter switch and held his breath for ten seconds before exhaling the smoke. He closed his eyes for a moment and then took another hit, and then another, until there was nothing left on the foil but ashen remains.

Shabu kept Choco Bon-Bon going, helped him maintain erections for however long the shot required. In a typical day on the set he could do five, six, or even seven scenes. And in

the Japanese porno industry, where male leads are paid by the ejaculation, this meant that Choco Bon-Bon's daily payment would be commensurately higher.

Directors preferred working with him and producers liked his results: Choco Bon-Bon put in a full day's work, wasn't difficult or troublesome on the set, and was easy to get along with. He had worked with all the legendary directors—Kaoru Toyoda, Bakushi Yamashita, and Toru Muranishi. Female leads didn't mind him, with his slight mustache and deeply tanned, sharp facial features, he was less repulsive than some male actors in the industry. And he bathed regularly.

Choco Bon-Bon was rail thin, which was good because his skinny hips made his penis look even bigger by comparison. He also kept his pubic hair trimmed short, to give the illusion of additional centimeters on screen. And he kept his mouth shut, didn't talk back to directors who might berate him for not splattering directly onto a girl's face when he came, didn't tell certain female actresses their pussies stank, and didn't make too much of a fuss when his payments were late or short. His rate had reached ¥500,000 a cum shot, top of the scale for male leads.

Choco Bon-Bon, as he sat on the bed shaking another rock of *shabu* onto the piece of tinfoil, talked about what was on his mind: a Kharman Ghia. Everyone dreams, and Choco Bon-Bon's dream was to own a late-fifties model 1400cc Volkswagen automobile whose body had been designed by Porsche. The cars were just becoming hip in Japan, where retrograde styling was in and the Kharman Ghia's inverted bathtub shape had caught the fancy of car buffs and one very popular porno star.

"You have to think small," said Choco Bon-Bon of his modest dream. "Some actors talk about retiring and buying a house in the suburbs. Some talk about getting rich—"

He took another hit.

"I just want wheels," he said as he exhaled. "I'm no dreamer."

Japanese porn is a gigantic business, estimated to generate as much as $10 billion a year. The most sophisticated distribu-

tion system in the world retails the product via video stores, convenience stores, vending machines, even mom and pop groceries. The industry is hardly shackled by Ministry of Justice regulations that require a fuzzy blip over the male and female genitalia. (Almost half the industry operates outside the censorship requirements anyway.) Nobody knows the exact number of titles released or filmed each year—retitled releases, "new" videos comprised of spliced excerpts from other videos, and "home" videos make tallying impossible—but an approximate figure, quoted by industry sources, is 14,000.

Shoji Onodera has directed at least thirty adult videos. Maybe more, he can't remember them all. (He's made four with Choco Bon-Bon.) He won the AV Best Director Award in 1991, one of his best years. His releases that year included the smash success *Sexual Ecstasy One*, a title that did ¥75 million in sales alone. Rentals were still being tallied by his staff at Captive Productions in Shinjuku.

Shoji Onodera parked his Lexus near a twenty-four-hour convenience store, which happened to stock a few of his most recent releases. He descended the stairs beneath the shop. He had bags under his tired, brown eyes, and a well-tanned but fleshy face. He wore sweat pants, sneakers, and had a towel wrapped around his neck. On his wrist was a thick gold Rolex and on his finger he wore a ring with an emerald a half-inch in diameter that was surrounded by a dozen two-karat diamonds. The gaudy ring and the cheap towel were Onodera's sartorial trademarks.

Slamming the basement door behind him, he began barking orders, patting backs and dispensing encouragement to cast and crew already assembled on the set. In his enthusiasm, he was more like a high school wrestling coach conducting practice than a film director.

Onodera needed four hundred minutes of takes to make the sixty minutes that would eventually constitute *Sexual Ecstasy Two*. Every minute shot, even in the Beta-format tape he used, cost ¥70,000. That included wages, the cost of studio rental, videotape, boxed lunches, and beverages, but didn't include

the use of condoms or pretesting for the HIV virus. The Japanese AV industry, unlike its American counterpart, doesn't regularly test actors or actresses before a shoot.

The set was a bed, of course, which Onodera ordered the grips to move around until he was satisfied with its location. Then the lighting man went to work. The cameraman started shooting test footage. The assistant director checked battery levels, as the soundman/boom operator taped a microphone to an aluminum pole.

Finally, the actor and actress were ushered from the dressing room/kitchenette in white terry cloth robes. Jun Yahagi was a wiry-framed twenty-six-year-old who had been in the business six years. He was a dependable lead who knew every trick in sexual liaisons during which pleasing the director was more important than pleasing his partner. He was no Choco Bon-Bon, but then who was? His lithe frame was kept supple not only from the contortions he was put through by directors like Onodera, but also from four weekly trips to a health club. Yahagi was paid ¥50,000 per ejaculation. If everything went well today, he would walk away with ¥150,000.

Actress Taira Kan, twenty, with round, dark eyes, high cheekbones, and full, pouty lips, had worked on six AVs, and she, like Choco Bon-Bon, was saving to buy a car. Adult video may be the only industry in Japan where women are paid more than men. Taira's rate was ¥1 million per day, whether she did one, two, or three scenes or one, two, or three costars. The discrepancy in day rates between male and female leads reflects the industry's insatiable demand for fresh *maguro* (which directly translates to "tuna," the nickname for female actresses in the Japanese porno industry) who look good under harsh, white movie lights and can turn in a credible performance. Most male leads are interchangeable. AV enthusiasts pay more attention to the female lead of a film than the man.

Onodera explained the characters to the two actors. He improvised, making up the scenario as he went along. "You are a secretary," he told Taira. "You work in Shinjuku, no, Ikebukuro,

in the public relations department of a major corporation. You don't usually do things like this. You are shy. But you are incredibly turned on *because* you are shy." Onodera sat on the bed beside Taira and patted her on the back. "Okay?"

Taira nodded.

Onodera turned to Jun. "Have you ever fucked a secretary?"

"No," Jun said.

"Well," Onodera said, wrinkling his brow, "it's just like fucking an adult video actress."

Taira perked up suddenly. "I used to be a secretary!"

Onodera clapped his hands together. "So we're shooting a documentary."

The grips, soundman, lighting man, and assistant director all sighed. The Office Lady and the Salaryman is the most common "plot" in the Japanese AV business. These two veteran actors should have known by now what was required of them. This was more acting coaching than the crew was accustomed to—but maybe that's why Onodera was one of the best.

The click of the video camera disengaging from the tripod as the cameraman went in for tight, hand-held close-ups was the AV equivalent of the snap of a Hollywood clapboard.

"It's a job, it pays the rent and then some," said Jun between takes. "I have real goals beyond AV. You know—a wife and kids, with a house in the suburbs. And this stuff all goes to finance a dream that will be realized when these videos have been recorded over with some aerobics program."

The cast and crew waited around, sipping tea and smoking cigarettes, as the bed was dragged from the set and tatami mats were laid down for a "traditional" scene. The black curtains hung behind the mats were supposed to give the impression of an old-fashioned brothel. Onodera needed to reshoot a sequence from another video that came out too dark in the initial shooting. He wouldn't be using the same actors and actresses, who wore topknots and traditional wigs for the original shoot. It didn't matter. As long as the tatami mats were down and the cameraman didn't linger on the actors' faces, no one would care about the break in continuity.

Clearly in command, Onodera joked with the cast while the grips worked, complimenting the actors on their endurance. But when he shouted at an actress, as he did when Taira wasn't delivering a convincing performance—she stopped moaning whenever there was a position change—his anger reminded them that they weren't artists honing a craft. This was business, and forty-five seconds of unconvincing moaning meant costly over-dubs later.

Showered and dressed in her conservative street clothes, Taira really looked like an office lady. Onodera gave her a bear hug and a fatherly kiss on the forehead as she was leaving.

Onodera and his partner, producer Yokichi Yamaguchi, rode in Yamaguchi's blue Mercedes from the Captive offices in Shinjuku down to the Hotel Queen DeGaulle for a meeting with Choco Bon-Bon. Expressway 4 near Shinanomachi was backed up, and the late afternoon August sun beat down on the car. Outside, the temperature was over 95 degrees and the relative humidity was close to 100 percent, but it didn't raise the temperature inside the air-conditioned cabin.

As they jerked forward and stopped, Onodera explained to Yamaguchi his vision for *Sexual Ecstasy Three*.

He had a simple idea, really, but in the Japanese AV world it didn't take much for a simple idea to suddenly seem great, terrific, *sugoi* (fantastic). He would take a fresh *maguro*, as young as he could find, maybe a virgin, if that was possible, and not only would she be fucked and eaten, but she would also be anally penetrated. Onodera wanted to pull out all the stops. Choco Bon-Bon would do the buggering. He was expensive, but it would be worth it.

Onodera talked it over with Yamaguchi, a slight man with a bushy mustache and centimeter-thick eyeglasses. With the glasses on, his eyes looked as if they were bulging; without them he was legally blind. Yamaguchi listened as Onodera excitedly outlined his vision of *Sexual Ecstasy Three*. They had to have Choco Bon-Bon, he insisted. *Sexual Ecstasy Three* could be even bigger than *One* or *Two*.

in the public relations department of a major corporation. You don't usually do things like this. You are shy. But you are incredibly turned on *because* you are shy." Onodera sat on the bed beside Taira and patted her on the back. "Okay?"

Taira nodded.

Onodera turned to Jun. "Have you ever fucked a secretary?"

"No," Jun said.

"Well," Onodera said, wrinkling his brow, "it's just like fucking an adult video actress."

Taira perked up suddenly. "I used to be a secretary!"

Onodera clapped his hands together. "So we're shooting a documentary."

The grips, soundman, lighting man, and assistant director all sighed. The Office Lady and the Salaryman is the most common "plot" in the Japanese AV business. These two veteran actors should have known by now what was required of them. This was more acting coaching than the crew was accustomed to—but maybe that's why Onodera was one of the best.

The click of the video camera disengaging from the tripod as the cameraman went in for tight, hand-held close-ups was the AV equivalent of the snap of a Hollywood clapboard.

"It's a job, it pays the rent and then some," said Jun between takes. "I have real goals beyond AV. You know—a wife and kids, with a house in the suburbs. And this stuff all goes to finance a dream that will be realized when these videos have been recorded over with some aerobics program."

The cast and crew waited around, sipping tea and smoking cigarettes, as the bed was dragged from the set and tatami mats were laid down for a "traditional" scene. The black curtains hung behind the mats were supposed to give the impression of an old-fashioned brothel. Onodera needed to reshoot a sequence from another video that came out too dark in the initial shooting. He wouldn't be using the same actors and actresses, who wore topknots and traditional wigs for the original shoot. It didn't matter. As long as the tatami mats were down and the cameraman didn't linger on the actors' faces, no one would care about the break in continuity.

Clearly in command, Onodera joked with the cast while the grips worked, complimenting the actors on their endurance. But when he shouted at an actress, as he did when Taira wasn't delivering a convincing performance—she stopped moaning whenever there was a position change—his anger reminded them that they weren't artists honing a craft. This was business, and forty-five seconds of unconvincing moaning meant costly overdubs later.

Showered and dressed in her conservative street clothes, Taira really looked like an office lady. Onodera gave her a bear hug and a fatherly kiss on the forehead as she was leaving.

Onodera and his partner, producer Yokichi Yamaguchi, rode in Yamaguchi's blue Mercedes from the Captive offices in Shinjuku down to the Hotel Queen DeGaulle for a meeting with Choco Bon-Bon. Expressway 4 near Shinanomachi was backed up, and the late afternoon August sun beat down on the car. Outside, the temperature was over 95 degrees and the relative humidity was close to 100 percent, but it didn't raise the temperature inside the air-conditioned cabin.

As they jerked forward and stopped, Onodera explained to Yamaguchi his vision for *Sexual Ecstasy Three*.

He had a simple idea, really, but in the Japanese AV world it didn't take much for a simple idea to suddenly seem great, terrific, *sugoi* (fantastic). He would take a fresh *maguro*, as young as he could find, maybe a virgin, if that was possible, and not only would she be fucked and eaten, but she would also be anally penetrated. Onodera wanted to pull out all the stops. Choco Bon-Bon would do the buggering. He was expensive, but it would be worth it.

Onodera talked it over with Yamaguchi, a slight man with a bushy mustache and centimeter-thick eyeglasses. With the glasses on, his eyes looked as if they were bulging; without them he was legally blind. Yamaguchi listened as Onodera excitedly outlined his vision of *Sexual Ecstasy Three*. They had to have Choco Bon-Bon, he insisted. *Sexual Ecstasy Three* could be even bigger than *One* or *Two*.

"With Choco Bon-Bon and the virgin, fucking the virgin up the ass—" Onodera stopped. He didn't need to explain himself further.

But Yamaguchi, who never paid much attention to the videos or the stars, only to locations and costs, still didn't get it. "Why does she have to be a virgin?" he asked. "And where the hell are we going to find a virgin?"

"It's a figure of speech," Onodera admitted. "I mean a girl in her first video. Starting her career by being buggered by Choco Bon-Bon, that's what I mean. She just has to look like a virgin."

"They all look the same," Yamaguchi said.

No they don't, Onodera thought to himself. He had been looking over girls for years, fresh tuna brought in off the streets by scouts for his review and perusal, sometimes right onto the set. The scouts, who took a 50 percent cut of the girl's fee if she was hired, would stand by obsequiously as Onodera looked over the girls. He could tell instantly if a girl would work out, or if she just wasn't AV material—or at least not Captive Productions material. He turned down beautiful girls with fulsome figures whom the crew was catcalling for, and chose, to the crew's disbelief, homely girls who'd turn out to have that animal sexuality or hunger or the passion or they just loved getting fucked. That was the girl he looked for. The girl who was shy but liked it. The girl who was a little insecure about her looks and so was pleased to be regarded as a sex object, flattered to be in a porno film, thrilled that men all around Japan would be masturbating into tissues at the sight of her pussy wet and split on the television screen.

For *Sexual Ecstasy Three*, Onodera needed one of those girls. As young as possible. Eighteen. Nineteen at the oldest. And he would need Choco Bon-Bon.

The thermostat in the suite at the Queen DeGaulle was set at 15 degrees Celsius (55 degrees Fahrenheit) and Choco Bon-Bon was still warm, so he was sitting at the edge of his bed wearing only a G-string and a red T-shirt. Onodera and

Yamaguchi, having walked from the air-conditioned car, through the sweltering garage, and then back into the air-conditioned hotel lobby and now into Choco Bon-Bon's Arctic suite, were covered with sweat and shivering simultaneously. Onodera took in the room, noting the bits of blackened tinfoil that were scattered on the desk, atop the television, and on the bed next to Choco Bon-Bon. Choco Bon-Bon hadn't offered either of the men a chair. There were two chairs by the window; Yamaguchi took one of them while Onodera stood.

The room had the heavy, turpentine smell of *shabu* smoke. The blue-and-gray curtains were drawn to keep out the sun. Choco Bon-Bon had a wired, jittery look that Onodera guessed came from having been awake for a few days. From the looks of it, Choco Bon-Bon had smoked enough crystal meth to stay up for a month. But no one could tell Choco Bon-Bon what to do.

Onodera paced the small room, from curtains to the front door and back again. Just as he began to explain his idea to Choco Bon-Bon—and Onodera was rare among AV directors in that he would actually discuss ideas with mere actors—Choco Bon-Bon hit the remote and turned on the television to a children's cartoon. A family of rabbits was being chased from its warren by a big, angry, Caucasian farmer.

Who cares about explaining the story? decided Onodera. He stopped talking and watched the cartoon. The farmer waved a pitchfork menacingly and then lunged for the baby rabbit who barely managed a wiggling escape between the pitchfork's tines.

"Trash," muttered Choco Bon-Bon as he switched off the television. He turned to Onodera. "So, what's the story?"

Onodera, surprised at Choco Bon-Bon's sudden interest, laid out the details. The fresh girl. The anal intercourse. And Choco Bon-Bon, to be the lead in the biggest and best *Sexual Ecstasy* yet.

Choco Bon-Bon listened. "My price is one million yen," he said to Yamaguchi when Onodera finished talking, and added, "a shot."

"No male gets a million a shot," Yamaguchi protested.

"Talk to my manager," Choco Bon-Bon said and switched the television back on.

"Trash," he muttered again to himself. When Onodera and Yamaguchi left, they could hear Choco Bon-Bon in the room behind them flicking a lighter and then a faint sucking noise as he inhaled more *shabu*.

No male in the AV business got a million a shot, ever, Yamaguchi explained to Onodera and then to Choco Bon-Bon's manager. No one. It was unheard of. An insulting proposition. Captive Productions was one of the top companies in AV, and they had done a lot for Choco Bon-Bon's career. (*Tales of a Hard Banana, Charming Gyrations, This Is Great Pussy!*, and *Bazooka* were among the titles they had collaborated on.)

This required anal intercourse, Choco Bon-Bon's manager pointed out over the telephone, and Choco Bon-Bon had strong feelings about anal intercourse.

"Strong feelings?" said Yamaguchi in his velvet office chair.

"He believes it's trash," the manager, who took 40 percent of whatever Choco Bon-Bon made, explained.

Yamaguchi told him to forget it. They would get someone else.

Onodera had a fit. "He's the best. How can we do this without him? These other guys might not keep it up for long enough or they might come too soon and ruin the thing. It's a delicate balance," the director lectured Yamaguchi. "We need Choco Bon-Bon because he's a sure thing. And because we don't have a famous tuna."

Could they do it without the anal part? Yamaguchi wondered. Say with just straight sex?

Onodera shook his head. No. Not if they wanted to make a yen on the video.

So Choco Bon-Bon was hired at a million a shot. That meant he would have to ejaculate once for his Kharman-Ghia. Or twice, if he wanted a show car.

*　　*　　*

The auditions for the girls and the other male roles were held in the Captive Productions offices. An office audition indicated this would be a special job; for most videos Onodera usually hired girls who scouts brought directly to the set. He prided himself on his ability to make snap judgments about character and sexuality and how that would translate to the small screen. His decisions were instinctive and could be expensive, but when they worked, the results were spectacular.

Once, for the title sequence to *Speisu Garus* (*Space Girls*), he was shooting an oiled and lubricated buttocks that was being massaged and then penetrated by an oiled and lubricated fist. To the average director it wouldn't make much difference whose buttocks and whose fist was employed. But Onodera was demanding, trying girl after girl in the sequence, directing that their hind parts be oiled with a combination of syrup and sea-slug brine that shines on videotape, then watching through the monitor and deciding against first one, then another, and finally a third girl. The assistant director, watching the monitor, couldn't tell the difference between one ass and the next. Even the male lead whose fist was employed was becoming bored of massaging flesh and probing vaginas. Onodera then chose an unlikely girl, one whose knocked knees were distinctly unsexy, and ordered her lubricated. The shot opened as a tight silhouette of the greasy behind and then the male's hand entering the frame, first rubbing then probing. As the shot pulled back and showed the girl's jerking, bucking head, Onodera ordered her to look at the camera. She did. And she drooled.

"Perfect!" he shouted. "Cut."

The auditions for *Sexual Ecstasy Three* brought out the whole galaxy of *maguro* and male actors. Young starlets looking for their first break. Older stars looking to stay in the business. The Reikos and Eikos and Keikos. Ries and Mies and Mayas. Emis and Toshimis and Hiromis. Anyone Onodera recognized he wouldn't consider for the female lead. Of course, there would be other roles, smaller parts, the various *maguro* and

men who do the scenes leading up to Choco Bon-Bon's million-yen shot.

They had decided they could afford Choco Bon-Bon for only one shot, the anal penetration scene. The plot had to be modified so that the fresh *maguro*, when Onodera finally found her, would mistakenly, through keyholes and by walking in on couples, watch the first several setups as her initiation into the sexual realm. Then gradually, by a voyeuristic viewing of several other couples, she would become initiated into the world of sex, and though she would lose her "virginity" to another male lead—maybe Jun Yahagi—before Choco Bon-Bon, she would never truly enjoy an orgasm. (Here, Onodera stole from his own Japanese remake of *Deep Throat*. Doctor Choco Bon-Bon would examine her and deduce that her clitoris was actually in her anus, thus necessitating his rear entry to gratify her. It was a simple, proven formula that made maximum use of Choco Bon-Bon's acting skills and his nationally renowned testicles.)

But as the girls and boys paraded past, Onodera found it difficult to cast the leading lady. He watched from his leather desk chair, sipping iced oolong tea and smoking Hope filterless cigarettes. He didn't like office auditions, it was hard to tell how a girl would react to a cum shot to the face in these sterile conditions. On the set, he could call over a male lead and have him tongue-kiss the girl on the spot to see how she would react. Or he himself would reach under her skirt and into her underwear. In the office, with the framed posters of his films on the wall and the crystal Best AV Director Award plaques hanging behind him, he felt more like a doctor or lawyer than a pornographic filmmaker.

These girls were pretty—some of them knockouts—but none had the virginal quality he needed. The strange thing about AV girls was that they dress conservatively. No leather bondage gear or body-conscious clothing for them. Instead, they wore office-lady skirts and conservative hairstyles with bangs. A few of the bigger tunas who were recognized no matter what they wore came in showy leopard skin or skintight neoprene. AV superstar Miki Mayuzumi, star of *Inverse Rape*, wore

jeans and a T-shirt. Rie Tezuka, leading lady in *A Documentary Dissection of a Woman's Body,* whose short, spiky hair had made her famous, wore sweat pants. The girls all perspired a little, wisps of hair sticking to their foreheads or small droplets of sweat beading at their necks.

As Onodera walked down busy Yasukuni Street on his way to a soba noodle shop, he cursed the heat and wiped his face with the white towel. He found himself studying the young women walking toward him; if he saw a woman he felt would make a first-rate tuna, he wouldn't hesitate to approach her and introduce himself. And he always told her straight out that he was an adult video director.

"A woman should know from the beginning," Onodera insisted. "At first they may pretend to be disgusted. But very few refuse to speak to me at all. If they're alone."

Especially if they were insecure about their looks. Onodera never approached the best-looking woman in a bar—he himself didn't drink—or noodle shop. His taste in women was more eclectic.

"I don't know why I like certain types of women," he said as he walked down the busy street, ducking between other pedestrians. "But I've been very lucky. Every girl I find I end up using. No scout can match my track record."

Osamu Sekiguchi, an AV manager who has worked with Onodera on numerous occasions, says Onodera is among the hardest-to-please directors in the business. "He is different because he doesn't take just any good-looking girl a manager brings in. He's picky and that's what makes him difficult. But if he chooses to use a girl, she's made in the business. She'll definitely get more jobs after that."

Onodera's own taste in women was less complicated. Since he divorced his first wife after she discovered he had acted in two pornographic videos (the male actors having not performed satisfactorily, in Onodera's opinion, necessitating his filling in as a pinch hitter), he had gone out with a succession of younger women. There had been a few AV starlets. And he had also

dated women who weren't in the industry. But any woman he was with eventually became dissatisfied with Onodera.

"I'm married to my work," Onodera stated proudly as he sat down in the noodle shop and ordered his regular noodle dish from the bent-over old lady who ran the restaurant. He came to this traditional restaurant every day in between auditions. He was referred to as *sensei*—master, the same phrase used for prominent painters or judo instructors—by the old lady, who was familiar with the nature of his work. She had never seen one of his films, and was completely indifferent to the nature of those films, but she had once seen Onodera-sensei on a television talk show and that had been enough to convince her that this man who was always sweating profusely in the summer deserved *sensei* treatment.

Onodera never considered the moral implications of his work. He had been assailed by feminists, Christians, and devout, puritanical Buddhists who believed his work to be degrading and demeaning to women and the human spirit. But Onodera saw himself as the descendent of a long line of Japanese artists who rendered erotic subject matter with taste and sophistication. Hadn't *shunga*—antique, erotic, highly graphic woodblock prints—been the pornography of the Tokugawa Era? Weren't they now considered by many people to be fine art? And though Onodera didn't see himself as an artist, he felt his work, at times, straddled the artistic. And perhaps, the possibility that his work would be taped over with aerobics lessons notwithstanding, *Sexual Ecstasy Three* would someday be regarded with the same reverence as Utamaro Kitagawa's early-eighteenth-century *shunga*.

"But I know I'm not making Kabuki here," Onodera admitted as he slurped up a bowl of noodles. "This is business."

Choco Bon-Bon only went out at night and then only to buy more *shabu* or lemon sorbet, the only food he liked when he was speeding. He didn't like taxis; the waiting in traffic made him nervous. And he could not stand the subway; the crowds drove him to paranoia. So he strolled, taking long, lop-

ing strides down the crowded, hot summer streets to find Noto-san, his dealer, who could sometimes be found at a small snack bar near Shibuya Station. If Noto-san wasn't there, then Choco Bon-Bon had a problem: he might have to go across town to Ueno Park in the Low City to buy from the Iranian dealers who hung out there. (He liked buying from the Iranians because he imagined there was less chance they would recognize him.) He would have his choice of taxi or train for the long trip across town.

But with his own Kharman-Ghia, then maybe traffic wouldn't seem so bad, and he could zip over to see the Iranians whenever he wanted. He always wore shades when he went outside, and he had grown a mustache to further obscure his identity. Choco Bon-Bon knew that the chances of his face being recognized were miniscule compared to the chances that his testicles would be recognized, if he were to expose them in public. He believed in precautions, however, especially when buying drugs. Hadn't Mako Mako, another male lead in porno and action films, been busted for buying *shabu?* And then there was former Hiroshima Carp baseball pitcher, Yutaka Enatsu, who was sent up for four years for having less than two grams. This was serious stuff, especially in a country where the media was constantly warring on drugs.

And besides, Choco Bon-Bon thought as he caught his reflection in the window of the Seibu department store, wasn't he something of a role model? Out there among the millions of AV fans there must be a few who regarded Choco Bon-Bon as an example, as a leader. He tried to imagine a real fan painting his balls deep brown in tribute to Choco Bon-Bon.

A barker on the street was handing out flyers to a live-sex show in the area. Most male actors supplemented their income with live performances in the Kabuki-cho red-light district of Shinjuku, where over two hundred clubs put on sex shows every night. Choco Bon-Bon still periodically worked the shows, when his manager thought the price was right. He found them tedious, especially the spotlights, which inevitably shone down

on his testicles once he had contorted his body into some uncomfortable pretzel to show them off at full advantage.

He turned up one of Shibuya's crowded side streets and then down a narrow alley. He walked down the steps to the snack bar where his dealer, Noto-san, sometimes hung out. There were a few salarymen and the bartender, who was peeling a lime. But no Noto-san. (Choco Bon-Bon had called Noto-san's pager from the hotel but wasn't surprised that Noto-san hadn't returned his call. Noto-san, like most Japanese drug dealers, was constantly changing pagers and cellular phone numbers; Japanese dealers can be very hard to locate.)

"Welcome," shouted the bartender as he heard Choco Bon-Bon descend the stairs. Then he looked up and recognized him as one of Noto-san's customers. (Speeding customers tended to be among the worst clientele a snack bar could have: they were never hungry.)

He shook his head at Choco Bon-Bon. "Haven't seen him all day."

Choco Bon-Bon didn't like being around all that food and turned to climb the stairs.

His last few hits of *shabu* had been an hour ago so Choco Bon-Bon was still jamming. As long as he had his shades on he could stand the harsh white lights of the cars of the Yamanote Line, the railroad that circles central Tokyo. The train was at least air-conditioned, but it was so goddamn slow. He had forgotten how many stops there were on the loop between Shibuya and Ueno. Ebisu. Gotanda. Osaki. It was endless. And then he remembered that there was a subway line that was a straighter shot from Shibuya to Ueno. He started cursing himself and thinking what a fucking idiot he was and maybe those people who said *shabu* was bad for your brain were—

No way. He couldn't start thinking like that. What he needed was some Valium and Fiorinal or Halcion or something to take the edge off a little. It's hard to relax when you're on speed. And his appetite was starting to return. In the last three days—or was

it four days? how long had he been at the Hotel Queen De Gaulle?—he had eaten two scoops of lemon sorbet, about six hundred calories.

He would get even thinner and then his penis would look proportionally even bigger. Dieting was always a good career move.

Thank God he wore shades—they protected him from the harmful rays of the fluorescent tubes that lit up the subway car like a video shoot. Salarymen were reading their sports newspapers with news about the Pacific League race, which was tight this year. Or was it the Central League? Well, one of the baseball leagues was having a race this year, as if he cared.

How do these people stand it? he wondered. How, day after day, do they sit in this glaring, probing white light and read their comic books and sports newspapers and petite paperbacks and go to and fro wherever people go to and fro from. Choco Bon-Bon had only held one job before he became a porn star: he had been a *tsukeru* (bait). A group of his friends from high school used to roll homosexuals near Shinjuku's second crossing and it was Choco Bon-Bon who lured them into the alley where the boys set upon the faggots, taking wallets, watches, cigarettes, and even sneakers if they were wearing a good pair. The *okama* rarely fought back. (Years later, when Choco Bon-Bon saw the Rodney King videotape, he was struck by how similar it looked to when he and his posse were beating up queers.)

His looks had always been an asset. Well-defined cheekbones. Long nose. Strong jaw. Sort of a longish face. He looked like James Dean rendered by a Japanese comic book artist.

The kids in their school uniforms, the office ladies in their drab dresses, the salarymen in their pin-striped suits, sometimes Choco Bon-Bon wondered if anyone besides him was having any fun in this town. That's why he needed that car, the drop-top Kharman Ghia, to keep him away from this riffraff.

His gums were sore. He hadn't brushed his teeth in days.

* * *

The south entrance of Ueno Park was a wide, granite stair-well whose sweep and epic scale was similar to the steps of the Lincoln Memorial in Washington, D.C. But the grand stairway had lately come to resemble a Middle Eastern bazaar. At open-air stalls mustachioed Iranians grilled shish kebabs and round, flat, floury loaves of bread. Music that sounded like cats in heat blared from jerry-rigged speakers. Bootleg cassettes of Arabic artists Choco Bon-Bon had never heard of were spread out on blankets along with counterfeit batteries and imitation brand-name liquor. The whole place stank like some kind of spice that Choco Bon-Bon wasn't familiar with but that made him a little nauseated, or it could be the *shabu* that was making him nauseated, or the body odor of all these Iranian men milling around.

There were no Iranian women; they had been left behind in Baghdad or wherever the Iranians were from. Only the men came, to work construction, slang some drugs and then go home, back to their wives. Or some stayed on, shacking up with Japanese girls. Choco Bon-Bon didn't really know what all these Iranians were doing in Tokyo. He had heard they were all here illegally. But if the police were serious about deporting the Iranians they would know where to find them. There was a small police station about a hundred yards away.

Ueno Park had been the site of the last holdout of the forces opposing the Meiji emperor in 1868, and after their defeat, the emperor ordained the area a public space to preserve the many ancient Buddhist and Shinto shrines there. He also wanted to ensure that as Tokyo modernized there would be plenty of open space in which the masses could recreate. But the Meiji emperor could never have imagined that the south entrance to the park, the stone stairwell nearest the bronze statue of Takamori Saigo, a samurai who sided with the emperor during the Meiji Restor-ation, would become one of Tokyo's leading drug bazaars.

Today, almost anything could be obtained in the shadow of Saigo's stern, bronze, pigeon shit–encrusted visage: heroin, speed, hash, cocaine, and diarrhea-inducing lamb shish kebabs.

The only things you couldn't rely on these Iranians for were good quality cassettes and drugs like Ecstasy or LSD. Or pills. They never had good pills.

Fake Halicon. Fake Mandrax. Fake Valium. Who the hell would bother to make fake Valium, Choco Bon-Bon wondered, when any doctor in Tokyo would give you twenty five-milligram yellows just for showing up?

You take what you can get, and the Iranians, lately, had good speed. Clean *shabu*. It was expensive, about ¥20,000 a gram, but worth it. Choco Bon-Bon walked among the Iranians huddled in groups. For a moment, he felt a certain solidarity with the Iranians; like him, they all wore mustaches. Mustaches were still not popular among Japanese men, and Choco Bon-Bon noticed those few men who did sport mustaches. All hail the mustaches!

But the problem with all the mustaches was that they made it harder to find the guy he had copped from before. It was dark, the music was blaring, the air was smoky. He couldn't find anyone he could recognize. Just mustaches.

"Phonecard?" A mustache asked him in Japanese. (The Iranians spoke two languages: Farsi and Japanese.)

He waved a hand in front of his face. He didn't need a counterfeit phone credit card. He had about a dozen complimentary genuine phonecards in his wallet.

"Phonecard?" Another mustache.

"Phonecard?"

He kept waving his hand.

"You need something else?" A mustache asked him in Japanese.

"Yeah," he said. "*Shabu*."

"*Shabu shabu?*" The mustache grinned.

"Yeah."

"Okay." He told another mustache something in Iranian, and that mustache went running off and conferred with another mustache. Ten seconds later Mustache Number Two was back with something folded in a small piece of newspaper.

"Twenty thousand," Mustache Number One said.

Choco Bon-Bon inspected the poorly folded bindle. These Iranians could learn a few lessons from the Japanese about packaging, he thought, as he opened the newspaper and saw several good-sized slivers of methamphetamine.

He nodded.

"It's good," Mustache Number One said.

Choco Bon-Bon slipped two ten-thousand-yen notes out of his wallet and handed them to Mustache Number One, who seemed surprised that Choco Bon-Bon didn't want to argue about the price.

Mustache Number One looked at the bills as if they might be counterfeit. "You need something else? How about *teri-yaki?*"

Teri-yaki was Japanese slang for heroin.

That might be nice, Choco Bon-Bon considered. He didn't have any Valium or any downers, and sooner or later, preferably later, he would have to crash. He didn't know heroin, he'd only done it once, and he remembered it took the edge off things, pretty much demolished that edge beneath layers of billowy unconscious, which sounded pretty good to him right now.

He bought ten thousand yen's worth in another badly folded bindle. This one, when he opened it to look over the dope, had a newsprint photo of handcuffed Hiroshima Carp pitcher Yutaka Enatsu staring back at him.

Emi, an eighteen-year-old runaway, sat on one of the twin beds in a fluorescent-lit business hotel room paid for by Captive Productions. Fluorescent light rarely flattered; yet Emi, Onodera noticed, wearing only lipstick, was strikingly beautiful. The harsh, probing light revealed no blemishes, no teenage acne, just a ton of adult angst as she mulled over a one-million-yen-per-day offer to appear in a pornographic video.

Her body, Onodera noted as he wiped his face with his white towel, looked right for the job: long legs, curved hips, and full breasts—the kind of girl Japanese guys dream about but never meet. And she was so shy. Almost, he couldn't

believe it, virginal. He could hardly contain his delight at having found the right tuna. She was reluctant, sure, but that was normal in a case like this. But consider her situation: a million yen to be sodomized on videotape was more than she was going to get for a toothpaste commercial. And she had to face facts, she wasn't going to get any toothpaste commercials.

She didn't know anyone in Tokyo besides a few Japanese girlfriends from Los Angeles, and those girls were in the AV business themselves, which is how Onodera heard about Emi. Some girls fly back and forth, working the American and Japanese AV circuits. Onodera knew a little about the American business. There was a niche in the American porno market for Asian women. The movies had names like *Sweet Asian Hitch-Hiker* or *Entering the Dragon Lady* or *Rising Buns*. A thousand dollars for a weekend in a secluded house in Lake Arrowhead was what those girls got. Compared to those rates, and fourteen-hour shooting days with three setups a day, Onodera felt he was offering Emi a very fair deal.

And what options did she have? Her Japanese family had disowned her after she'd moved to America to be with her boyfriend, a musician named Rob. When her boyfriend began pressuring her to marry him, she retreated to Tokyo only to find her father wouldn't take her calls and her mother was practically a vegetable, shuffling from nervous breakdown to nervous breakdown. A friend of hers, Hiromi, a girl who worked for Captive Productions and had done some time in L.A., let Emi share her suite and then told Onodera about Emi's predicament—and her pubescent looks.

"This is a great opportunity for you," Onodera said, leaning forward and joining his hands together at the fingertips. His body language communicated sincerity. He nodded his head thoughtfully. "You will get a chance to appear with one of the biggest stars in the business. I'm not supposed to tell you this, and this is strictly confidential, but we have signed Choco Bon-Bon as the male lead."

When she didn't react to that bombshell, Onodera was confused.

"You've never heard of Choco Bon-Bon?"

"No."

This was going to be harder than he thought. "Ask Hiromi, she knows him. He's a very big star, very high-class, that's why I mention him."

Onodera offered her a cigarette. She refused. She didn't even smoke! This was too much. He had to have her.

He watched as she nervously looked about the tiny room. Compared to the threadbare carpet, broken desk chair, and sagging double mattress, Onodera himself was a picture of opulence and fleshy, exuberant, cheerful well-being. His watch was the thick gold Rolex. On his finger was the gigantic emerald mounted amid the dozen diamonds. Even in the room's drab light, the ring was brilliant.

Onodera noticed her staring at the ring. It was worth about a million yen; the emerald was fake, but the diamonds were real. He slid it off his finger. "If you do the video, just the one video," he said, "this is yours."

He held it out to her.

She took it in her hand, felt its weight, studied it closely.

"This," she said, "plus the million yen."

Suddenly Onodera wondered if he had the right girl.

He quickly overcame his doubts once Emi was on the set. She was so shy, so consumed with self-doubt.

"Even after Onodera-sensei gave me the ring, I wasn't sure," she recalls. "I thought of going back to my parents, and saying, 'Here I am, take me back, send me back to school.' I even dialed the number a few times and hung up. It's not because I'm afraid they're pissed off at me, but I just feel it's a step backward. You know, I'm no kid anymore. Eighteen is too old for high school. How else am I going to get the money for an apartment? This is a one-shot deal. I'm not going into the business. I mean, it's a hard choice."

Onodera hadn't told Emi exactly what her role would be. She was still under the impression that she would have to perform straight sex—standard intercourse. He didn't want to frighten her away with his grand finale.

He drove her in Captive Productions' blue Mercedes to the location for *Sexual Ecstasy Three*: an imitation Tudor-style house in the swanky Den-en-Chofu section of Tokyo that producer Yokichi Yamaguchi had converted into a cost-effective and highly efficient AV production facility. There were seven rooms in the spacious house, so while shooting was going on in one room, a different room could be dressed for the next setup. The crew and actors therefore spent less time waiting around as sets were struck and changed; they were paid by the day, so the more work Onodera and Yamaguchi could get out of them the better.

Onodera introduced Emi to a muscular, steroid-created, Day-Glo G-string-clad male star named Demizu Demon. Demon was noted for his phenomenal strength and gigantic muscles that enabled him to suspend his partner at mind-boggling angles during shoots; he could hold a woman in the air by the buttocks with one arm while he performed cunnilingus and simultaneously massaged her breasts with his other arm. His weakness as an AV lead was his penis, which was of average size, but, when compared to his buffed-out, five-foot-eight-inch frame, sometimes came across looking puny. Emi was bashful at meeting Demon, who was polite and cordial. Onodera told them they would be working together; he indicated to Demon he should try to become friendly with Emi, to make her more at ease.

While the assistant director and grips were preparing tape and checking sound levels, Onodera sat Emi and Demon down at a kitchenette and poured cups of oolong tea. Demon took off his shirt.

"You like his body?" Onodera asked Emi.

She nodded.

Demon flexed his muscles and held out his arm to her. The gigantic mass of contorted muscle bulged with thick veins.

"Touch him," Onodera suggested.

She tentatively held out a hand, not sure if she was doing this because it was part of the job or because she really did want to touch him. She ran her hand over his bicep and then down his chest to his nipple. She smiled and pinched it.

Demon laughed and started moving his pectoral muscles up and down rapidly.

"Fantastic," Emi said keeping her hand on his chest.

"Do you like him?" Onodera asked.

"Yes." She was trembling a little.

Onodera was immensely pleased by what he saw. Her apprehension combined with her excitement at breaking a taboo made her the perfect tuna. She was vulnerable yet obviously aroused.

"Would you like to work with him?" Onodera asked.

"Yes."

Onodera congratulated himself. He was a genius.

For her first day of shooting, Emi worked twelve hours in a simulated luxury hotel suite. She played the chamber maid who brought room service champagne to a businessman played by Demizu Demon. In the first setup, about which Emi was very enthusiastic, Demon did his usual displays of physical strength and starlet-twirling acrobatics. He penetrated Emi while she did a handstand and, holding her aloft by her legs, twirled her around. And, of course, he did his trademark move, in which with one hand he swept Emi into the air so that she was suspended in midair and performed cunnilingus on her as if she were a slice of pizza.

In all Japanese AV movies, the male lead must ejaculate into the female lead's face, no matter how impractical or improbable that would be considering the positioning of the actors at the time of the male orgasm. Demon, who was holding Emi in midair and penetrating her from behind, had to throw Emi down on the bed and flip her over in order to come in her face.

It was grueling work, for the male and female, to have nonstop, jackhammer sex for thirty minutes with a crowd of fifteen in the room.

"In the beginning," Emi remembers, "I was excited. I thought

it would be like sex and this guy was so big and muscular that, even though he wasn't that handsome, I imagined it would be interesting. But after about ten minutes, it became physically painful, a lot of balancing and strength, and my legs were cramping. And there wasn't enough air in there, something not powerful enough about the air conditioning. The suite windows didn't open and they taped aluminium foil over the windows to keep out the light. Everyone was smoking. I kept panting, trying to gulp down more air and Onodera shouted that he loved the panting. 'More panting,' he ordered. It didn't hurt, but it wasn't me."

She did two more setups that day. After the first, she began drinking heavily. Half a bottle of gin. She became so drunk she could barely follow Onodera's instructions.

"It wasn't me," she now says. "There was gin, guys, gin, guys, gin, guys, until finally someone ripped the aluminium from the windows because they were changing setups and, even though it was nighttime, the trees outside and the cloudy sky reminded me who I was and where I was."

She was contracted to do one more day of shooting.

Seeing that his star tuna, after her initial thrill at working with Demon, was having trouble adapting to the industry, Onodera faced a dilemma. While he wanted her malleable, he didn't want an unconscious, half-drunk zombie on his hands. For the big sodomy scene with Choco Bon-Bon, she had to be sober. And he still hadn't told her about the scene. Yet that would be the magic of *Sexual Ecstasy Three*: in a sense, Emi really was a virgin, at least in that orifice.

Emi drunkenly napped on the sofa in the office of the converted Tudor-style. Onodera sat in the chair behind a cheap metal desk and watched her sleep. He laid a white terry cloth robe over her and left her alone.

He woke her with a cup of hot green tea, an *oyako-don* (chicken and eggs on a bowl of rice), and some Fiorinal, a strong prescription painkiller. The food was satisfying after Emi's long day, and the Fiorinal took care of her hangover headache.

Although in the air-conditioned mansion it was hard to tell, it was four in the morning. Outside, the temperature was still in the high nineties. The crew and cast were long gone.

"You need a ride?" Onodera asked.

Emi nodded.

"Come on," he said, "I'll drive you back to the hotel."

He knew not to ask how she felt or how it had been. No matter what she answered, he'd heard it all before. And besides, she was getting paid well for the job: two million for two days work, plus the ring. That was over a year's salary for most Japanese girls her age.

She excused herself and went to the bathroom to change back into her street clothes.

They drove fast and smooth on the two-lane, two-tiered Expressway 3 into central Tokyo, the city beneath them lit as brightly as the ring on Emi's finger. In Tokyo, when traffic's light and you're in a good car with good suspension, the feeling of rolling fast on the elevated expressways over the wards and precincts of that immense city can be transcendent: you are in an artery, pumping through the heart of the world.

Onodera dropped the bomb on her. He told her, in the politest Japanese he could muster, what she would have to do that day.

"No way," she said.

"You have to," he explained as he turned down an off-ramp. "This is how we're making this video special. This is more than business; this is exploration. This is research into the soul of—"

"No."

Onodera stopped at a red light. "I could have hired any of a thousand girls who would be grateful to be fucked in the ass—excuse me, sodomized—by Choco Bon-Bon. Mio Nishino, Miki Mayazumi, Miyuki Komatsu. Major, major actresses would have loved the part, but I chose you, an unknown tuna—if you'll excuse the expression. A virgin. Yes, that's right, a virgin. At least in this sense. From the rear—you understand."

She didn't respond. She was staring out the window. From

ground level, where you could see the missing bulbs on the shop signs and the FOR LEASE banners hanging in vacant storefronts, Tokyo was considerably less appealing.

Onodera wiped his face with his towel. He was sweating despite the car's air conditioning.

"That's what makes Captive Productions special. That's what will make this video a work of art. Like a *shunga*," he added.

"Like a what?" Emi asked.

"You know," Onodera mentioned a few of the eighteenth-century erotic woodblock masters: Suzuki Harunobu, Kitagawa Utamaru, Isoda Koryusai.

"Never heard of them," Emi said. "They made porno movies in the eighteenth century?"

"Kind of," Onodera said.

But Emi was immovable. "It will hurt. It's gross. And I don't care who this Choco Bon-Bon is or what these *shunga* or whatever are, this whole thing is stupid."

He tried the artistic merit explanation again. "This is not just another video, this is special—"

"Shut up."

Onodera wiped his face. "How about another million yen?"

"Okay."

Yamaguchi was furious when he heard about the additional million yen Onodera had promised Emi. They were already five million yen over budget. Choco Bon-Bon had been costly, the video was taking four days to shoot instead of the usual three, and now Emi's additional million.

"And *Sexual Ecstasy Two* hasn't reached fifty million yen yet," Yamaguchi pointed out to Onodera the next morning. *Two* had cost only ten million to make. No major stars. Just standard tunas and good, reliable male leads. (Demizu Demon had done stellar work in that one.) "We're in a recession now," Yamaguchi pointed out, "don't forget."

"Look at the rentals for *Sexual Ecstasy One*," Onodera told

Yamaguchi. "We'll pass a hundred million on that. And the reason *Two* didn't do that well was because we didn't have any major stars. With Choco Bon-Bon, we've got a star."

"A male star," Yamaguchi pointed out. Male stars lacked the drawing power of female stars.

"The biggest male star."

"Still," Yamaguchi sighed as they bogged down in midmorning traffic, "this is it. No more."

Onodera had been hoping he could somehow list the cost of the ring he had given Emi as expenses. But with Yamaguchi in this frugal mode, he decided he would have to think of another way to recoup that loss.

Or maybe that was what separated him from other directors. He was willing to make that kind of sacrifice, ready to do whatever it took to please his crew and cast, to make his video, to fulfill his vision. *Sexual Ecstasy Three* would be the biggest AV hit of the late summer. Maybe it would even be exportable to foreign markets. China. Hong Kong. Thailand. Even America. Who knows? This could be a breakthrough video, the next *Deep Throat*, a video that made Onodera famous worldwide. The whole ride out, he had worried that Emi wouldn't show up. He had thought about picking her up at her hotel himself, but then at the last minute decided he had to discuss the budget with Yamaguchi instead, so had driven out with him.

When they arrived at the mansion, the entry was cluttered with the shoes of those who were already there. Onodera was relieved to see Emi being ushered into makeup.

Sexual Ecstasy Three was going to work. His discovery, his gift to the AV industry, was here. She understood her role and was ready, willing, and able. His crew knew their business. He certainly knew his business. And Choco Bon-Bon knew his business. But, come to think of it, where was Choco Bon-Bon?

"He's late," said his assistant director. He shrugged. "We sent a car for him."

Yamaguchi, overhearing this, rolled his eyes. "A million a shot and he's late."

* * *

At the Hotel Queen DeGaulle, Choco Bon-Bon nodded from the junk he smoked after he had finished the last of his speed. The heroin, after a few hits, made him feel as though his whole face was sagging like one of those trashy cartoon characters when they get sleepy. He lay back on the bed, oblivious to the bits of tinfoil sticking to his bare back. The tinfoil made a rustling noise and was cool, cooler even than the air-conditioned room. He was awake, but he was dreaming. He was asleep but with his eyes open. A neat trick.

Oh, this was better than Valium or Halcion or Percocet or Cercine or Fiorinal or any of that other crap he sometimes took to come down after smoking *shabu* or when he had to get ready for a video. This was so much better, so much heavier, like being run over by a big, soft, padded, cottony car. A Kharman-Ghia, he thought—a big, soft, padded, cottony Kharman-Ghia, and he was driving it. Lying down and closing his eyes and driving it. No traffic. No trains. No crowds. No videos. No cum shots. Just Choco Bon-Bon in a Kharman-Ghia made of cotton.

There was a knocking coming from somewhere, from the door to his room. He ignored it and kept driving, lying back on the bed and driving up, up, up in his dream car.

V

KEIKO

THE EARLY-BREAKFAST CLUB

That night was the first night in her buttoned-down life that Keiko Nakagami didn't know the guy's name before he banged her silly. They met at MZ MZ, a club in Tokyo's Roppongi district, where white-label techno music and Black Label scotch made a lethal combination. It's not like introductions were needed after thirty minutes on the dance floor and then thirty necking in a darkened booth. She just forgot to ask for his name. An Australian guy.

Maybe he had told her his name. At the very beginning. Peter or Paul, something with a P. And when he suggested it, they left, drinks half-empty on the table, her friend Rie gasping and his friends giving him thumbs-up signs. She wasn't about to bring him back to her parents' house in the suburbs, so she went with him to an apartment he shared with two other models in the fashionable Hiroo section of Tokyo. Walking distance, really, but he hailed a cab and spoke to the driver in his lousy Japanese, and she didn't correct him. She sat there and gazed at the first foreign guy she had ever gone home with in her life.

Keiko, her coral blue dress shimmering in the fluorescent light and her red high-heels echoing loudly down the white tile subway tunnel, carefully stepped over a blue-pin-striped body who lay snoring with his eyes closed and mouth open. Sake victim, Keiko thought, another salaryman bites the pavement. It was 5:30 in the morning at Ikebukuro train station, Tokyo's primary terminal for trains to Tokyo's northern suburbs. Outside, it was already a bright, humid spring day.

A few other girls were already on the platform, waiting on orange plastic seats for the first train of the day back to the suburbs. Two men in overalls and a few guys in convenience store uniforms also waited, smoking cigarettes and reading the morning papers. Keiko ignored the men.

She looked over the clothes of the other girls. A bright orange skirt she admired. A black cocktail dress with gold belt that wasn't bad. A white dress with a blousy, frilly top that was hideous.

Two girls asleep in their chairs, black-haired head against black-haired head, were dressed similarly to Keiko in banana- and lime-colored skintight minidresses that shone bright as candy against their artificial tans. Keiko, her head throbbing and her walk not too steady, froze. Those two girls had it. Damn. She studied them for a moment. Flashy gold chains around their necks. Thick gold watches. And the bright colors. Straight out of Rocky America, Keiko's favorite store, an oasis of brightly colored minidresses and short shorts, neon and Day-Glo and whatever's brighter and tighter.

The platform was silent save for the mumbling of a drunken salaryman awaiting the first train. Keiko was somewhere between drunk and hungover, having crawled out of bed with the Australian an hour ago and hurriedly dressing, hoping the guy wouldn't wake up. There was nothing she hated more than catching the eyes of the person she had just slept with staring at her as she struggled with her pantyhose.

But he had been looking, the handsome Australian, who hadn't been as big as the rumors about foreign guys led her to believe. He said something in his accented English that she didn't understand, but she could guess he was asking for her phone number and she just pretended like she didn't know what he was talking about and headed to the bathroom for a warp-speed makeup job. Came out looking like about a hundred yen, which is less than a dollar.

Bye-bye, she waved to him and slipped on her red fake-suede four-inch stilettos and slipped out the door. And the sun was already out and it was so goddamn bright as she hobbled on her heels down the narrow street to Gaien-Nishi Avenue, where two cabs stopped when she held her hand out over her head, lit cigarette pointing at the sky as if she were that Statue of Liberty they had in Australia.

The tunnel began to rumble and screech with the approach of the first train of the day. The girls roused and straightened themselves and the men snuffed cigarettes and walked over near the edge of the platform. The train ground to a stop, the

doors slid open, and Keiko boarded the train back to the suburbs.

It's hard being from the *kogai* (the suburbs). Especially when those suburbs are any of the hundred bedroom communities that encircle Tokyo with their twenty million Japanese who depend for their income, culture, and fun on Japan's premier megalopolis. Think of them as twenty million vampires, sucking the energy out of the city, zapping away what big-city life they can during twelve-hour workdays, five-hour drinking parties, or four-hour nightclub crawls and hauling it back to the 'burbs on packed commuter trains or jammed expressways. It's a nasty life of long walks to the train station and family-style chain restaurants that take Japanese food—soba noodles, curry rice—and somehow cook the flavor out of it so it's as bland and dull as the town you live in.

The suburbs weren't planned. They are a result of Tokyo's gradual shift westward since the time of the shoguns. The industrial boom of the late nineteenth century, the building of railways, and the construction of a dense highway network for the 1964 Olympics all contributed to suburban sprawl. East Tokyo, the area that constituted Edo during ancient times, is laid out in a grid pattern modeled after classical Chinese cities. West Tokyo and the suburbs are a tangled mass of roads that make sense only according to ridge lines, valleys, and animal tracks that were long ago consumed by concrete and pavement.

No two streets of suburban Tokyo seem to run parallel for more than a few hundred yards. Cabbies and cops don't know their way around them. Everyone's winging it, consulting maps faxed to them prior to their trip or encyclopedic city atlases that resemble computer chips viewed through a microscope.

Tokyo has always been a crowded city. When the building of efficient mass transit and highways allowed Japanese to live outside the city's twenty-three central wards and commute into the city to work and recreate, the suburbs exploded. Why live in congested old Tokyo when you could live an hour out of

town, in, say, Saitama, and pay half the price for a house twice as big? In the period just after World War II millions of Japanese went for the suburban dream in a big way. Or rather, in a small way. In Japan the suburban dream is far from the American ranch-style house, double-door refrigerator, Weber barbecue counterpart. The Tokyo suburbs mean a tiny house with tiny bedrooms. The small red- or blue-roofed houses are called *bunka jutaku* (cultural dwellings) and are typically three or four cramped rooms. Forget ranch-style, Mission-style, Tudor-style, or any style. You get a house, and you're lucky you did because if you were in the city you would have a room, or two at best, and try raising a family in an apartment the size of a private detective's office.

So the appeal may be obvious—get out of the city and live a little—but it's a wasteland out there. Street after narrow street of "cultural dwellings," as monotonous as row houses lining the alleys of an English coal mining town. Nothing to do at night because the local shopping street is deserted by nine o'clock and even the last movie plays at eight P.M. on weekdays. When Dad the salaryman wants to have some fun he stays in Tokyo, rides his expense account at a restaurant or hostess bar, and Mom, well, Mom's a housewife. Laundry, cooking, making sure the kids get to cram school. She meets her friends at a coffee shop near the station. They sip cappuccinos, gossip, and stuff themselves with sweets. Japanese moms must consume 80 percent of the crême brulées, tiramisus, and mille feuilles in Japan.

The suburbs aren't bad for children. There are toy shops, though nothing like the wondrous toy meccas of Tokyo; no one-hundred-foot HO-scale train dioramas or twelve-foot-high Godzillas. There are little parks and the occasional abandoned lot. On weekends or those rare afternoons you're not busy studying you can ride down to the video game center or to the movies.

But once you hit puberty, the 'burbs will suffocate you.

"By the time I was sixteen, I really, really wanted to get away from Niiza," says twenty-one-year-old Keiko of the suburb north of Tokyo in which she grew up. "It was okay when I

was small, when I was still in the doll-playing stage. But around the time I started getting interested in boys, I became curious about Tokyo. The big city, that was a big deal to me. I imagined it as being like a different world."

Niiza is a bedroom community that never seems to wake up. "At night, after the trains from Tokyo stopped running, you could go down to the station and sit on the tracks and stare straight down them toward Tokyo," Keiko recalls. "At first you can only see down to the next station, but once your eyes adjust you can make out another station and then another. They are clusters of light, separated by dark patches. At first they all look like one cluster, but then you can tell them apart. Station after station. I used to imagine I could see all the way into Tokyo."

Keiko was a star in high school. Her grades were only average. What set her apart was her looks. Keiko developed fast by Japanese standards. At sixteen she was already five feet eight and a C-cup, and even under a bulky school uniform the boys could tell she was a woman. Not that she minded. She knew, almost instinctively, that this would be fun. Exactly what "this" was she wasn't sure. (Japanese social science teachers are notoriously inept at sexual education, usually explaining reproduction in clinical, biological terms that make sex sound as much fun as crop rotation.)

Even before she knew how to exercise it, Keiko sensed the power her sexuality gave her. Out on the playing fields during P.E., while the boys played baseball or soccer, Keiko and her friends would sit or stand over by the fence, pouts and frowns frozen on their faces. They never got a speck on their gym shorts or white T-shirts. The boys shied away from them, somehow aware they weren't in the same precocious league as the girls. Even the gym teacher, a short, bespectacled thirty-seven-year-old obviously a little intimidated by Keiko, didn't insist these girls play games. He tossed them a soccer ball once. It rolled over to the fence and one of the girls sat on it.

So high school was an easy time. Keiko wasn't going on to one of the good colleges. She had decided by the time she was in tenth grade that she would enroll in a junior college, which

suited her salaryman father (Konica Cameras) and housewife mother just fine. Keiko had a younger brother who would require the family's undivided financial and emotional resources to get into one of the good schools. In Japan, a son's needs still take precedence over a daughter's.

Why did Keiko need college? the family reasoned. She'd get a suitable husband. Maybe even a husband from one of the good schools. And anyway, the mother noticed, Keiko seemed to be a very popular girl.

Mom was right. Keiko lost her virginity when she was seventeen, to a boy she met at an annual festival at the Niiza shrine. These festivals, held on temple or shrine grounds, are staged by traveling festival companies and are Japan's equivalent of carnivals. The boy was a year older and attended a better high school than she did. But what Keiko went for was his height. For Keiko, who both turned on and turned off Japanese high school boys because of her size, it was a relief to find someone to whom she didn't come off as a kind of Far Eastern Brigitte Nielsen.

Seventeen was a trifle young for a Japanese girl to give it up. Eighteen is usually the year. Sixteen is downright precocious, only about 15 percent of Japanese girls lose it that early, but it has become increasingly rare for a Japanese girl to maintain her virginity past the age of twenty-one.

"I liked him a lot at the time," Keiko says of her first sexual experience. "But it's funny, I can't remember his name anymore."

In a society in which discrimination against women in the workplace is still the norm, many young Japanese women discover themselves and their identity in the world they have come to dominate: nightlife. As the median age of marriage for Japanese women has risen from twenty-two in 1949 to twenty-eight in 1991, younger Japanese women are careering, partying, and living more than their mothers ever dreamed. But since women's salaries are on average only 52 percent of their male counterparts, how can a young woman afford many nights on the town? By living with her parents.

The Tokyo rail system shuts down before one A.M. on weekends and reopens at five A.M., so many of the young women who want to party in town stay out until the morning light and catch the first train back to the suburbs, slip into bed for an hour or two, change into their office-lady uniforms, and then jam back into the city to pour tea, answer phones, or make photocopies. They are called the *ari-burei zoku* (early-breakfast club), because those who didn't get lucky can be found killing time in coffee shops waiting for that first train.

Conservative Japanese companies still prefer girls who live at home with their parents—hence Keiko's tedious commutes to and from the 'burbs. (This hiring practice also justifies a lower salary.) Many companies still force office ladies—or OLs—to wear uniforms, even in companies where male employees are not required to do so. Hired between the ages of eighteen and twenty-four, the OLs are not expected to make careers in the company. Instead, they are office ornaments, there to adorn the workplace for a few years as they serve tea, make copies, and perform other menial tasks. They are supposed to be married and out of the office by their late twenties. Office romance, though common, is officially frowned upon. Management wants to see its male employees married, not involved in distracting workplace affairs. Japanese offices, however, just beneath the placid surface, are sexually charged environments where the number of liaisons occurring at any one time can be mind-boggling and exceedingly complex. Those few women who do try to make careers in the Japanese corporate hierarchy run into the "pin-striped curtain," that barrier keeping them off the fast track as men annually take another lap. A career woman in Japan therefore finds her options narrowing quickly by her late twenties: she can put up with the discrimination, start her own business, or get married. In the meantime, however, she can play.

By day OLs are at the beck and call of their male supervisors; at night, as they dance in their form-fitting *bodi-con* (as in body-conscious) clothing, they become the object of innumerable Japanese salarymen's fantasies. The girls change in com-

pany bathrooms or wear their Rocky America dresses under their nondescript OL uniforms, and it's like Superwoman stepping out of a phone booth when they emerge in their nighttime garb. When they move from corporate culture to club culture, it's the girls who occupy the top rung.

Like so many spaces, MZ MZ used to be the haunt of uptight salarymen in gray or blue suits, white shirts, and over-shined loafers who were desperately trying to squeeze some fun out of a reluctant Tokyo. The salarymen used to set the tone. They defined Tokyo. They had the money, so the clubs tailored the fun to fit what they thought a salaryman would want. It was guys in tuxedoes at the door. Overpriced cocktails stuffed with miniature umbrellas or plastic monkeys. And old Beatles songs. The girls were the type salarymen were supposed to want to marry. Straight hair. Dimply smiles. Miniskirts that looked like something out of London's swinging sixties.

No wonder karaoke became so popular.

Then girls like Keiko began appearing on the scene, confi-dent about their bodies and their style—a hybrid of Japanese comic book siren and Raquel Welch circa *One Million B.C.* Suddenly it was the girls who were sure of themselves and the guys who didn't know what to do. The guys, after all, outside the office, were just a bunch of insecure dorks who were better acquainted with their right hands than the rites of spring. The girls had style, sass, and were independent; the men were a bunch of mama's boys. The men looked at the girls, knew they wanted them, and had no idea how to go about getting them. At the clubs, the girls had emerged.

You can date the change to 1986. A generation of Japanese finally came of age knowing they were rich. After all, the rest of the world was telling them so. *Time* magazine covers. Front page *New York Times* stories. Japan as Number One. The new generation's parents had recounted stories about the war and the American occupation. When they were so poor they mixed their white rice ration with soybeans and barley—barley!—so that it would feed a family of six; when Roppongi, Tokyo's trendy

nightlife district, was exclusively for American G.I.'s because no Japanese could afford the cover charges and pricey imported liquor.

By 1986, it was out with the auto-reversed Beatles, in with two direct-drive Technics turntables. Off with the tuxedoes, on with the Stussy T-shirts and Timberland boots.

Today, the only foreigners the Japanese let into the clubs are models and hostesses. They lend atmosphere. Attract young salarymen on expense accounts, buy them drinks.

Makoto Maruyama, director of the Roppongi Circus disco, says the clubs changed because the clientele changed, "A few years ago our target demographic was the salaryman. Now, we've got kids who grew up flipping through *i-D* or *The Face*. I cannot believe there is a more lucrative city in the world right now for running a nightclub. It's not like the salarymen don't come out anymore. They still do. It's just that they go home and change first."

According to Amy Yamada, the thirty-four-year-old author of the best-selling *Bedroom Eyes* and one of the most popular writers for the under-twenty-five set, "Young girls are learning to speak up, that's what changed. They know how to open their minds. Many things helped them—books, culture. I don't know if there's more sexual freedom now than before. When I went out to clubs when I was eighteen and nineteen we were doing the same things, it's just more open now."

The clothes, so tight as to redefine form-fitting, are Sir-Mix-Alot's "Baby Got Back" video to the thousandth degree. "Japanese girls used to have short legs so they wanted to show a lot of leg to make it seem they had longer legs," says Toshio Ohno, editor of *Fine*, a magazine devoted to Japanese youth culture. "The style is also an imitation of American hip-hop culture, with some modifications. Most of the girls probably don't even know where the style started."

One observer, writing in *The Face*, traces its origins:

> Unashamedly nouveau riche, the *bodi-con* cult began to emerge as far back as ten years ago in Osaka and Kobe. Its

early development featured tight short skirts and dresses (principally by Azzedine Alaia and Thierry Mugler), expensive showy jackets (Silver Fox or alternatively Fila goose-feather styles) and ridiculous amounts of Cartier, Tiffany, Louis Vuitton, and Chanel everywhere else. The hair styles were as distinctive as they were appalling: a long, straight mane combined with a funny little permed fringe.

The *bodi-con* look has become progressively more ostentatious as time has passed, with the look plumbing new depths of vulgarity with successive seasons. Lacroix and Lagerfeld remained the to-die-for labels, with a lack of fashion originality overcompensated for by an emphasis on sexual showiness.

Other sociologists claim that girls such as Keiko dress as they do because it is their way of inverting the values of a male-dominated society. Today's woman gets what she wants by intimidating men, not by becoming the clichéd, docile, subservient model of Japanese womanhood. No better way to get what you want from a Japanese man than tits, hips, and ass bulging from candy-colored neoprene.

"I dress the way I do because I like the power it gives me, that's true," Keiko says. "But it's not as though I'm going to become president of the company because I shop at Rocky America. I mean, it doesn't get me a nice apartment in Tokyo. It doesn't get me out of the suburbs. I dress like this because it's fun."

Keiko and her friend Rie sat at the bar at Juliana's, a disco in Tokyo's warehouse district that caters to the *bodi-con*s. Wednesday night and the place was packed. On platforms around the dance floor where only girls were allowed they danced and flaunted their Alaia and Mugler. The men danced ritualistically before the platforms, gazing longingly at the *bodi-con*s as though the neon colors and tan flesh on display before them were the intertwined deities of a Buddhist tantric painting. The salarymen's stained white shirts, loosened ties, and perspiring faces were proof of their devotion. There were hundreds of them, lost in the swirling techno hit "Fax Me."

Keiko and Rie sipped complimentary Moscow Mules—the vodka-based cocktail-of-choice for the *bodi-con* set. Keiko was tanned to a fine brown from using the last of her tanning-session coupons at the Sun King Tanning salon in Ikebukuro. She loved the afternoons there, even if each half-hour session actually lasted only twenty-four minutes. She went into the booth nude beneath her white towel. No tan lines for her. She wore a Walkman because the in-booth speakers at Sun King weren't as loud as she liked. She wanted her techno music pumpin' so she could groove under the plastic eye mask to Rave Alert or Contact. It was like a twenty-four-minute respite from the trains, walking, and working that filled most of her day. It was meditation. For twenty-four minutes—for only ¥3,000 ($27)—she took a little vacation, a little trip, naked under the purple UV lights with the music blaring and her body just feeling so *warm*, even though the UV lights weren't supposed to be warm. She imagined she could feel her skin cells, or whatever they were, turning over in the light and browning and glowing. For her it was a ritual. Keeping tan. Keeping shaved. Keeping her body smooth and sexy. At five feet eight inches she wanted to be every bit a woman.

And she succeeded. Even the manager of the Sun King asked her to model for the company. The wormy little guy with the receding hairline had also once tried to stick his hand up her skirt, but still, it was nice to know that even for a guy who sees hundreds of great tans, Keiko's stood out.

As she sipped her drink she remembered she had to buy more tickets to the Sun King. She needed that time at the salon, just as much as she needed her time at clubs like Juliana's. Anything to take her mind off the job.

Tan, fit, sexy, tall, pretty-enough-to-model-for-a-tanning-salon Keiko worked at a department store in Ikebukuro as an elevator operator. She stood facing a button panel four hours a day and said, "Fourth floor. Audio, video and electronics, compact discs and cassettes, washers, dryers, dishwashers, and appliances. Watch your step." The elevators were all self-service, but department store managers still liked the old-fashioned ele-

vator girl pushing buttons, announcing the wares available on each floor, and sweeping her white-gloved left hand along the door panel each time the door opened or closed to simulate operating the door.

"Fifth floor. Designer dresses, blouses, pants, and tights. Also, women's shoes and children's shoes."

Management had finally given in to pressure from elevator girls who insisted that seven hours in an elevator led to, among other things, manic depression and myopia. Now during a seven-hour shift each girl had to spend only four in the elevator. The other three they sat in information booths. The job was still suicidally boring, a nightmarish combination of mind-numbing routine and syrupy politeness. She had graduated a two-year junior college for this?

Keiko was paid ¥155,000 ($1,400) a month, average wages for a female her age.

The DJ, some British guy with a big nose who kept interrupting the music to say nonsense that Keiko couldn't make out, began spinning some hip-hop tracks that Keiko wasn't very fond of. She ordered another drink and fanned herself with the feather fan that accessorized her yellow-and-gold, genuine Junko Koshino dress—not from Rocky America, but still trendy— her Chanel rope-chains and thick, gold dukey chains that shone bright against her deep tan.

Including the Australian, Keiko had slept with twenty-four men, about six times the average for a twenty-one-year-old. She was comparatively promiscuous, and she admitted that, but she'd had more opportunities. The way she looked at it, she had turned down more guys than some girls who'd only done it with one or two men in their lives. So if you go by a saves ratio rather than merely counting goals allowed, then she didn't seem like such a bad girl.

And as long as she kept making that morning train back to the 'burbs, her business was her business. Mom wasn't telling any of her friends that daughter was out getting banged by Australian models; in fact, since she had graduated from junior

college seven months ago she had been going on more *omiai*s (arranged meetings as possible preludes to arranged marriages) than ever. The guys were repulsive. *Futsu no sarariman* (normal salaryman) but with zero charm. Just bodies in suits. Corporate cannon fodder. Bad haircuts and cheap shoes and futures mired in the 'burbs. That's what these guys had to offer. Not that Keiko was a snob. Well, okay, she was a snob, a little, but she was bigger, better, faster, tanner, flashier than any generation of Japanese girls before her; she deserved more. She cried out for more. Demanded it. The prospect that her future would be the basic suburban 1.7 kids and small house and endless desserts and coffee with a clatch of friends who gossiped about cram schools and their husbands' year-end bonuses terrified her. Keiko may not have been book smart—the only authors she had read were Banana Yoshimoto and that *Little House on the Prairie* woman—but she had seen a few things in Tokyo. (On vacations from the elevator, she had been to Saipan and Guam, resort islands popular among Japanese because of their proximity and sunny climes.) Keiko wanted out of the suburbs. The guy didn't have to be rich. He didn't even have to be that handsome. He just had to get her out of that life.

In the meantime, it would be nice if she could find some guy, some sponsor/boyfriend, who would pay her way into the clubs because her budget permitted her to go to Juliana's, MZ MZ, or Baroque only twice a week. It cost ¥5000 to get into each, and that made ¥10,000 a week, which times four weeks equaled ¥40,000 a month—or about a fourth of her total income. If she went more frequently she would be cutting into her clothing budget, about ¥40,000 a month, and transportation and food—her mother was making her chip in ¥10,000 for the household. And she was always saving for another trip. Maybe go to Australia this time, if she could afford it, see that Statue of Liberty up close.

Jap Bastard's throbbing, pulsing techno-hit "Bottom Line" came on and Keiko and Rie stood up to dance. The swirling, sweating mass of salarymen parted as the two girls strolled through the dance floor to the wood platforms they preferred.

They climbed up and danced, waving their fans around as the strobe lights began flickering and the DJ—that stupid DJ!—kept talking that gibberish. Keiko looked down at the crowd of men, all gazing upward as they followed the line of her calf and thigh to her crotch, trying to catch a glimpse of her panties. They were pathetic, those men, those dozens of white shirts and striped ties and hopeful expressions. She danced a little and smiled at Rie, who had a blank look on her face. Don't look like you're enjoying it, Keiko remembered, make these men think you'd be just as happy dancing in an empty room.

Her mother was dressed in beige tights, blue skirt, white blouse, and blue jacket. She kept her hands folded on her lap. Dad wore a blue suit, blue slacks, a white shirt, and blue tie. Uncomfortable and awkward being in the Ikebukuro Prince lobby with his wife and daughter on a Saturday, he didn't really know how to behave in situations like this, and it showed. Keiko sat impassively, dressed in the dullest clothes she owned: black imitation Ralph Lauren, like someone had died, and her mother's pearls.

Dad checked his gold-plated Seiko.

The lobby coffee shop of the Ikebukuro Prince was furnished with overstuffed simulated leather chairs, clear plastic tables, and worn green carpeting. The light was dull yellow and the view was of the Prince's tiny, unkempt garden. This hotel wasn't the pride of the Prince chain, but then Ikebukuro didn't deserve much better. Keiko spent way too much of her life there, she reflected, and now, even on a Saturday, she was in Ikebukuro, waiting for the Hashimoto family and their twenty-six-year-old son to show up.

Another *omiai*, this one organized by a friend of her mother's—Mom gave her friend ¥10,000 as a token of their appreciation—from out in the suburbs, a woman who knew a woman who had a marriageable son. College graduate, good job—computers or something—and an interesting hobby: scuba diving. Before meeting the man in question, Keiko was always presented with photographs—staged portraits of the bachelor

posed rigidly against a blue background. If Keiko wished, she could have turned the meeting down based on his looks alone, but she rarely did. It mattered to her family that she maintained her *tatemae* (public character) even if her *honne* (true character) was something else.

*Omiai*s are still common in Japan, and Keiko put up with them as a fact of life, like split ends or yeast infections. About a third of all marriages in Japan are arranged, and despite all the media hype about "love marriages," most young men are still so uptight around the opposite sex that *omiai*s are the only chance a young *dasai* (styleless) guy has. Reared in a segregated environment where boys are taught algebra and girls learn to cook, brought up on a steady diet of baseball, martial arts, and cram schools and dressed by their mothers or in standard black school uniforms—modeled after nineteenth-century Bremen Naval Academy standard issue—the boys are particularly unsuited to rituals of dating and mating. They just don't know what girls want. They are shy, withdrawn, can't make conversation or crack a joke. All they can do is gawk. The *omiai* probably would have died out a decade ago if it weren't necessary for young men; for middle-class families like Keiko's, the family the daughter marries into hardly makes much difference, as long as the father has a job and they aren't Korean or *Burakumin* (the long-discriminated-against Japanese underclass).

Not that Keiko and her friends were a bunch of sluts. She adamantly refuted those accusations. After all, Keiko lived at home, with her parents, so she wasn't a bad girl. Some of the other elevator girls had curfews set by their parents, but if Keiko's dad tried to impose a curfew he'd have a full rebellion on his hands. He hadn't been in Keiko's room since she had begun her precocious puberty, pointedly staying away—he didn't want to know about whatever it was young girls thought, felt, or did.

When the Hashimotos arrived there was a minute of steady bowing by everybody, father to father, father (slightly less bent) to mother, father (practically not a bow at all) to son. Finally it was Takehiro to Keiko, and Keiko made sure to bow dead even

with him. Who cares if that wasn't sufficiently respectful? Let everyone know right from the start that she was no patsy. And she could tell from the way Takehiro gave her the once-over—like a salaryman at Juliana's—searching for clues about her body beneath the black death dress, that he was interested. He was tall, Keiko liked that, an inch taller than she.

The two families took the elevator up to the hotel's French restaurant and had to wait ten embarrassing minutes for a table. (Saturday is shopping day in Tokyo, and 12:30, their appointed meeting time, is lunch rush hour, but no one ever takes that into consideration when planning an *omiai*.) Keiko kept bowing and nodding and giggling and finally just kept her head bowed to avoid the Hashimoto clan's probing eyes. On the platform at Juliana's, showing a country kilometer of thigh, she didn't mind the staring and gazing of the men in the pit below her. But here, in the waiting lounge of the hotel's French restaurant, with kids crying in the background and the black tuxedo–clad maître d' standing behind an imitation oak podium, she hated the appraisal, resented it. Compared to this, the nightclubs seemed wholesome. Men made no secret of judging you by your sex appeal; there was no lying there—what you see is what you get. But here, with Mrs. Hashimoto trying to see into her soul, to somehow figure out if ten years from now Keiko would still be doing the dishes and washing her precious son's underwear, this was dirty business. Too many layers of lies and potential lies.

Give me the nightclub anytime, Keiko thought. There I know where I stand.

Their table was between a bawling baby on one side and a group of suburban wives on the other. The men conferred about what drinks to order. Wine, it was decided, would be appropriate. The waiter brought out a bottle of French red that was chilled practically to freezing. Keiko suspected something was wrong as soon as she tasted it; she remembered that red wine wasn't supposed to be served chilled. But she wouldn't bring that up in this company; no one knew enough to send it back. She wondered for a moment if the restaurant could make a

Moscow Mule and then laughed to herself as to what a scandal it would be if she were to order one.

They ordered deluxe lunch sets—consommé, green salad, steak or chicken main courses, sides of rice—and made the kind of small talk that makes trench warfare seem like a great way to spend the afternoon. Takehiro was very popular at his company. He had recently been promoted to a junior management position in the sales department of Fujitsu Computers. Keiko's father grunted his approval. Furthermore, Mrs. Hashimoto continued, Takehiro was very well educated, having graduated from Nihon University, where, in addition to his academic excellence in computer sciences he anchored the kendo squad. He had numerous friends, but, his mother hastened to add, he was not the type to stay out late, and he was a model son in every sense. In between discreet sips of flavorless consommé, Mrs. Hashimoto described her son as believing in hard work, unflinching loyalty, and unremitting perseverance as the foundations of a good home, happy family, and successful marriage. His prospects at work, she reemphasized, were excellent.

Keiko faked sipping the soup as she listened to her mother respond with a listing of Keiko's many virtues: her obedience, loyalty, diligence, education, and, she hardly needed to point out, uncommon beauty, all factors weighing in Keiko's favor. Implicit in her mother's testimonial was the argument that Keiko's looks more than compensated for her mediocre education, unimpressive job, and unusual height, which some families might object to right away. Most Japanese find the idea of a bride being taller than the groom repellent. But Takehiro was actually an inch taller than Keiko.

Keiko had to give Takehiro some credit: he seemed as bored and uninterested as she was. Certainly he wasn't talking much, but he wasn't staring down into his soup like the saps at most omiais. To his own mother's distress he seemed to be inspecting the ornately decorated, overstaffed cavernous room like a curious child on his first visit to a restaurant. They were seated near the windows, which provided a good view of northern Tokyo on this cloudy spring day. When his food arrived he

began to eat heartily, slicing the steak neatly and using the fork gracefully, not improvising clumsily with it the way some Japanese men did. He glanced at her occasionally, once even grinning, and—or was Keiko imagining something?—she caught him shrugging at her as though body-languaging "Isn't this a joke?" But she was silent. She smiled. She nibbled.

The fathers didn't say much. They talked a little baseball, but it got them nowhere. Keiko's father, the suburbanite, was a Seibu Lions fan. Mr. Hashimoto, like 70 percent of Japan, rooted for the Yomiuri Giants.

The mothers held the floor, chatting amiably, comparing and boasting and bragging and looking proudly yet wistfully at their offspring.

"Where have the years gone?" wondered Mrs. Hashimoto.

Her son dutifully shrugged an I-don't-know answer to her.

The whole *omiai* lasted two hours and then Keiko was free.

"Second Floor. Books, magazines, stationery, date books, calendars, pens, office supplies. Goods made in Korea and China. Lamps and furniture."

"*Shigoto-ba wa tsumaranai-ba,*" Keiko joked with her friend Rie. (The workplace is the wrong place.) How much of this could a girl take? Sometimes, she imagined her vision was going, that she was becoming near-sighted from staring only a few inches ahead hours at a stretch. What if she needed glasses? She would have to get contacts, she assured herself—she didn't want to mess with her looks.

She walked with Rie along Inokashira Road, near the famous hill where some of Tokyo's busiest, pay-by-the-hour love hotels are situated. (The "love hotel" is Japan's response to the spatial and social limitations that preclude privacy for so many young couples. Because most unmarried twenty-somethings still live with their parents, the love hotel serves a basic function: nearly every Japanese over the age of twenty has patronized one. Even married couples with young children, desperate for a little privacy, use them.)

Keiko was personally acquainted with several love hotels in the area. She was fondest of The Contemporary and the Ace of Jacks. The Contemporary, with its back-lit panels showing the styles of the rooms, ranging from "Jungle" to "Traditional," was the more reasonably priced—¥7,000 for two hours during peak nighttime hours.

But today was Monday, the day their department store was closed, and Keiko and Rie were shopping for clothes, not rooms. Keiko repeated her line, "The workplace is the wrong place."

Rie, who was a little slow, didn't seem to think the saying was very clever. But then again, Rie was surprised that Keiko had gone home with that Australian and Keiko had just assumed that Rie would have been jealous. The guy was handsome, in a *Patu-rikku Shuwa-zhee* (Patrick Swayze) sort of way. No one could deny that.

But Rie, for all her nightclubbing and dancing and *bodi-con* style, wasn't as much a party girl as Keiko. She also, Keiko had decided, wasn't very much fun. But Keiko needed a girlfriend; her parents didn't mind Keiko going out at night if she went with a girlfriend. Once in a while, she could say she was sleeping over at Rie's and stay out all night. Rie went along with it.

A woman in her mid-twenties walked toward them, frowzy in sneakers, baggy jeans, and a red sweater. In an *onbu* (a back-slung harness) she carried her baby, who clutched at her shoulders with both arms. The baby's eyes were half-closed as it was jostled by the mother making her way down the busy street. The mother carried a shopping bag in each hand. She had short hair and clear skin; her eyes were wide and round. She might have been pretty once, Keiko observed, before she was married. But now, walking past the same love hotels where she had probably, in premarriage days, trysted with her fiancé, the woman looked fatigued and—*hidoi!* awful!—so unsexy.

"When are you going to get married?" Keiko asked Rie.

"As soon as possible," Rie said.

"Why?"

"Because I hate working in the elevator." Rie explained. "Who wants to do that all their lives?"

Sometimes Rie made sense.

They wobbled on their flashy stilettos down the hill, past the maze of hotel streets until they came to Parco 4, a store that sold compact discs and digital compact cassettes, and then past Octopus Army, where young gang kids shopped for baggy pants, sneakers, and baseball caps. Boys were hanging out front—kids sixteen and seventeen who gawked at Keiko and Rie as they walked by.

"Hey, hey, hey." The boys' chests swelled and they picked up their skateboards and stood stock-still and respectful, as if they were peasants and Keiko and Rie were samurai.

She remembered when boys like that had been her boyfriends. She had outgrown them. Maybe, she wondered, she would outgrow the Moscow Mules and techno music and Rocky America dresses.

That afternoon at Rocky America, she bought a shiny, black rubber imitation Thierry Mugler skirt. Then she wanted to go to Isetan department store, a much more conventional shopping venue. Rie shook her head, but Keiko bought a pair of sensible, black Chanel pumps.

"They're better for walking around," Keiko explained to Rie.

"Hello, uh, this is Takehiro Hashimoto speaking, may I please speak with Keiko Nakagami?"

"That is me."

"Uh. Thank you very much for coming to lunch with my family and I the other day."

"No. No. Thank you very much, Hashimoto-san."

"Uh. Call me Take."

"I'm sorry, 'Take.'"

"It was very nice meeting you."

"Yes, it was very nice meeting you as well."

"Uh, the restaurant served a good lunch."

"—"

"Uh. Would you like to go out on the weekend. Perhaps, uh, during the day?"

"Afternoon?"

"Uh, afternoon . . . that's okay?"

"That's okay."

"Uh, then good-bye."

"Take?"

"Uh?"

"What day?"

"Uh, Sunday."

"Then bye-bye."

Had he been more nervous on the telephone than he was in person at the *omiai?* Or was he just distracted? Perhaps that was his phone manner. Keiko had to admit that when he called she was very pleased. Of all the losers she had lunched with in hotel restaurants he was the most promising. Tall, handsome, not totally shy. And she liked the gap in his teeth. But what kind of wimp suggests a daytime date? Talk about playing it conservative.

Still, she was looking forward to it. She found herself planning an outfit in advance. A conservative pair of tan pants and a simple brown blouse. Gold chain belt. And her new Chanel pumps.

The night before the date, Keiko and Rie went out. It was the first time they had ever been to Twilight Zone, a three-floor nightclub near Shimbashi crossing. The doorman, a short, pompadoured Japanese in a many-lapelled tuxedo, was clearly unimpressed by Keiko and Rie; he charged them full admission and didn't give them any drink tickets. Usually, girls get discounts; if they pay, they *always* get drink tickets. Didn't this guy know the conventions?

Keiko fumed as they waited in line to check their coats and bags. But once they were inside, she saw that this place was different. First, all the girls wore jeans, T-shirts, and black work shoes. Or they wore work clothes, the kind of stuff Keiko had

seen in hip-hop videos. Second, half the girls were foreigners—Americans, English, Australians, Canadians, Germans, Italians, Greeks—and they were all as tall as Keiko. (Rie was a head smaller than anyone else.) The girls were models. There were no *bodi-cons* in the house. And the music was . . . Keiko didn't know what it was but it definitely wasn't techno. It was some kind of nineties house music with disco bits sampled in.

The first floor had a concrete bar with austere, slate-gray tables around it. There was no roped-off VIP section where Keiko and Rie could sit. The room throbbed with noise but—another shocking feature—the boys and girls were shouting over the music to each other. Keiko looked at Rie and shrugged. The bartender, dressed in a white shirt, bow-tie, and black pants took their orders.

Two Moscow Mules.

He raised his eyebrows and then mixed the green drinks in tall, thin glasses.

Keiko looked around the club. Everybody else was drinking some kind of clear drink—vodka? gin? *shochu* (Japanese grain liquor)?—from plastic bottles.

She carried the glasses to the end of the bar where Rie waited, her bow legs shaking beneath her knockoff Christian Lacroix skirt.

"Who told you this was a good place?" Rie asked.

Keiko couldn't remember. They sipped their drinks—fluorescent glasses of vodka, lemon, and Midori that Keiko felt marked them as outsiders. Whatever this place was, with its beautiful models and tall, muscular white guys in T-shirts and jeans and stolid, unimpressed doorman and bartenders serving up some kind of clear drink, Keiko had never seen anything like it. So many models. So many foreigners. Even the Japanese people with their baggy work clothes—that stuff was like nothing Rocky America had ever sold. Downstairs, on the dance floor, through machine-made smoke, Keiko watched the beautiful boys and girls dance and sway to house music.

"There aren't any platforms," Rie pointed out in shock.

Keiko didn't know what she was looking at: the boys and

girls were dancing together with a kind of frenetic, pulsing undulation. They were losing themselves in the music, the crowd, the lights, the smoke. It wasn't the club itself that was different— besides the music and doorman, the decor was standard early- nineties nightclub. It was the vibe, the atmosphere, the *funiki*— not to mention the fact that Keiko and Rie were the only *bodi-con*s there. Two foreign guys walked by grinning widely and pointing at them.

Keiko wanted to vanish.

But when Rie said, "Let's leave," Keiko shook her head. All over the club, in a lounge room off the bar where video display terminals showed spiral patterns and transforming geometrical shapes, on another, smaller dance floor where strobe lights flickered violently, boys and girls were dancing in an almost tantric daze. Then it struck Keiko what was different about this place: the boys and girls seemed intent on something besides each other's bodies. They were dancing, staring at the VDTs and drinking from those plastic bottles; the girls, as pretty as they were, weren't showing leg or tit in their ill-fitting, unrevealing clothes, and the guys didn't seem to mind. Everybody seemed to be having a great time, and *it wasn't about sex*. This was heresy. Keiko had never been to a nightclub where the currency wasn't sex. This was like a nightmare, a world where a sexy rack and tight dress didn't matter.

As she wound her way down the spiral staircase she turned toward the banister to avoid some guy on his way up.

"You came." The Australian guy who had picked her up at MZ MZ said when they locked eyes.

She shook her head. Then she remembered: it was he who'd told her about this place.

"You never gave me your number." He shouted over a remix of Cripple's "Judgment at Neuromancer."

He was as cute as she remembered. Dark stubble, blue eyes, long sturdy nose. As he spoke she noticed his teeth were perfectly straight and white. Capped, she decided, the opposite of Takehiro's flawed smile.

"Your number," he grinned. "Never mind."

He turned and walked down with her. He wore jeans, a white T-shirt, and cowboy boots. Once they were down near the concrete bar, he looked at her outfit and smiled. They stood next to a concrete wall that had red and black graffiti scrawled all over its cracked gray surface. A few ravers passed them making their way toward the staircase. "You want to dance?" he shouted.

She shook her head.

He looked at her drink. "What is that?"

She thought for a while before answering, "Moscow Mule."

He held a bottle of water in his hand.

She pointed at it.

"Water," he answered.

She shook her head.

"It's water," he said again.

He smiled once more, that perfect, movie-star smile (like *Patu-rikku Shuwa-zhee)*. Water, she wondered, who drinks water in a nightclub?

The Australian guy—he had a great abdomen, she remembered, ribbed and cut like a starving bull—kept grinning at her. "I like you," he shouted, "and I know your name. Eiko."

He had her name wrong. She just shrugged and grinned back at him.

"Why did you dress like that?" He looked her over. "Oh fuck it, who cares. Hey, do you want a trip?"

She didn't understand.

"A trip, some Ecstasy."

She knew that word. She had heard about this wonderful drug called Ecstasy that was supposed to make you feel happy or joyful. She scanned the room. So that's what everyone was doing.

From his back pocket he removed a small white, badly formed pill and broke it in two. "You only need half."

He handed it to her.

"You owe me for that," the Australian shouted. "That cost five thousand yen."

She looked at him and, for the first time that night, smiled. She swallowed the half hit of Ecstasy.

For ten minutes nothing happened.

Then she felt nausea.

Then she blew her mind.

The club was a swirl of happy, smiling faces wandering around in the darkness. Sometimes Keiko wanted to sit down, to lounge and watch one of the video display terminals and sometimes she wanted to dance. She could lose herself in dancing, in spinning and shaking and undulating. The Australian was with her, walking beside her as she stumbled around, dancing with her, lying down on one of the couches with her. She wasn't walking too steadily, but the anxiety she had felt when she arrived had disappeared.

The person she had to avoid was Rie. Rie was still sober and was boring and was complaining and wasn't dancing and wouldn't do anything fun. Whenever she saw Rie all Rie did was say how she wanted to leave.

No Rie. Whew, have to get away from her.

Rie bad.

Australian guy okay.

Club good.

Ecstasy great.

For a moment she flashed on Takehiro. She had to laugh. Poor Takehiro with his little job. Wait, poor her with her terrible job. Oh God, that elevator. As she lay in the lounge room watching a VDT of orange, blue, and purple triangles swirling around, her life came into sudden focus: Takehiro and his gapped teeth would rescue her from the elevator. But—and here was the hundred-million-yen question—what would she then be stuck with?

The Australian grinned like an idiot and sipped from a bottle of water. ("Water's better when you're on E," he had explained. He also told her he was from somewhere called South Yarra in Melbourne.) Handsome, charming, and he would be back in Australia in a few months. Australia with its Statue of Liberty holding up a flashlight, promising a good life for all those who

passed beneath her outstretched arm. What a place it must be! In Japan, if they had a Statue of Liberty it would be a man, some gigantic statue of a guy in a blue suit and instead of a flashlight he would be holding an umbrella and the inscription would say, "Work hard."

She didn't want to think of Takehiro or the *omiai* or the bad job or the future that was closing in on her fast—you couldn't be a *bodi-con* forever.

Maybe these were the best moments. This was her time. For a flickering instant during her otherwise good trip, she shuddered.

They stumbled out of the club after dawn, the gray light creeping along the dirty, cobblestoned streets, the first trains of the day rumbling above them on the elevated railway encircling Tokyo. The Australian guy had an arm around her as they made their way alongside the elevated railway—the club had been built during the bubble years as an exclusive spot for expense account–riding executives but had since been taken over by the young and hip.

First trains of the day, Keiko thought to herself. The deep, groaning, hissing sound of ten-car commuter trains pulling into Shimbashi Station reminded her of the curfew she was consciously missing. Rie had gone hours ago, shaking her head in disgust at the pleasure her friend was taking in this strange and un-*bodi-con* environment. But Keiko had decided she wouldn't be catching the first train home that night. She wouldn't be waking up in her stuffed-animal-laden bedroom beneath her poster of bare-chested actor Akai Hidekatsu. She could imagine her mother's reaction at not finding her there and her father's agitation at finally having to confront the fact that his daughter was not a classic good girl. Screw the suburbs, she decided.

She went with the Australian back to his apartment, where his roommates were already asleep. They didn't even make it to his bedroom. As soon as they were in the front door he reached for her beneath her rubber Thierry Mugler and managed to pull off her panties. She was already wet so they did it once right

there in the entryway. It was light out and the trains had been running for hours.

In his bedroom, they lay together on his tiny single bed as his roommates woke up and the noise of coffee being slurped, cereal being crunched, and toilets being flushed began to fill the apartment. The Ecstasy was keeping her awake, and she wondered if she could make another getaway. But he was a nice guy. She couldn't remember where he had said he was from. South Melbourne? With difficulty she tried to imagine going with him to Australia. Not many images came to mind: sheep, some kind of coral reef. A lot of packaged beef like that stuff that came in the supermarket with Australian Import stamped on it. And that statue.

She listened to the sounds of the men outside the small room and then suddenly remembered she had her date that afternoon. She looked at the Australian beside her, with his razor stubble and waves of blond hair, and strong, long nose. He was asleep. There really wasn't any choice. The Australian was handsome; Takehiro was Japanese.

It was decided.

Keiko returned home to a household in turmoil. Her mother was hysterical, shouting at her and crying and then begging her to get dressed for her meeting with Takehiro. They had called Rie's parents. They had called the police. What would the neighbors think? And what if the go-between with the Hashimoto family, Takehiro's family, heard about this all-night escapade? Everything would be ruined. And Takehiro was a nice boy. Perfectly respectable. What was wrong with her? Her mother was livid, wringing her hands in her white-and-green apron and rocking back and forth as she kneeled on the floor.

Her father, to his credit, was calm. He impassively watched the Seibu Lions play the Nippon Ham Fighters on television and drank Sapporo beer. He may have been angry, but this was a woman's issue. Now if his son had done something stupid, then he would have to say something. But he had given up on

understanding Keiko from around the time she hit puberty.

He had known for years that Keiko had been sneaking in around dawn; and his wife had known as well. It was the breach of etiquette that really bothered his wife. Just as long as Keiko got dressed in something conservative and went out with this Takehiro who seemed like a normal, decent fellow, there was no harm done.

Akiyama of the Lions stroked a double with no one out so the Ham Fighters pulled their pitcher.

When Takehiro smiled at her through his crooked teeth and asked if she liked playing golf, she just shook her head. They walked through a crowded shopping street near Shinjuku. The street was closed to automobile traffic and had been converted to a "pedestrian paradise" bustling with Sunday shoppers. Takehiro wore a simple blue blazer, jeans, and loafers. Keiko wore the tan pants and brown blouse, the simple gold chain belt, and her new pumps. She was exhausted. The Ecstasy had worn off hours ago during the fight with her mother and had left her in a state of fatigue that three cups of coffee couldn't dispel. It was sunny out, but it would have been rude to wear sunglasses, so she squinted through the brightness at the gap in Takehiro's teeth and tried to keep walking, to keep putting one foot in front of the other. It was like marching, Keiko reflected, like a soldier going into battle.

Takehiro must have known something was wrong with her. The makeup and conservative outfit couldn't hide bloodshot eyes and a punch-drunk temperament. But what he didn't know was that she had been in bed with an Australian six hours earlier. What would he have thought of that? She laughed to herself and perked up.

"Do you like tennis?" Takehiro was now asking. He wasn't shy, just conventional. And smug. He seemed confident that this question was somehow the right one to ask next. It was what men always asked on first dates, so Takehiro asked it.

Yes. No. Never heard of it. The answer was irrelevant.

"I like the outfits," Keiko said.

And they continued walking.

They stopped into a wood-paneled coffee shop where a cassette played the kind of hard techno music that Keiko liked. Her favorite song, Jap Bastard's "Bottom Line," was blaring and she smiled as they sat down in a booth by the window. The view was of the crowded street outside and the posh storefronts across the boulevard. Takehiro excused himself to go to the bathroom. While he was gone, Keiko catnapped listening to the familiar, thumping, pulsing techno music. For a moment she dreamed of a Japanese wedding—kimonos, a Shinto priest, a big, huge wig, something like what the Crown Prince and Princess had had. She couldn't see who she was marrying.

Then she saw the Australian guy—whatever his name was. Only it wasn't really a wedding; the priest was a DJ, they were in a club, and the Australian was telling her his name, but she couldn't hear it over the loud techno music. If she could only catch his name . . . but then Takehiro came back and she abruptly jerked herself awake.

There would be time, she reflected, to catch his name. There would be time for all those things, Keiko thought to herself in a half-awake reverie as the music thumped behind her. She gazed at Takehiro, at the gap in his teeth, and felt sorry for him. Too bad, he met me too soon.

VI

HIRO AND YOSHIHARA

THE BEST AND THE BRIGHTEST

Hiro Ikeda, a chubby, bespectacled boy about to turn eighteen, studied the pass list posted on the wrought-iron gates of the Komaba campus of the University of Tokyo. Four thousand eight hundred fifty-six *kanji* (Japanese names) were listed—but not his. He had failed the University of Tokyo entrance exam. For a full ten minutes Hiro stood frozen in total shock amid hundreds of other black uniform–clad high school and *juku* (cram school) students. A few of the boys about him were quietly crying, others were hugging each other and dancing about in joyous jigs of celebration. To Hiro it was as if some avatar had descended and told a few lucky souls they were destined for heaven and that the rest were condemned to hell.

Exam hell. Because anyone failing the University of Tokyo, or Todai (pronounced "toad-eye"), entrance exam who was not prepared to settle for admission to a lesser college becomes a *ronin*, a masterless samurai, as he spends the next year or two or three, cramming, cramming, and cramming for another try. "Being a *ronin*, having to study every day, all day long, and practically never going out, is so bad." Hiro grimaces. "It's like having the life sucked out of you."

Hiro first attended cram school during his senior year of high school. He had never kissed a girl; he had rarely drunk a beer. What free time he had before that was spent playing video games, at which he excelled; or constructing military models, particularly World War II–era 1/700-scale battleships manufactured by the Tamiya corporation. But even such innocent pursuits had to be shelved in the single-minded drive for Todai acceptance. His father, a salaryman at a major electronics company, and his mother, a housewife, had long cherished the vision of their son going to Todai. And Hiro was proving a good student, good enough, his high school teachers encouraged, to possibly pass the Todai exam. But seven thousand dollars in cram school fees had to be invested if Hiro was to have a real shot. And if he didn't make it? Then the dreams of another suburban Tokyo family would sink as surely as one of Hiro's model battleships.

* * *

The word *ichiban* translates literally as Number One. But it also means the best, the finest, and finally, the one and only. In Japan Todai is *ichiban*. No other college in the world can match it in influence, prestige, and clout. Not Harvard. Not Yale. Not Princeton. Not Oxford. Not Cambridge. Not even, it has been seriously suggested, all of the above, combined.

The Todai entrance exam determines who is destined for what passes for the good life in Japan—employment in a key government agency or at a top company, corner office, fat expense account, mistresses, and golf course memberships. And it determines who is destined for a no-name company, office in the sticks, small expense account, little money, and nary a mistress.

Only 1,763 of Todai's 15,451 1992–93 undergraduates were female, and most of them will remain in academia, which, though highly sexist, is less flagrantly so than Japan's governmental and corporate hierarchies. In business, even women from Todai are usually relegated to ornamental roles.

As the elite college of Japan, Todai produces an old boys' network that is a faster, more efficient means of taking care of business than any official or corporate channel: it is a virtual shadow government operating behind the scenes to ensure that Japan, Inc., runs smoothly. More than four hundred presidents of the top 1,400 Japanese corporations come from Todai. Eighty percent of Japan's postwar prime ministers graduated from Todai. In the mighty Ministry of Finance, over 90 percent of the senior bureaucrats are Todaisei (Todai alumni); in the powerful Ministry of Trade and Industry, 80 percent. One-quarter of all members of the Diet, Japan's parliament, are also Todaisei.

"If I have a problem that involves the government," confides a Todaisei who is now managing director of one of Japan's largest banks, "I go to my *dososei* (fellow alumni) at the Ministry of Finance. Two of them are section chiefs. And it is much easier to solve problems when you are dealing with people you know and know well. There is nothing sinister about it. Of course, if I had gone to a different college, I would not have this option. But if I had gone to another college, then I would not have risen quite so high in this bank, either."

Recently, a ministerial commission considered a quota limiting the number of Todai graduates allowed to enter government service. But nothing came of it. The commission was headed by a Todaisei.

The odds are almost as heavily stacked against a non-Todai Japanese male, harboring dreams of political glory or private sector grandeur, as they are for women in general. It is as much a function of the Todai entrance exam to determine the future of Japan as it does that of the individual aspirant. The premium of a Todai admission ripples down through the entire Japanese educational system to the nursery school playpen. Because certain high schools have established reputations for their skill in preparing students for the Todai entrance exam, admissions to these elite academies are highly prized. In turn, because certain junior high schools excel at sending students to those high schools, competition for slots at these junior high schools is fierce. A conscientious parent starts preparing his child for the junior high school entrance exam when the tot is still in first grade, but many parents begin even earlier, focusing their nursery school toddlers toward the entrance exams of prestigious kindergartens as soon as they are toilet trained.

The Sundai Preparatory School, the *juku* Hiro crammed at, is a complex of bright modern buildings in the Suidobashi section of Tokyo. At 9:30 P.M. the main entrance resounds with the rhythmic shuffle of Adidas and Nikes as tired students finally depart after six-hour study sessions during which they have been drilled, prepped, and quizzed repeatedly in exercises designed to strain the limits of trivia and esoterica retention. An example of a college entrance exam question:

> At Vaals, the borders of the Netherlands, _____, and Belgium meet. The Maas river winds south from Vaals, passing through a series of locks that indicate the Maas is descending from _____, Holland's only mountainous region. The surrounding area is farmland and the primary crops are apples, _____, and _____. After skirting the border of

_____, the Maas passes through _____,
a forest 70 km. wide and _____ km. long.

The answers? Go to cram school.

Satoru Saishu, a wiry man who wears tailored, English-style jackets with elbow-patches, gathers his books and the sample exams completed by students into a heavy brown satchel. An assistant professor at Todai who moonlights at the Sundai *juku*, Saishu was one of Hiro's instructors and remembers the chubby, confused, anxious teenager as "a little quicker than average. But I was his math instructor, and he never had a problem in math."

Were high-pressure, test-taking assembly lines really the best way to select the men who would eventually run Japan? "No," says Saishu. Then he pauses as he surveys the empty fourth-floor cram school classroom. "But perhaps this is the best way to select the boys and girls who should go to Todai."

The leaders of tomorrow's Japan, these children possessed of abnormal abilities to memorize and regurgitate reams of contextless information, who can spend sixteen hours a day studying for three day exams, are total nerds. Yet despite the fact that these nerds have been too engaged in cramming to learn anything more about sex than that which can be self-administered, almost any Japanese girl finds them extremely attractive. Because once admitted to Todai they are transformed into nerds with a future. (They are also nerds from wealthy, influential families averaging annual incomes of $100,000.) Those for whom this system has worked rarely see any reason to modify it for those who follow them. Why change the rules when you have already won the game?

Todai students are unhip. Japanese George Bushes come from Todai, never an Axl Rose. The Todai student, at his most fashionable, is the stylistic cousin of the American preppie, dressing in polo shirts or oxfords, khakis or jeans, deck shoes or sneakers, and, frequently, a backpack. Or he is a hopeless slob, an *otaku* (computer nerd) who dresses in hooded sweatshirts, jeans, and running shoes.

Although a walk around the Todai campus can resemble a trip to a Trekkie convention, to judge Todai students so simplistically is to totally miss the point. Todai students are not to be measured by the same standards that apply to the rest of Japanese society. The affiliation with Todai is a battering ram into the Japanese psyche, an excuse for a multitude of sins ranging from date rape to mismatched socks. Todai gives its nerds a composure and surety rarely found among other young Japanese, an aura of confidence stemming from the certain knowledge that they are set for life.

"When I found out I had passed," Hiro Ikeda recalls one year after the crushing disappointment of his first failure, "I knew that was the single greatest experience of my life. Nothing that ever happened to me before and nothing that could possibly happen to me in the future could possibly match the emotion. It was as if a gigantic bird that had been sitting on my chest for a very long time suddenly beat its wings and flew away and I would never have to feel such a weight again."

Hiro was sprawled in the tatami-mat room of his *geshuku* (small, off-campus student apartment), which rents for about $500 a month. It has a small kitchenette that he uses to heat up an occasional pot of tea or ramen noodles and a small, modular bathroom in which the shower, sink, and toilet have been molded from one giant sheet of plastic. On one side of the room, a new 21-inch Sony television and VCR sit on the wood-platformed indentation where pictures of dead relatives are sometimes displayed.

Hiro, who has shed the baby fat of his cramming days, wears faded Levi's and a white windbreaker. Instead of glasses he now peers through extended-wear contact lenses, his dark hair is cut and shaped in a mini-pompadour, and his deep brown eyes and ruddy cheeks are clearly defined. "Once you get into Todai," says Hiro, "you know everything will be easier, that everything will be okay, that you've made it. So what's the point of doing anything once you are at Todai if there is no longer anything to be gained?"

Indeed, the criticism most frequently leveled at Todai is that its students are appallingly apathetic. In other words, today's Todaisei may be unfit to rule tomorrow's Japan. Such naysayers tend to forget that college in Japan has always provided the only period in a Japanese male's life when he will have guaranteed free time. After college, even for those destined for the good life, there will be the drudgery of a salaryman's long hours, the trudgery of long commutes, the demands implicit in launching a marriage and starting a family. In Japan almost everyone agrees that college is a fine time in which to do nothing. Especially at Todai. (One Todai alumnus, who played center field for the Todai baseball team until his graduation four years ago, laughed when asked if he ever studied while in college. What did he do, then? "Baseball," he said. "Baseball and drinking.")

Assistant Professor Saishu decries the fact that Todai students now seem to lack any interest in politics. "The system drills it out of them," he complains. "Because politics, like everything else, is fashion. And in today's climate it is no longer fashionable to think politically. The people I went to school with are now salarymen, working in government, or, like me, working for the same system they once rebelled against. But at least, at one time, we showed we cared. Very few students care anymore, even while they're in college."

In his third-floor campus office overlooking a cracked, dry, Baroque-style fountain—an architecture student's abandoned master's project—Hisao Koyama, professor of architecture and a graduate of Todai in the turbulent sixties, concurs with his colleague. "The situation now is a problem. Students should take their studies, and politics, more seriously. If not, they will have no ideas when it is their turn to govern. Ninety percent of my classmates when I was in college were Communists. We used to talk about ideas and politics. And these Communists have since gone on to government ministries and corporate executive suites. They left their politics behind but took their ideas with them. The student body now is intellectually lifeless."

Yoshihara Nishiyama, a slightly built, dandruff-flecked, black-haired junior, is the editor of the weekly University of

Tokyo student newspaper. He shares the faculty concerns. "I worry about where tomorrow's leaders will come from. These days Todai students only learn how to memorize for the exams and can't come up with new ideas. Most students have one-track minds—'I'll go to law school, I'll enter the bureaucracy, I'll follow the success route.' Students consider it embarrassing or tacky to talk about ideas. Especially political ideas. What kind of environment is this, where politics is tacky but vomiting is fashionable?"

The political apathy among students today may very well derive from an acute shortage of serious political discourse in Japanese society itself. Only recently, for example, did Japan—after almost four decades—end the scandal-ridden one-party government rule. "I don't think Todai students are any less politically aware than the general population," says architecture professor Hisao Koyama. "But traditionally we have looked to Todai to provide leadership in politics. And if we don't encourage the students to think in the classroom then they won't think outside of the classroom." Prominent writer and social critic Foumiko Kometani puts it more bluntly: "College has become a complete joke. Students don't think because they don't study. And they don't study because nobody makes them."

But Akito Arima, president of the University of Tokyo, defends his institution by the numbers. "Check the statistics. If our academic system is so easy, then shouldn't everyone graduate in four years? Yet thirty percent of our students have to spend at least an extra year or two before getting their degrees." However, belying that statistic is the simple fact that it is virtually impossible to flunk out of Todai. Less than 1 percent of the student body is asked to leave in any one year for academic reasons. President Arima, whose university receives over 5 percent of the total national educational budget, finally admits that "Perhaps, frankly speaking, some students may have it a little easy. But I don't feel the educational regime in this university is *that* easy. Todai today is as capable of producing excellent leaders as it has ever been at any time in its history."

* * *

It is hard to say which came first, Todai or Japan. Founded by Imperial decree in 1871, the Todai Law Department developed the political philosophy of a constitutional monarchy revolving around the emperor, the linchpin of the Japanese nation. (And the law department remains the *ichiban* of Todai's departments; admissions to it are the most highly sought after). But the university also has a tradition as the center of Japanese intellectual life. Almost every Japanese male writer of international repute—Nobel Laureate Yasunari Kawabata, Junichiro Tanizaki, Ryunosuke Akutagawa, Yukio Mishima, and Kobo Abe—spent their salad days at Todai. Liberal politics and radical views have always been heatedly discussed and aired on campus—particularly during the Taisho democracy of the twenties. True, the college has rarely served as a countercultural center à la Berkeley or Harvard, yet Japan being Japan, Todai figures prominently in the history of the Japanese left; it was the site of the greatest symbolic event in the history of Japanese radicalism.

In 1968, the Non-Sect Radical Movement, an anarchist party embodying, its members say, the spirit of the Paris Commune, led massive student demonstrations that shut down the college for seven months. The unrest began when the Todai Medical School expelled eight students, ostensibly for assaulting an assistant professor while protesting a decision by the medical school that denied interns additional time off. Among those expelled was a pre-med student who was 1,500 miles away from campus in Kyushu at the time of the alleged incident. Subsequent requests by student groups to redress the situation were ignored by the administration; in typical Japanese fashion, it refused to lose face by acknowledging a mistake.

Assistant Professor Satoru Saishu, a graduate student at the time, was one of the protest leaders. He blames the hypocrisy of the administration for the demonstrations. "How could the University tell the students to look for the truth in their studies," he asks, "when the University itself was caught in an outright lie?"

On July 5, 1968, over 15,000 students launched a campus-wide student strike. By July 25, the unrest turned into a riot, with students seizing administration buildings and lecture halls. The 2,500 members of the Non-Sect Radical Movement, forming the core of the demonstration, headed negotiations with police and university officials. The occupation of the Gothic Yasuda clock tower was perhaps the high-water mark for radical politics in Japan. Considering Todai's status as the incubator of the ruling class, the Yasuda clock tower is universally recognized as a symbol of Japanese power and authority, a Washington Monument East. Yet for seven months, the Non-Sect Radical Movement held the tower, running an "alternative university" and flying their black flag. Sleeping on the floor, sharing communal ramen and soba noodles, they conducted "reeducation" seminars. Japanese police and university officials waited for media attention to cool down before forcefully dislodging the students, storming the tower and literally driving them out with cattle prods and truncheons.

"It was terrible violence," Saishu recalls. "They came with tear gas, fire hoses, attack dogs, even helicopters. We had no chance. There was no way to resist." Although there were no fatalities, this incident would go down in history as Japan's Kent State.

In 1932 Yoshikazu Uchida, a professor of architecture who would one day become president of Todai, designed the Komaba dormitories to house five hundred students. When the dorms first opened, their sturdy concrete construction and indoor plumbing were considered models of clean, modern student housing. Conditions have deteriorated steadily ever since. The filthy communal baths, darkened halls, and plywood doors are what one would expect in a Calcutta shantytown. Overgrown shrubs entangle and consume abandoned bicycles and motor scooters. Most windows are broken.

The vast majority of University of Tokyo students, even those from far-flung prefectures, shun the dormitories, citing the appalling conditions and the radical politics of its residents as

the reasons, and live off-campus in private apartments or *geishuku* such as Hiro Ikeda's. There is virtually no allotment of substance in Todai's annual $80 million budget for the maintainance of the Komaba dormitories. "That's where all the freaks live," says Hiro Ikeda.

The "freaks" are Todai's few politically active students. The Non-Sect Radical Movement, hero of the Yasuda clock tower, has its headquarters in the Komaba dormitories. As do their archrivals, the University of Tokyo Communist Party Central Committee. The anarcho-syndicalists, feminist, and anti-vivisectionist movements also maintain quarters in the dorms. As the last redoubt of Todai's "political" movements the dorms house but a tiny percentage of the student body. Membership in the Non-Sect Radical Movement, for example, has slipped from the sixties' 2,500 to just 15. "The few students who live in the dorms," insists Professor Koyama, "embody the liberal spirit of this college."

The Central Committee of the Non-Sect Radical Movement is meeting this Tuesday night, as it does every Tuesday night, in the dormitory-suite-cum-cradle-of-the-revolution shared by Shunshi Koyama and fellow undergraduates Yoshi Inaba and Masaki Shiraki. Both rooms of the suite are a collage of old papers, dirty dishes, empty beer bottles, and cigarette butts. The floor-to-ceiling bookshelves are lined with well-thumbed paperbacks by Bakunin, Mao Tse Tung, Thoreau, Kropotkin, and Judith Krantz. On the walls are posters promoting the Spanish Anarcho-Syndicalist Movement, the Free Burma Movement, and the movie *Terminator 2*. Ax handles, gas masks, helmets, and a threatening panoply of blades and knives are massed in one corner of the room. "For the revolution," Shunshi confides.

This suite has been in the possession of the Non-Sect Radical Movement since the sixties, passing on each year to new members as seniors graduate. Scrawled on the walls are graffiti from generations past: REVOLUTION NOW, DOWN WITH THE TODAI COMMUNIST PARTY CENTRAL COMMITTEE, FUCK THE DEMOCRA-

TIC SOCIALIST PARTY, and, in English, THERE'S A LADY WHO'S SURE ALL THAT GLITTERS IS GOLD . . .

Todai newspaper editor Yoshihara Nishiyama is attending tonight's meeting in the hope he can convince the Non-Sect Radical Movement to participate in a march that Saturday protesting the Peace Keeping Operations (PKO) bill, the amendment to the Japanese constitution that has allowed the dispatch of Japanese troops overseas for United Nations–sanctioned wars. The bill was significant in that the Japanese constitution explicitly forbade the formation of an army and specifically prohibited the use of self-defense forces outside of Japan such as those currently deployed in Cambodia.

Before Yoshihara can make his pitch, Yoshi Inaba, the handsomest member of the Central Committee with his short hair and cleft chin, slips on a black, double-breasted blazer, grabs a couple of condoms from a desk drawer and leaves for an apolitical love-hotel rendezvous with a young co-ed from Ochanomizu Women's College. The other members of the Central Committee, as politically committed as they are, look after him with envy.

Yoshihara is a hesitant speaker, obviously someone more comfortable imparting ideas in newspaper editorials than in impromptu oratory. But he does succeed in getting his point across as he evokes images of 1968, when the Non-Sect Radical Movement stood tall and, despite a lack of cohesion and the usual blundering, managed to shut down the campus and shake the nation. "The Yasuda Tower," reminds Yoshihara impassionedly. "Your predecessors, who sat in this very room, stormed the Yasuda Tower. It took tear gas, riot police, and helicopters to drive them out. And you, you . . ." He stops and scans the table. Yoshihara's pause, as he searches for the right words, has an unexpected dramatic effect. Five mouths disengage from five beer bottles. Unable to find a clever slogan with which to finish his speech, Yoshihara settles for clumsy rhetoric. "You won't even participate in a stupid march for a smart cause."

The Non-Sect Radical Movement returns to its drinking. When they finally come to a decision about attending the anti-

PKO march, it is to decide not to decide and allow each member to make his own decision. Yoshihara extracts the personal assurance of each of the five members of the Central Committee present that they personally will attend the anti-PKO march as individuals.

"I will be there," promises portly Shunshi Koyama as he wipes his glasses on his T-shirt, "if I am awake."

The march is scheduled for noon.

Yoshihara kicks back in his chair, content that he has done the best he could do with this bunch. The Communists, if they hear the Non-Sect Radicals will not come as a unit flying its colors, might even be convinced to participate.

He checks his watch. It is eleven o'clock. "Time for a beer run," he suggests. The members of the Central Committee spring into action. Hands reach into pockets, yen notes pile on the table, bills are counted, and two members of the Central Committee are dispatched to an off-campus liquor store for another case of Sapporo.

By the time the "runners" return, an old Aiwa stereo has been switched on, and the music selection shifts from Led Zeppelin to the Blue Hearts to Complexx to Nirvana. As smoke fills the room, a lazy hand dangling a cigarette accidently sets a balled-up piece of notebook paper on fire, precipitating a massive spilling of beer as a fire-fighting measure. The sooty, blackened mess is left to dry.

"The problem with being politically active," says Shunshi Koyama after he opens another beer, "is there just aren't very many politically active girls."

Hiro Ikeda and *Todainodohai* (Todai classmate) Masa Inegami steer three girls down Shibuya's crowded, neon-lit streets. Hiro is in black loafers, Levi's, and a green Ralph Lauren sweater. Masa is wearing the pegged herringbone corduroy trousers that enjoyed a peculiar popularity around the Todai campus this year. As the group strolls past, nightclub touts thrust out invitations and street vendors hustle sand paintings and battery-powered stuffed pandas.

They end up in a *karaoke* box—a pay-by-the-hour room the size of a pickup truck bed where they pile into the orange conversation pit and pass around cans of beer and a microphone. The *karaoke* box, for Japanese students, serves as a transitional station from public drinking establishment to more private, intimate rooms in love hotels. Shibuya, with Tokyo's widest selection of pay-by-the-session love hotels just up the hill and numerous *karaoke* box establishments near the train station, is a favorite haunt for Todai men looking to *suru no shakuhachi* (a euphemism for sex that translates literally to "play the flute"). Even to arrange an evening meeting with a woman in the Shibuya area is suggestive of the possibilities up the hill.

A hit song from the sixties by Kunihiko Kase & the Wild Ones plays on the *karaoke* machine as Masa Inegami warbles along incoherently, concentrating on the lyrics rolling by on the monitor. The group cheers when the song ends and Masa passes the mike to Michiko, a pretty twenty-year-old with long black hair and a rosy-cheeked complexion, who selects a more recent number by Seiko Matsuda.

The three *bodi-con* girls have been out with Todai men before, and despite the fact that Hiro and Masa are, by matrimonial standards, very good catches, no one seems likely to be playing the flute tonight, a fact that distresses Hiro and Masa but not calamitously so.

"There are always girls around," Hiro says later. "I mean, it's not like we're rock stars or something, but we're Todai guys, you know, so there are always girls who want to meet us."

There also are always corporations eager to hire them. Hiro owns one suit, a blue double-breasted wool and polyester blend manufactured by Style Monster. Two months previously he wore the suit for the first and only time for a job interview at Nippon Kiera, a company that manufactures absorbent synthetic pebbles suitable as insulating material or kitty litter. Nippon Kiera had sent Hiro two videotapes, three brochures, and had called him five times. With his junior year winding down, Hiro decided to poke around the job market, which,

even in these recessed times, still brims with opportunity for a Todaisei.

By his junior year, a Todaisei becomes the object of corporate recruiting campaigns comparable to those waged by American college football coaches eager to land blue-chip high school prospects. Newspaper editor Yoshihara, a communications major, reports, "I've got two big boxes full of letters from companies. And they keep coming every day. There is no way I can open them all. They don't care who I am, what I've done. They only know one thing—Todai."

A personnel manager for All Nippon Airways, which was voted Japan's most popular company by last year's college seniors, explains that he tries to hire Todai men because "You will never look bad later—even if the guy is lazy or turns out to be an idiot, you can always point out that he went to Todai, and everyone will understand why you hired him."

For a small company to land a Todai man can be an image-enhancing coup, one that raises the status of the company. "The Todai guy is like the company mascot," says a bond trader for a small Japanese brokerage house. "The boss will come by to look at him once in a while." Corporations go all out on their annual recruiting drives, offering some students cushy, lucrative internships if they commit to work for the company after graduating. (Some of these "internships" don't even require the student to show up before graduating, though he will be collecting a salary.) Lately, major corporations have found the annual recruiting drives so distracting they have agreed to an official recruiting season, starting in May. But the prospect of losing out and not landing enough Todai graduates is so daunting that most companies cheat by recruiting before the official start of the season, sponsoring corporate tours, expensive dinners, and drinking parties. Stories abound of personnel managers even buying women for potential recruits.

The kitty litter company employed a more conventional approach. "They gave a speech," Hiro recounts of his day at the kitty litter company. "And they showed us a video of what they do. There were big mounds of pink and white and blue

pebbles being moved around by cranes and trucks. It was sort of impressive."

Nippon Kiera then catered a lunch of pork cutlets and curry rice for Hiro and fifty other college students and discussed the company's vacation programs and plans for a new employee fitness club. On his way out, Hiro was tapped on the shoulder by an unctuous company representative who asked him if he was interested in an internship. Good pay. And you couldn't beat the hours: no hours a day, no days a week.

Hiro declined. "Working at a company looks pretty boring," he says. "So I'm not committing myself to anything."

Hiro Ikeda does not think about leadership, the history of Todai, social inequalities, or the future of Japan—he never has nor will he ever be tested on these topics. Nor, like most of his classmates, does he concern himself with the current state of his country. "What's going on now in this country may be wrong—I don't know," he concedes. "But I won't have any problem making a living, so it's hard for me to think of any reason to bother to worry about things."

On a dusky spring afternoon he is sitting on the steps of the Yasuda Tower sipping from a can of Yebisu beer. A couple strolls by, dressed in natty collegiate attire: a long-haired girl in jeans and a black sweatshirt and a boy in generously pleated khakis and houndstooth jacket. Finished with classes for the day Hiro drinks in small, steady swigs, waiting for his friends so they can get down to the business of planning a quadruple-date/drinking party that night with some female students from a nearby junior college.

"My first two years I went to maybe half my classes," he says as he empties the can. "But I didn't fail any classes. Well, I failed one," he catches himself, "which I'm taking over now. But this final year I'm really going to hit the books."

Hiro, however, had missed his Foreign Affairs course at 8:30 that morning. "That one's tough," he says, and nods. He also passed on Torts, which is in session as we speak. "Late lunch," he explains.

But Hiro is fully determined to be a major player in tomorrow's Japan.

"I don't want to be prime minister or anything like that," he smiles. "I'm thinking maybe about going back to cram school to learn French and then practicing at the World Court in Geneva."

The Hague, he is told.

"Dokodemo." He shrugs. "Wherever."

VII

KAZU AND HIROKO

THE MAP MAKER

The black guy, an American, didn't know he was helping to salvage a relationship when he boasted to the pretty blond standing beside him at the bar that he had forty kilos of Humboldt County sinsemilla he was looking to move.

She was short, about five-three, with hair down to the middle of her back and a well-built, conscientiously exercised body squeezed into a black Yohji Yamamoto dress. She looked at him as if she didn't know what he was talking about, but secretly she liked what she was hearing. She sipped her Sea Breeze and shrugged. "Exactly how impressed am I supposed to be?"

He extended his hand, and she took it, noticing a thick signet ring on his index finger with crossed swords over a *Semper fi*. Jarhead, she thought, from Atsugi or Yokosuka or another of the U.S. military bases south of Tokyo. "Samantha," she said. "I'm Sam. Nice to meet you."

The bar, Gas Panic, was loud and dimly lit. This wasn't Sam's scene at all: big, beefy marines with buzz-cuts shimmying with Japanese girls in tight cocktail dresses to the Cult or Faith No More. Gas Panic catered primarily to foreigners and some of the seedier Japanese elements of Tokyo society. It was a fluke she was in here at all. She had had a fight with her boyfriend before leaving for work this evening at the hostess bar. And when work had finished an hour ago and she hadn't felt like going home, she decided to have a drink to kill some time before calling Kazu, hoping they could patch things up.

Fucking Kazu, she thought as she drank. He obviously didn't love her. But at the forty keys she perked up: this was something that Kazu would love. An excellent excuse to go see him.

Greg claimed he was a former marine, now a civilian employed by the U.S. Navy as an airplane computer systems analyst. She got his number and promised, swear to God, she would call him.

"Don't go, baby," he said. "We could have a party. I got some ice. You like ice?"

"Another time maybe," she said, and split, giving him her best smile.

* * *

Kazuhiko Kim, twenty-five, shirtless, sat up in bed and paid more attention to Rachel than he had in weeks. Rachel (Samantha was her working name) was standing at the foot of his bed and telling him, in her halting Japanese with plenty of English thrown in, that she really didn't want to come see him but felt she should do him a favor and tell him about this American guy she just happened to run into who had a lot of grass he was looking to unload and whose phone number she had.

"How much?" he asked her.

"Forty kilos."

He ran through the arithmetic. In Tokyo, a kilo of high-quality sinsemilla is worth about ¥7 million ($64,000). Whole-sale, where Kazu was used to operating, the price was more like ¥4 million ($36,400). Forty kilos would therefore cost, con-servatively, ¥160 million—over $1.4 million—a nice piece of change, even in Tokyo. Certainly more scratch than Kazu could come up with. And forty keys was more weight than he could reasonably hope to move.

Still, this could be what he had been waiting for. Kazu hadn't risen from being a *bosozoku* to *yojimbo* (nightclub manager and bouncer) to middle-level drug dealer and trusted *chizu-gyosha* (map maker) for the Yakuza without picking up a few tricks and meeting a few people. He wasn't a member of any Yakuza fam-ily, though there was considerable pressure from the Kowa-kai to enlist. He was a *furyo*—independent. He and his two-man crew—one guy for muscle, one for brains—worked without the tutelage of any higher underworld power broker.

Kazu was of Korean descent in a society that insitutional-ized prejudice. Koreans weren't allowed to participate in the National High School Baseball Tournament. Korean families that had lived in Japan for three generations still had to carry iden-tity cards and be fingerprinted, just like a migrant worker in Tokyo for a ninety-day stay. His father had been a construction worker, a day laborer, who died when Kazu was nine. Kazu's

mother, Tsuriya Kim, had raised Kazu and his brother herself, working in a *ramen* restaurant six days a week.

Kazu quit school when he was eleven and started hanging with members of Kill Everybody, the toughest motorcycle gang in Yokohama. When he was fourteen he had his own bike, a Yamaha 450, and was making the rounds of local shops to distribute the Kill Everybody decals and stickers that the shops were obligated to sell. Twenty stickers a week at two thousand yen a sticker or your shop would suddenly experience a large drop in clientele due to the unsavory motorcycle gang hanging out in front all day long, or you might, inexplicably, have a costly fire in your stockroom. Kazu's chapter was two hundred strong. And gradually, as older members went to jail or left to join the Yakuza, Kazu emerged as the leader of Kill Everybody.

Then kidnapping became popular as an easier means of making money than extortion. "Kidnapping changed everything," Kazu says. "We were all into kidnapping the leaders of other gangs and then demanding a ransom. No one would go to the police—and the police thought it was kind of cute for us to be beating on each other anyway."

It was kidnapping that hastened Kazu's departure from the gang—he himself was abducted in May 1984 by a rival gang, the Midnight Angels. For four weeks, while they negotiated with Kill Everybody for his freedom, they beat him intermittently with a car antenna and their fists and kept him bound with ropes and bamboo in a house near Yokohama's port district. It took them a month to make the deal, for a lousy ¥500,000 (in 1984 about $2,000), and Kazu, when he was finally released, decided if his gang had that much trouble coming up with ¥500,000, he was better off alone.

He resigned as president of the Yokohama chapter of Kill Everybody on June 16, 1984, two days after his release. He still has the scars from the car antenna—a series of slashes on his side just below his chest.

Rachel was running out of things to say. Kazu lit a cigarette.

She asked Kazu if he was interested in the black guy with the grass.

"Maybe," Kazu said, snuffing his cigarette. His hair was long, down to his shoulders, and he had to hold it back with his right hand so that it didn't fall into the ashtray. "Let me think about it."

Rachel set her black Chanel bag down atop the television. She walked over to Kazu and sat on the bed beside him and tried to look into his eyes, but Kazu found the remote control and turned on the TV.

Young, wealthy Japanese who traveled and lived abroad during the seventies and eighties often brought back new habits on their return. These drug users are not the sooty underbelly of Japanese society from which Kazu emerged. They are the children of the industrialists and executives who built Japan, Inc. Apolitical and apathetic, they tend to be more comfortable in Issey Miyake than a salaryman suit, able to find their way around a French menu while unable to read classical Japanese, up on the latest white-label releases out of London while never having heard a three-string samisen.

Kazu, who deals ice, cocaine, Ecstasy, and marijuana, says most of the kids he turns on are from wealthy families or in the entertainment industry. "They're people who have money and time to burn," he explains. "And for them, I think, drugs have become a status thing, like BMWs or Swiss health resorts—but a status thing with an edge, because it's illegal."

In 1985, when Kazu first moved from Yokohama to Tokyo and worked as a doorman/bouncer at a disco in the trendy Roppongi district, he was shocked by what the kids would buy. "Darvon, Valium, muscle relaxers, even glue," Kazu remembers. "People would pay five thousand yen [$20] for a Darvon! And these people were video producers, television stars, and they didn't know where to cop anything."

So Kazu hooked up one of his old connections from his *bosozoku* days who could provide Mandrax and speed. He told the muscle-relaxer dealers in knockoff Kenzo and Armani suits

to get the fuck out of the club, and he took over the racket, selling the best buzz the kids had ever felt. "In the discos and clubs, there was a huge market for drugs. I saw it. You could feel it," Kazu now says of his revelation. "The kids had read about E or speed in *The Face* or *i-D,* and they wanted to get off. So I brought in different things—downers, coke, E, to see which would sell best."

Cocaine and Ecstasy were the best-sellers. With a gram of 80 percent pure cocaine going for ¥30,000 ($270) or a hit of Ecstasy retailing at ¥10,000 ($90), Kazu had stumbled upon a redefined Japanese dream. He lived in the Tokyo fast lane, mingling with rock stars and models and taking corporate executives' kids' allowances in exchange for an eighth of an ounce of blow or six hits of E. He had made it further and faster than anyone he knew. Three-room apartment in the ritzy Aoyama section of town. Expensive, hip clothes. Pretty girlfriends.

The *shinjinrui* were succumbing to the same temptations to which American youth had fallen victim. Cocaine seizures by Japanese law enforcement officials in 1985 were a mere 129 grams; by 1990 seizures totaled 68.8 kilograms, approximately the same level as U.S. seizures in the early seventies. Growing evidence of a Colombian connection exists: in 1990 police in Yokohama seized 33.4 kilos off a Colombian freighter and arrested three Colombians on charges of drug trafficking. American DEA agents and U.S. military police suspect ties between the Yakuza and Medellín cartels—and scattered arrests like those in Yokohama indicate that more cocaine than ever is flowing in from Colombia.

The National Police Agency and Japanese customs officials admit they are unprepared to deal with a massive influx of drugs. Police Superintendent Yoshiharu Ota, assistant director of the National Police Agency's Drug Enforcement Division, explains: "We think that the cocaine problem could become a very serious problem, as serious as the fantastic amount of methamphetamine abuse in Japan. We are number three on the Colombian cartels' list after the U.S. and Europe. After all, we still have the money."

A former American federal agent who works with the Tokyo Metropolitan Police to improve interdiction methods says, "Japanese methods are so ridiculous that they sometimes bust the mule when a bigger dealer could be netted by following the guy who's holding. And when you consider that the NPA is not allowed by law to use undercover officers, then Japan is wide open right now for drug smugglers and dealers. What they're seizing is maybe two percent of what's being imported. They've got an explosion of drug use in the population."

Japanese policy is to attempt to choke drug use at the user level by administering virtually identical penalties for possession as dealing. For example, sentencing guidelines for possession of cannabis call for a five-year term; the sentence for dealing is seven years. The former U.S. federal agent contends that this policy "simply doesn't make sense. I hate to say this, but the Japanese police have got their heads in the sand."

National Police Agency seizure amounts indicate an increase in usage of every type of drug, though the amounts are still minuscule by American standards. Heroin seizures in 1991 were 27 kilos, while cannabis seizures reached 205 kilos. Drugs like Ecstasy and LSD, which are harder for customs authorities to detect, are flooding in from the United States, England, and Thailand, often in the backpacks or suitcases of enthusiastic world-ravers. Ice, smokable methamphetamine, which is manufactured in several factories about Japan—primarily in Kyushu and in Chiba, an industrial suburb of Tokyo—is becoming so popular among young, hip Japanese for its extended high and euphoria that it may be making cocaine déclassé. (Injectable methamphetamine has long been Japan's blue-collar drug of choice with an estimated half-million addicts.) One high-level ice and sulfate amphetamine dealer estimated the amount of ice manufactured in Tokyo alone at ten tons a year. The *shinjin-rui* want their product. And someone has to provide it.

Kazu woke at two in the afternoon. He dressed hurriedly— polo shirt, jeans, and Timberland boots. He took the cordless phone into his living room and closed the bedroom door behind

him. He called Tachi, the brainier half of his crew, and discussed who might be interested in forty keys of sens. Their regular partners, the Kowa-kai, were Tachi's first suggestion, but Kazu didn't want to deal with them this time. They were getting too smart. They had worked with Kazu so often he worried they no longer needed to buy his expertise for this type of deal. Tachi, almost as a joke, suggested the Matsui-kai. Perfect, Kazu said. Matsui-kai is a group of members of the Inagawa-kai who had left the big family to start their own crew. While it didn't have the Inagawa-kai's reputation for ferocity, it did have capital: trillions of yen in spot credit from its Inagawa-kai *oyabun*s. And Kazu knew that the godfathers were itching to get into the drug business.

He woke up Rachel. "Call your friend—what's his name, with the sens," he told her.

"Who?" Rachel yawned. "Greg."

"Call him and arrange a meeting."

Kazu and his crew had long filled a crucial niche. They were a bridge between the Yakuza and the rest of the drug world. The Yakuza, three years ago, finally realized how much money there was to be made in dealing narcotics other than their traditional *shabu,* or methamphetamine. (The National Police Agency estimates the Yakuza already control about 50 percent of the $10 billion annual amphetamine business.) But the Yakuza lacked the expertise or personnel to effectively enter the drug business.

"They are amazingly stupid," Kazu says. "They don't know how to test drugs. They step on shit unprofessionally. Sometimes they even buy bullshit. Bad coke. A kilo of grass with ten ounces of stems in it." The Yakuza needed *furyo* like Kazu who could hook them up or, conversely, who could distribute. So when the Kowa-kai had a deal to make, they came to Kazu and asked him to "draw the map"—decide the logistics of the deal, the who, what, when, and how much. Or he would come to them if he heard about an amount that was more than he could handle.

(While the Yakuza are gradually learning to traffic drugs more effectively, there are still impediments to a smooth interface with foreign gangs like the Colombian cartels. According to the former U.S. federal agent, "There is still a language problem. Very few Colombian coke dealers speak Japanese. And none of the Yakuza speak Spanish." The most common interface is through Japanese who emigrated to Colombia and are returning, or through Colombian girls coming into the country to work as hostesses or strippers.)

Kazu's understanding of the mechanics of drug buying, selling, and dealing made him a popular man among the Yakuza. But he had a Gatsbyesque dream: to be accepted in the high society in which he dealt drugs. Kazu spent most evenings at the Kapa Yakitori restaurant in Aoyama, a cellular phone at his elbow, and an I.W. Harper, ice, and water in front of him. The beautiful people—models, trust-fund kids, rock stars, young actresses, and up-and-coming designers—gathered there a few nights a week to eat, drink, and become merry.

That night, as Kazu walked in, he saw Hiyoshi, a surfer from Kanagawa whose family owned one of the world's largest film companies. Kyoko, who smoked a cigarette beside him, hosted a TV Asahi trend-update show. Michiko, next to her, had recently released an album on Virgin Records Japan. Noboru, a music video director, was making a call on his own cellular phone. And Kenji, down the bar, was the scion of a wealthy Kyushu samurai family.

He liked to watch how they moved, how they sipped drinks or slipped on jackets. The lazy, slightly arrogant roll of their tongues. The soft confidence in their voices. The assurance that comes from knowing you are rich; in Manhattan or Tokyo, money sounds the same.

From his Korean heritage to his criminal provenance, Kazu felt he wasn't like these beautiful people. These beautiful people liked having him around only because of his role as a dealer. And the only way to get into their crowd, to permanently get in, was through marriage.

His target was Hiroko Yoshida, the girl sitting down the bar

with Kenji. She was descended from one of the *zaibatsu*, family-owned superconglomerates that had dominated prewar Japan and now had a large interest in one of Japan's largest banking and insurance corporations. She drove an AMG Hammer 190. Her skin was chestnut brown from tanning at her fitness club's salon. Her naturally straight hair was permed to kinky curls at an exclusive salon with a private underground garage. She didn't shop for clothes; the women in her family had been patronizing the same Nishi Azabu seamstress shop for three decades and used them to make Gaultier and Yamamoto knockoffs that cost more than the originals.

The sight of Hiroko, whom he had slept with a few times in the past four months, made Kazu resent Rachel. Rachel reminded him of himself, a foreigner in Japanese society getting by on the wrong side of the law. Hiroko was a classic goddess: blue-blooded Japanese, beautiful and rich.

There had been a party that summer at Hiroko's parents' country house on Lake Ashino near Mount Fuji. Thirty-five kids, diving into the heated, gray-slate swimming pool with its lake view, and dancing in the living room drinking Veuve Clicquot champagne, and hanging out upstairs in the imitation hot-spring bath with air blowers like a Jacuzzi. A custom-designed sound system, with minispeakers all over the house and gardens, cranked out the Rolling Stones.

Kazu had supplied forty hits of E and an ounce of blow. And, even though he was staying sober, he had never felt so buzzed as he did walking around the patio, arms locked with Hiroko while their friends were splashing around in the pool, obviously fucked up and loving it.

At that moment, Kazu had felt in the eye of it. Dead center of the coolest scene in Japan. Upstairs, later that night, in Hiroko's parents' bedroom with Hiroko tripping on a hit of E, they had made love for the first time. Kazu, at one point in the evening, even proposed to her.

And the next morning Hiroko pretended they barely knew each other.

Now, in the Kapa Yakitori, he waved to her down the bar.

She waved back and smiled. He went over and sat down beside her. His mind was a mass of conflicting thoughts. He ordered a drink.

"Are you going out tonight?" he asked.

Hiroko took a drag from her Marlboro Light. "Maybe to that party Connie's throwing—some warehouse near Shinagawa."

He had heard about this party from Rachel. "Come out with me," he said. "Let me buy you dinner."

"I don't really eat," Hiroko said, and laughed.

"Then watch me eat."

The barman set down Kazu's drink. He sipped. Hiroko never responded.

From the ANA Hotel bar high above the city you can see all of west Tokyo—the brightly lit Tokyo Tower, Shinjuku's new twin-spired city hall, the office building lights flickering on in the dusk, the thousands of cars crawling along the express-ways, the commuter trains on the elevated railways disgorging masses of passengers. Kazu sat in a plush booth listening to Greg tell him the grass had been smuggled into Japan on a U.S. military cargo flight from the Bay Area. Greg wanted to get rid of it all as fast as possible. There were already traces of mold on some of the buds, a factor that Kazu took into account in the negotiations.

Rachel sat between them, translating in the places where Kazu's English broke down.

Greg asked Kazu if he had any tattoos.

"No," Kazu said.

"I thought all you Japanese gangsters had tattoos," Greg said, sipping a mineral water.

As Kazu had hoped, Matsui-kai had told him they were interested. The deal was in motion. Forty kilos of grass and a million dollars' worth of yen had to change hands, and Kazu would draw the map.

Usually, on a deal like this, Kazu would receive a fee—maybe ¥2 million ($18,200). Or, if he chose, he could get into the deal at wholesale prices. He never spoke about his pay-

with Kenji. She was descended from one of the *zaibatsu*, family-owned superconglomerates that had dominated prewar Japan and now had a large interest in one of Japan's largest banking and insurance corporations. She drove an AMG Hammer 190. Her skin was chestnut brown from tanning at her fitness club's salon. Her naturally straight hair was permed to kinky curls at an exclusive salon with a private underground garage. She didn't shop for clothes; the women in her family had been patronizing the same Nishi Azabu seamstress shop for three decades and used them to make Gaultier and Yamamoto knockoffs that cost more than the originals.

The sight of Hiroko, whom he had slept with a few times in the past four months, made Kazu resent Rachel. Rachel reminded him of himself, a foreigner in Japanese society getting by on the wrong side of the law. Hiroko was a classic goddess: blue-blooded Japanese, beautiful and rich.

There had been a party that summer at Hiroko's parents' country house on Lake Ashino near Mount Fuji. Thirty-five kids, diving into the heated, gray-slate swimming pool with its lake view, and dancing in the living room drinking Veuve Clicquot champagne, and hanging out upstairs in the imitation hot-spring bath with air blowers like a Jacuzzi. A custom-designed sound system, with minispeakers all over the house and gardens, cranked out the Rolling Stones.

Kazu had supplied forty hits of E and an ounce of blow. And, even though he was staying sober, he had never felt so buzzed as he did walking around the patio, arms locked with Hiroko while their friends were splashing around in the pool, obviously fucked up and loving it.

At that moment, Kazu had felt in the eye of it. Dead center of the coolest scene in Japan. Upstairs, later that night, in Hiroko's parents' bedroom with Hiroko tripping on a hit of E, they had made love for the first time. Kazu, at one point in the evening, even proposed to her.

And the next morning Hiroko pretended they barely knew each other.

Now, in the Kapa Yakitori, he waved to her down the bar.

She waved back and smiled. He went over and sat down beside her. His mind was a mass of conflicting thoughts. He ordered a drink.

"Are you going out tonight?" he asked.

Hiroko took a drag from her Marlboro Light. "Maybe to that party Connie's throwing—some warehouse near Shinagawa."

He had heard about this party from Rachel. "Come out with me," he said. "Let me buy you dinner."

"I don't really eat," Hiroko said, and laughed.

"Then watch me eat."

The barman set down Kazu's drink. He sipped. Hiroko never responded.

From the ANA Hotel bar high above the city you can see all of west Tokyo—the brightly lit Tokyo Tower, Shinjuku's new twin-spired city hall, the office building lights flickering on in the dusk, the thousands of cars crawling along the expressways, the commuter trains on the elevated railways disgorging masses of passengers. Kazu sat in a plush booth listening to Greg tell him the grass had been smuggled into Japan on a U.S. military cargo flight from the Bay Area. Greg wanted to get rid of it all as fast as possible. There were already traces of mold on some of the buds, a factor that Kazu took into account in the negotiations.

Rachel sat between them, translating in the places where Kazu's English broke down.

Greg asked Kazu if he had any tattoos.

"No," Kazu said.

"I thought all you Japanese gangsters had tattoos," Greg said, sipping a mineral water.

As Kazu had hoped, Matsui-kai had told him they were interested. The deal was in motion. Forty kilos of grass and a million dollars' worth of yen had to change hands, and Kazu would draw the map.

Usually, on a deal like this, Kazu would receive a fee— maybe ¥2 million ($18,200). Or, if he chose, he could get into the deal at wholesale prices. He never spoke about his pay-

ment with his Yakuza partners before a deal. It was considered rude to quibble over prices, after all—that was what they had hired Kazu to do for them. The families depended on him to negotiate with the foreigner and get the price down to an acceptable range from which they could make a profit (Kazu's English was just up to the task). On a deal of this size, the biggest he had ever been involved in by far, he could count on three times as much money as he had ever received. Kazu also decided to invest thirty million of his own yen for six kilos at wholesale rates.

His map was this: Kawaguchi from the Matsui-kai and Kazu would check into a room at a small, out-of-the-way business hotel in Ota Ward at eight P.M. carrying a duffel bag full of Japanese yen and a triple-beam scale. Greg would arrive ten minutes later, accompanied by his partner, driving a rented white van with the forty keys and a Tellac 950 electronic money counter. Kawaguchi and Greg would count the money in the hotel room while Greg's partner and Kazu went down to the van and weighed the stuff. And when they both came back up and both agreed everything was copacetic, and when the money had been counted and found to equal ¥140 million, then Greg's partner and Kazu would go downstairs and wait in the van. Greg would come downstairs five minutes later and walk away, joined by his duffel bag full of money and his partner, leaving Kazu to wait in the van for Kawaguchi-san to return from the room. They would drive the van to Matsui-kai's warehouse, unload it, and return it to the rental agency. According to Kazu's plan, or map, and depending on how long it took to count fourteen thousand ten-thousand-yen notes, the whole transaction would be completed by 11:30.

Kazu explained the whole deal and Rachel clarified any linguistic confusions.

"We're rolling," said Greg.

Kazu turned from Greg to Rachel and thought of Hiroko.

Hotei Tomoyasu, guitarist for the Japanese hard-rock group Complexx, performed a sold-out, four-night stand at Tokyo's

Budokan auditorium in mid-January. The occasion was the filming of his new video, "Guitarism 2." Each night, over eight thousand fans came to watch the Japanese Eddie Van Halen perform his guitar pyrotechnics while a video crew, directed by Kazu's good friend Noboru, filmed the concerts. Kazu and Noboru's crowd drifted in and out of the backstage area during those four nights that the Budokan became the center of the hip scene in Tokyo.

Flush with cash from the deal, Kazu felt completely and totally on his game. Crew, management, roadies, and groupies were bombarding him with requests.

He usually arrived late, after the concert had started. The backstage area would be quiet, just a few friends hanging out, drinking and getting high while Hotei kicked out the jams onstage, which sounded, from the dressing rooms, a million miles away.

Kazu was the man. Rumors had already spread that Kazu had made a million-dollar deal. He didn't deny them. He didn't encourage them. He just waited and hoped Hiroko would hear about it. After all, when she wanted to cop, who did she talk to?

But Hiroko never turned up at Hotei's stand at the Budokan. She even stopped coming to the Kapa Yakitori restaurant, where Kazu dropped in nearly every evening to make the scene. He called her, leaving messages on her machine, but she never called him back. Friends said they had seen her at Gold discotheque or at the health club or at her family's vacation house and that she was fine, hadn't Kazu seen her?

Through Noboru, Kazu eventually heard about Hiroko's impending marriage to a prominent politician's son. The match was arranged between Hiroko's family and the politician, for the betterment of both families. Arranged marriages still happen, especially in the rich-kid circles to which Kazu supplied his product. But he never imagined Hiroko getting married to some straight University of Tokyo law school stiff. That wasn't her style.

When he called her from his living room, she asked him if he wanted to come to the wedding party. He couldn't be invited to

the ceremony, of course. "That's not really for people like you," she said. She asked if he understood.

He said yes, he understood, and switched the cordless phone off and walked back into his bedroom and climbed back into bed with Rachel, who was already asleep and probably also understood.

VIII

TUSK

TWILIGHT OF
THE IDOLS

YOU THINK IT'S SWELL PLAYING IN JAPAN,
EVERYBODY KNOWS JAPAN IS A DISHPAN.

The Sex Pistols

The first thing twenty-three-year-old Tasuku Itaya saw when he
woke up was an empty red lacquer bowl. It danced before his
eyes as he heard someone shouting, "Get up! You don't have
any miso soup and your manager stole all your money."

Tusk, as he was known to his thousands of Japanese fans,
sat up in bed and pushed the bowl aside as Reiko—no, he
remembered, her name is Ayako—turned around and carried
the bowl back into the kitchen, her panty-clad ass bobbing as
her bare feet smacked lightly against the tatami floor.

"Someone on the phone for you," she shouted over her shoul-
der.

Ken, Tusk's guitar player and buddy since childhood, was
on the line. Ohta, the manager of Tusk's and Ken's band Zi: Kill
(the Japanese pronunciation of "Jekyll"), was gone, vanished,
his assistants didn't know where he was. Even the police couldn't
find him. Ohta's office in Shibuya was closed and he hadn't
been to his own apartment in three days.

Ohta's clients' money had disapeared with Ohta. Zi: Kill's
client account balance had been over ¥20 million ($180,000),
including royalties from their latest album as well as show guar-
antees for their recently completed tour. That twenty million
had been the financial legacy of two CDs, a thousand gigs and
concerts, and over five years as a hardworking, independent
Japanese rock band.

"We're flat broke," Ken said quietly.

Tusk agreed to meet with Ken and the rest of the band at a
Harajuku coffee shop that afternoon.

Since forming in 1988, Zi: Kill had slowly worked its way
up, gig by gig, from insignificant live house band (Japanese
rock clubs are called "live" houses, as in "live music") to locally
popular live house band to headlining live house band. They

had signed with one of Japan's leading independent record companies, Extasy Records, and had released two compact discs, one of which had reached number 90 on the *OriCon* (short for *Original Confidence,* Japan's music industry trade journal) charts. For one hectic week in early 1991, they had been one of the hottest independent acts in Japan, reaching number 2 on the *OriCon* independent charts and signing for a one-month tour of two-thousand-seat venues.

"We thought it was all finally happening for us," Tusk recalls. "Everything was going our way. For the first time in our careers, we didn't personally know the people coming to our gigs. At Club 24 and 7th Avenue in Yokohama, when we first started out, we were actually paying people to come to our shows. The only other people in our audience were the other bands waiting to set up."

At Club 24 it is not unusual for new groups sharpening their rock and roll chops to pay to play. Unproven acts must guarantee the manager that they will sell twenty-five tickets at ¥2,000 ($18) apiece. Zi: Kill used to buy the tickets themselves and give them away to friends.

Tusk supported his rock-and-roll habit by working as a dishwasher at a *ramen* noodle restaurant. His long, frizzy hair tied in a ponytail, wearing a Yokohama Whales baseball cap backward, he fried dumplings and boiled noodles. "I hated having jobs. But I thought that was the only way I would ever get to play any music."

At sixteen, Tusk had dropped out of high school; Japan's exam hell wasn't for him. "I didn't want to become a salaryman," says Tusk, "I wanted to rock."

Spiky-haired Ken Metsudaira, twenty-three, Zi: Kill's guitar player and primary songwriter, worked at a video rental shop. "I detested it," he says of his day job. "But ever since I was small and watched the Bay City Rollers I knew I wanted to be a rock star. I was practically born with a guitar in my hand. I didn't mind paying to play, as long as I got to play."

"We started out exactly like thousands of other bands," Ken explains. "After a year in the live houses, we were so tight

it was like an explosion when we played. We were jamming every day, writing songs and doing covers and our playing was almost perfect. At that point, we were the tightest act on the live house scene."

The missing Ohta, who had managed a few minor acts as a salaried employee of Toshiba-EMI, was seeking talent for the new independent labels springing up in Japan in the early nineties. He first saw Zi: Kill at the live house called 7th Avenue where their blistering mix of power-pop originals and speed-metal covers of David Bowie songs like "Panic in Detroit" or "Suffragette City" made the rest of the acts sound like the amateurs they were. With Zi: Kill he sought the typical manager-talent relationship that would give the manager most of the power in deciding Zi: Kill's career and finances, while the group would in turn be paid a flat salary. The salary, ¥150,000 ($1,350) a month for each member, was guaranteed for the duration of the contract, even if the group never played live or recorded an album. Record and CD royalties and gate receipts, after the label, distributors, and promoters had taken their standard 90 percent cuts, would be divided equally between the act and management. Ohta controlled the group's finances, paying out the salaries each month as required but delaying royalty payments and concert fees. Like most managers in the Japanese pop music industry, Ohta in effect ran Zi: Kill.

Tusk hung up the telephone. He heard Ayako in the kitchen filling a pot with tap water to make tea. Tusk's apartment was a dark, tiny, six-tatami-mat room in the middle-class Mejiro section of Tokyo. The walls were plastered with old Warhol posters and a giant black-and-white poster of Tusk's idol, David Bowie, singing at the 9,000-seat Budokan Arena in Tokyo. The floors were strewn with CDs, Tusk's crepe-souled zebra-skinned creepers, a skirt, and a pair of Tusk's pegged black pants. The view from the apartment's one window was of another building's gray ferroconcrete wall, which was intermittently lit by the white neon flicker from the Ringer Hut noodle shop sign across the street.

As Ayako opened and slammed cabinet doors complaining that there wasn't any tea, Tusk thought of something Ohta, the manager-turned-snake, had ironically once told him: "You're a genius. You'll be playing the Budokan someday."

The first warbling to emanate from the rubble of bombed-out, postwar Japan that could be called pop music was *enka*, a stylistic hybrid combining the classical Japanese tones of instruments like the koto or samisen with more accessible and modern subject matter. *Enka* was Japan's first indigenous pop music and dominated the Japanese charts until the late fifties, when "group sounds" came in from England and the United States and inspired a generation of Japanese copycat bands seeking to bring a Western sensibility to Japanese pop. "The Japanese groups imitated, like car makers, whatever the Americans did," says early Japanese pop star Kunihiko Kase. "But the group sounds were important. They were our first real pop."

By mimicking the Beatles and the Beach Boys and adding Japanese lyrics, a few bands emerged as Japan's first music industry superstars. Kunihiko Kase and his group the Wild Ones sold millions of records during the sixties, as did the Spyders and the Tigers. They toured throughout Japan, playing to Japan's first generation to come of age in the postwar era. Concurrent with the "group sounds" was another Japanese copycat movement. In ancient history, back when Japan looked up to the USA and anything American still had a certain cachet in Japan, teen idols like Fabian or Pat Boone were embraced by Japan's youth as embodying the clean-cut and honest values that America supposedly represented. Japanese promoters, seeking to cash in on the popularity of idols, quickly launched thousands of Japanese teen idol acts who, combining bubble-gummy Western pop sounds with childish Japanese puppy-love lyrics, created a kind of vacuous pop known as "idol music." Among idoldom's biggest hits was Megumi Asaka's multiplatinum single, "Mebae," whose chorus refrains, "My boyfriend is a southpaw, my boyfriend is a southpaw." (Shonen Knife, a nov-

elty act and cult favorite in America, consciously parodies the Japanese idol scene with intentionally silly lyrics.) While the "group sound" evolved to become today's often innovative guitar rock and power-pop scenes, typified by groups like Zi: Kill, Japanese idol music plays to the lowest, squeaky-clean common denominator.

By the sixties the kids of Japan had discovered real rock and roll, and by the late seventies, the Japanese music industry had become the second largest in the world. In 1992, record, cassette, and compact disc sales in Japan totaled $3.4 billion. But when it comes to music, just as with automobiles, imported products no longer do well in Japan. While the Michael Jacksons, Madonnas, and Bon Jovis sell respectably, the number of units they move in Japan is not commensurate with their American sales. Foreign acts account for only 5 percent of the total Japanese music market.

Japanese teen idols still achieve epic success. Every year new ducktailed boys and ponytailed girls join the stream of Far East Fabians and Japanese Connie Francises topping the *OriCon* charts. Foisted upon music fans by the print media and ballyhooed by television variety shows, the *aidoru* (teen idol) has become more than a fixture on the charts. Hundreds of new idols, replicated and cloned from last year's equally fatuous models, appear and vanish within a few weeks of their highly publicized debuts. Hit products of 1992 were super-cute Kyoko Koizumi, with one million in sales of her last album, and equally cuddly bubble-gum rappers Smap.

Johnny Kitagawa, known in the business as "The Idol Maker," is a Japanese-American who grew up in Los Angeles and came to Japan with the occupying American Army after World War II. Johnny's taut, delicate skin, thick, silver hair, and vivid, sparkling eyes give him the appearance of an aging movie star rather than a music mogul. The only photograph adorning the walls of his multimillion-dollar condominium atop the Akasaka Tower in tony central Tokyo is one of himself seeming not out of place at the White House with Ronald and

Nancy Reagan. Johnny discovers and manages Japan's most popular idol groups. His roster has included the Four Leaves, Shonan Dai, Hikaru Genji, Smap, Tanokin Trio, and Ninja. These slender, prepubescent or adolescent boys have sold a combined forty million records.

"What I like to do is find a musical trend and then make a bubble-gum version of it. For instance, when rap became popular I made Smap. And for heavy metal we made Ninja," says Johnny. "Every time I rehearse an act, it becomes a hit. Check the charts. I choose the boys who have the good looks. I teach them to dance, to sing. My company writes the songs. We make the stars. That's my way."

Zi: Kill's Tusk condemns the idols and idol makers such as Johnny as "responsible for everything that is bland, boring, and fucked about rock and roll. If Zi: Kill had cut our hair short and been adorable, maybe we could have generated some interest from one of the idol managers, but that's not what we're about."

Like the members of American pop group Menudo, Johnny Kitagawa's boys are retired when they can no longer pass for teenagers. Johnny's standard contract calls for the idol to receive a salary and little more; Johnny retains the publishing and catalogue rights and owns the group's—and often even the idol's—name. The twilight of an idol's career can be tragic: adored and worshiped as a pimply teen, once his skin clears he finds his income has vanished and his fans have disappeared. Though a few idols go on to successful acting careers (Tahara Toshihiko, star of the hit television show "Kimpachi Sensei," got his start in Johnny Kitagawa's Tanokin Trio), most fade away without a trace.

"Idols are nothing but cute faces easily manipulated by idol makers like Johnny Kitagawa," says a concert promoter. "Idols rarely write their own music, nor devise their own images. They don't have the talent, the idol *makers* like Johnny are the ones with the talent."

Kita Koji, former member of Johnny's phenomenally successful idol group the Four Leaves, charges in his autobiography *Hikaru Genji* that when, at the age of twenty-eight, Johnny

dropped his contract, he was left without a yen despite the group's ¥4 billion ($36 million) sales.

But Koji's most serious allegations against Johnny involve not matters of economy but sodomy. Koji claims that when Johnny first took him on at the age of fifteen, he was regularly molested and sexually abused—or used—by Johnny and other young male idols in a dormitory Johnny provided for his budding young stars. "I was sixteen years old and experienced men before women," Koji recalls bitterly. "If I was homosexual or bisexual, I could put up with it. But I'm not and Johnny's caress was just like a living hell."

Koji presents Jo Toyokawa, another former idol, as a corroborating victim. "Do adult guys always do things like that?" he once asked Kita Koji about Johnny's nocturnal visits.

Are Kita Koji and Jo Toyokawa lying?

"I don't want to talk about that," Johnny replies. "Kita Koji takes drugs. I feel sorry for him. He was doing very well for years, and then he disappeared."

But are they lying?

"I love people," sighs Johnny. "So my boys and everyone who works with me love people. I don't do stuff, I don't even take medicine when I'm sick. I want to be a good example."

A record executive who has worked with Johnny for the past twenty years says the rumors about Johnny are true. "Johnny is that way. Look, these days, a kid thirteen or fourteen is not a boy anymore, so what's the big deal? This kind of stuff happens in this business because you get so close to the acts. You're on the road, with a kid all the time, eating, sleeping. The idol scene is an intense atmosphere. If these were thirteen- or fourteen-year-old *girls* then no one would be shocked."

"Put it this way," he says of Johnny, "I wouldn't let my son go to Johnny's company."

Though Johnny's alleged pedophiliac exploits are still occasionally reported in the media, in recent years he has become powerful enough to squelch most negative press. It was not always so. In the seventies, the press reported an idol's parents filing a deposition claiming that their son had been forced into

"indecent behavior by Johnny." The case was settled out of court.

"I feel sorry for those people," Johnny says of his accusers. "I hope they wake up and see I've been in the idol business for forty years and I couldn't have lasted this long if I wasn't a good example and an excellent manager."

"Fuck the idols," says Tusk. "Zi: Kill was never cute enough to be idols."

"They were always too hard-edged," agrees Masa Furuhata, a journalist covering rock and roll, "so Zi: Kill's options were more limited. They could never have gotten a management contract with an idol maker like Johnny Kitagawa."

Instead Zi: Kill was left to forage in the alternative music scene, where they did very well but were still a long way from big-yen and multi-platinum success.

By the time Ohta split with their money, the music press had finally discovered them. In the wake of extremely popular, power-pop/guitar rock acts such as X (the Japanese group, not the Los Angeles one) and Complexx, Zi: Kill had breakthrough potential.

The group moved from Yokohama to Tokyo, each member renting his own apartment. "We began living that rock-and-roll life," Tusk recalls. "I quit the ramen shop, started partying a lot. We had a little money so we went out to bars all the time. Lots of girls, that was the best thing about playing bigger places. The first time we toured—Nagoya, Osaka, Kyoto, Fukuoka—I changed from a guy who worked in a *ramen* shop and couldn't get laid, to suddenly being able to choose who I wanted."

Although they weren't getting rich, they were now professionals, exhibiting that on-the-make swagger that separates the genuine rock stars from the wannabes. Ken's and Tusk's childhood dream of playing Tokyo's Budokan was within their grasp.

"I saw Cheap Trick at Budokan," Ken says, "and Ozzy Osbourne and Loudness."

"People were saying we would be signed to a major label and then we would play the Budokan," Tusk recounts. "When

we were kids, we dreamed of shit like that. Everything in the dream was in place—girls, partying, the Budokan."

And then Ohta stole the money and Tusk woke up broke. After the meeting in a coffee shop that afternoon with the other members of the group and realizing there was virtually no way to recover the money, Tusk hit bottom. "The music biz," he decided, "is the last refuge of scumbags."

At the Sound Factory rehearsal studios, three A&R guys stood together near a table loaded with cold bottled oolong tea, mineral water, and iced coffee, smoking cigarettes and trying not to glance at each other. They were tanned and wore their hair in short, sharp waves that looked like pen squiggles. The word had already gone out: Zi: Kill was looking for new management.

Zi: Kill's bass player, Seichi, lazily slapped the bass line for the theme song to the popular "Woman Dream" television show on his Rickenbacker. Ken drank beer from a can as a Zi: Kill roadie tuned Ken's custom-made guitar. The drummer was on the phone with his girlfriend.

This was the first rehearsal since Ohta's disappearance. The future of the band, which just two weeks ago had seemed so full of promise, was now in doubt. Despite the fact that Ken had chosen it, Ohta, wherever he was, still owned legal rights to the name Zi: Kill. In Japan, where confrontation must be avoided at all costs, managers and labels were reluctant to get involved with a litigious act, even if the group wasn't at fault.

"At that point Zi: Kill had a bad reputation," says a reporter for *Asahi Entertainment* magazine. "The management situation was murky. They definitely had a following on the live house circuit and *Close Dance* (the second album) had some chart action, but there were rumors that they were fighting and were going to break up. Tusk was supposed to be out of control."

Tusk had gone on a drinking and womanizing spree that only ended when he was woken by an attendant at a pay-by-the-hour love hotel in the seedy Ikebukuro section of Tokyo.

The two hours he had prepaid were up. He was told to hit the pavement. The woman he had gone to bed with, an aerobics instructor in her late twenties, was gone. Tusk hurriedly apologized to the attendant, pulled on his pants, slipped on his zebra-skin creepers, and rushed to rehearsal.

Ken had also let himself go, staying in his Shibuya apartment all day, guzzling Shochu grain wine and experimenting with his ESP-MAZ guitars and a Quadriverb digital effects unit while standing around in a dirty kimono. Most of the noise, his girlfriend Mamiko recalls, didn't sound like music.

The band's rents were late because the salaries hadn't been paid. Seichi was threatening to start selling equipment, while the Sound Factory, their rehearsal space, was insisting they keep their equipment on premises until clearing their tab of overdue studio fees.

When Tusk arrived at the Sound Factory that afternoon with a bad headache and no money in his pocket, he had to face the immediate prospect of auditioning for the three A&R guys. His long black hair hung in frizzy strands over his pale, slender face. He rubbed his buffalo-colored eyes.

"Who said they could come?" Tusk whispered to Seichi.

Seichi recoiled from Tusk's breath. He slipped the bass strap over his head. "Ken did."

"We're not ready to audition again." Tusk took a bottle of oolong tea and twisted it open. "Where the fuck is Ken?"

Ken came back from the toilet holding a beer and bowed to two of the A&R guys.

Tusk motioned him over. "I'm not auditioning. Not today."

"Your breath stinks." Ken waved a hand in front of his face. "Rehearsing is rehearsing. So they watch us, so what?"

"No."

Ken finished his beer and set it down on an unused mixing board. "It's my band," he said quietly, "and I say we rehearse."

"Fuck you," Tusk hissed.

"You're fired."

For a moment he thought about it: a solo career. Singing

with a new band, his own band. Tusk and the . . . Suffragettes, after his favorite Bowie song.

But then the chances of getting a management deal, the dream of headlining the Budokan—all that would have to be shelved.

"Fuck it," Tusk said, shrugging off his black overcoat, "we'll do the B-song list."

About halfway into their set, as Ken was playing despite a broken string and extracting a critical mass of distortion from his amp, and Tusk, barely audible over the underpowered P.A. system, wailed the lyrics to "Hysteric" ("She's gone insane, the call came in now. You mean I'll marry a girl like that?") the A&R guys excused themselves one by one. They all had phony appointments and imaginary meetings that couldn't be missed.

Tusk stood with his arms folded over the microphone stand and waited out Ken's ponderous guitar solo. Seichi slouched toward his amplifier, listening to himself play.

"She's so hysteric. She's so hysteric," Tusk shouted the chorus into the mike.

When Ken's solo finally climaxed with a high-pitched noise like a monkey orgasm, he turned to the group and apologized.

Michiko, a girl with long, dyed red hair, pouty lips, and skin pale as plaster, who never gave her age but could always pass for sixteen, immediately pronounced the group as, "totally off. I've been with Zi: Kill for a long time, about two months. I first met Tusk, but now I'm friends with Seichi and today is the worst I've ever seen them play."

"We've been worse," Tusk later insisted, "the first time we toured, when we had just begun using fire pots and smoke for the stage show, we had streams of sparks shooting down at the band during 'Hysteric.' And before gigs I usually spray anything I can get my hands on into my hair—gel, mousse, hair spray. I build a pyramid of hair. I really like the Auslese brand super-hard gel, that stuff has hold. So I told the makeup girl to put about half a tube in my hair, and what I didn't know was that it was highly flammable, alcohol in the mix or something.

During 'Hysteric,' right when the second chorus begins and the sparks start shooting off, a spark goes into my hair and it catches fire. At first it's smoldering and then it goes up in flames."

Zi: Kill's loyal roadies had to spray him with a fire extinguisher. Tusk lost half his hair and vomited from carbon-dioxide inhalation.

"The crowd went crazy," Ken recalled. "They didn't know what it was, they thought it was part of the show. I heard about that guy in Metallica who got burned up badly. It could have happened to Tusk. Rock and roll is dangerous."

"Rock and roll is man's sport," Tusk agreed, fingering his hair, which had only just grown back. "We had to learn to survive. We're no idols—like we always say, fuck the idols."

For those lacking the dimples and billion-yen smiles that the idol-making machinery requires, the route to the top goes through the tube. You cannot meet anyone in the Japanese music industry without hearing the term "TV tie-up." A TV tie-up means that an act has agreed to write a theme song for a television drama, preferably a TV Asahi (one of Japan's leading networks) drama such as "Tokyo Love Story." Or the act has inked a deal to do the jingle for a major commercial campaign by a corporation such as Sony or Pocari Sweat. At any given moment, at least half the acts in the *OriCon* top ten got there through theme songs or commercials. (In the December 14, 1992, chart, for example, 7 of the top 10 singles were TV tie-ups, including the number one hit "Christmas Carol *No Koro Ni Wa*" by Junichi Inagaki, from the television show "Home Work.") The power of a TV tie-up reflects the insatiable Japanese appetite for television: the average Japanese watches nearly an hour more per day than his or her American counterpart. Many foreign artists are shut out of big Japanese sales because they don't have major TV tie-ups. According to some experts, even Michael Jackson's popularity in Japan is attributable solely to his former tie-up with Pepsi.

"TV tie-up is everything," says a spokesman for the Amuse talent management company. "With records, you have the

labels taking ninety percent, or maybe, if you've got a super-star, you can get them down to eighty percent. But with TV fees, management and the talent split the fee—no cut for the label." Keisuke Kuwata, an idol managed by the Amuse Agency, earned nearly three million dollars from TV tie-ups alone last year.

And how does one get a TV tie-up?

"You have to be famous," the spokesman explains, which presents a Catch-22 for young groups: If you want to be famous, you need a TV tie-up, but to get a TV tie-up, you have to be famous.

Koki Mura, managing director of Tokuma Japan Communications, one of Japan's biggest labels, believes TV tie-ups are bad for the industry. "We have a situation where radio means virtually nothing. The only way to make a hit is to tie in with prime time or do a commercial. Most of the Hot 100 are tied in with commercials. The television producers and commercial production companies may be the most powerful people in the industry and they like the same old faces and the same old acts. It is very hard for new groups to break into TV tie-ups."

One way is the old payola. Television and commercial producers are paid to use an act. "The payoff," says Koki Mura, "is almost standard."

The second best way to hit the Hot 100?

"Get your song on a karaoke machine," Mura says. "Get on a machine and you've got a hit."

And how does an act get on a karaoke machine?

"You pay."

At its worst, the Japanese music industry resembles the American music industry of the fifties with its generally accepted practice of payola and its reliance on bland, safe, manufactured idols to sell albums—or the American industry of the seventies that sold millions of "Laverne and Shirley" and "Welcome Back Kotter" theme song singles.

Until recently, the Japanese consumer had little choice but to passively accept the schlock being pushed or else buy music from the imported section of the CD shop. However, with the

recent development of a vibrant independent record company scene in Japan, comparable to the American alternative music scene that launched acts such as Nirvana or the Spin Doctors, the Japanese music industry shows signs of opening up. The rock group X, for example, has reached the million mark in album sales twice and has even headlined the Tokyo Dome, a 40,000-seat baseball stadium previously played only by the likes of Michael Jackson, the Rolling Stones, and Chiage & Aska—a Japanese duo with phenomenal TV tie-ups. (One of the mysteries of the Japanese music industry is that foreign acts tour much better than they sell.) Though they have since signed with Toshiba-EMI, X proved that an act could reach superstar proportions as an independent.

Pop success in Japan, for non-idol acts, is a five-step program: (1) live houses, (2) management contract, (3) independent record deal, and, if the independent release sells well or gets some attention, (4) major label deal. If the label likes the group it will pay off the appropriate television producers, karaoke machine manufacturers, and commercial production companies. Thus the group will achieve the pinnacle and last step of Japanese pop music success, (5) the TV tie-up.

What does this do to the music?

"The music suffers," managing director Mura regrets. "How good can the songs be when you try to fit the lyrics in with the plot of a TV show?"

When Zi: Kill is focused, it is one of the most talented, hard-driving acts in Japanese pop, and now they had nothing to do but focus on their music. Zi: Kill's music, at its best, is a cross between the Kinks and Metallica, with plenty of Ken's state-of-the-art guitar pyrotechnics thrown in. The songs are short, sharp, precise, power-pop numbers, like the Kinks with more edge or early Iggy Pop with great production. (Think of the Kinks's "Father Christmas" at 78 rpm with Eddie Van Halen on guitar and you get the idea.) When tight, Zi: Kill is all controlled rage and anger but with a childish exuberance. Too threatening to be idols, Zi: Kill is not so threatening as to be

without mainstream appeal. Put it this way, there aren't any tattoos.

"We were interested in Zi: Kill," says Tatsuru Takahashi of Zoom Republic Network, a talent management company that is a subsidiary of the Tokuma entertainment conglomerate, "but so were a lot of other companies. When they first had management problems, a few guys went to see them and came back saying they were a mess. But by the time I got down to the Sound Factory, they were tight. And they had worked out a few new songs. It seemed like they were over the problems."

The group, since the dark days after Ohta's disappearance, had pulled together. "Ken really took over," Seichi says. "He was like a samurai. 'Do this, don't do this. Play F, B-flat, F. Faster. Slower.' All I had to do was listen to him. And Tusk just shut up and did whatever he was told."

For Tusk the period was a musical rebirth. "I realized I didn't have much of a chance without Zi: Kill and Ken," he admits. "Being kicked out of the love hotel was the bottom for me; I mean, not only did I dream of playing the Budokan, I also had to meet a better class of women."

In April and May of 1993 the group was working on a dozen new tunes, a few of which, according to Takahashi Tatsuro of Zoom, had great pop potential—possibly, dare anyone say it?—TV tie-up potential.

"They have this catchy, hard rock sound," Takahashi explains. "Not a thrash sound you can't sell to TV. We signed them because we felt the act had potential, and they were a proven concert draw."

Zi: Kill was back on a monthly salary, ¥300,000 ($2,700) per member.

"I'll be honest with you. With Zi: Kill's talent, we're thinking they could write a TV commercial," says manager Takahashi. "They're that good."

As part of the agreement, they had to drop all charges against their former manager, Ohta, who has since returned to the talent management business.

* * *

Backstage at the sold-out 9,000-seat Budokan, Tusk and Ken sit with towels around their necks. Ken, his bushy eyebrows bristling with sweat, holds a bottle of Fuji mineral water as he waits for a roadie to change a string on his ES-335 guitar. The band has just left the stage after playing an hour and a half show that concluded a sold-out eight-city tour.

That the Budokan show sold out was no surprise, considering that Zi: Kill's latest album, *In the Hole,* had reached number 7 on the *OriCon* charts—without a TV tie-up.

Tusk's sweaty skin glistens in the white fluorescent light as he opens a can of Sapporo beer. Seichi wraps some athletic tape around his thumb. Ken lights a cigarette.

A few girls are in the room: short leather skirts, thick gold chains, high heels. Some of the girls, like Ken's girlfriend, Mamiko, came with the band. And there are a few groupies who have begun showing up at all of Zi: Kill's concerts lately.

Tusk smiles, his thin lips curling up as if he's snarling. The crowd out in the darkened arena shouts, claps, stamps the floor, and holds up cigarette lighters in tribute. Potential TV tie-ups and hung-over afternoons in dirty-sheet love hotels and even Ohta and his stolen millions suddenly seem unimportant.

"This is the dream," Tusk says, shaking his head to the applause and cheering.

Ken nods. "Bu-do-kan," he enunciates slowly.

A walkie-talkie crackles and a voice announces that the equipment is in place for the group's encore, the top-ten single "In the Hole," and manager Takahashi claps his hands together and shouts, "Let's go."

When Tusk hits the stage, his black hair wilting slightly but still shining under the harsh stage lights, he stands for a second, soaking up the noise, cheers, and shrieks.

Ken's guitar emits a high-pitched screech.

Tusk grabs the cordless mike and shouts: "Fuck the idols."

The crowd calls out for more.

IX

OZAKI

THE TRUE
BELIEVER

Yokichi Ozaki, twenty-four, sat in the tree-shaded picnic area of a concession stand at the entrance to Tokyo's Yasukuni Shrine, a memorial to Japanese who have fallen in battle. Next to him was a rice-paper-wrapped gift box of *wasabi-zuke* (hot raddish paste). He smoked an imported Davidoff cigar and watched a fleet of thirty privately owned armored sound trucks jockeying for parking spaces along the gravel road leading to the shrine's gate. The trucks' sides were festooned with Rising Sun banners and painted slogans demanding THE LIBERATION OF THE NORTH-ERN TERRITORIES, LOVE THE COUNTRY, and, simply, THE EMPEROR IS DIVINE. In the trucks' cabs, powerful Unitech and Aiwa sound systems were loaded with cassettes so that as the trucks made their way around Tokyo later that morning, they could blare martial music and nationalist screeds through roof-mounted speakers at ear-splitting volume.

A column of blue-uniformed men four abreast and seventy deep marched between the stationary trucks, boots crunching the macadam at uneven intervals. Some of the men marched with great precision and bearing, their uniforms impeccable and their steps crisp. Others had uniforms a few sizes too large and marched with an exaggerated attentiveness—like children playing at being soldiers. A few had dropped ranks altogether, ordered ice cream cones from the concession window, and now sat near Ozaki's picnic table eating and smoking. Around the men there hovered the smell of alcohol-saturated effluvia; they had already been drinking.

The ragtag parade was making its way to the shrine's altar, where the men would pay tribute before a day of cruising around Tokyo and disturbing the work force with their 1,000-watt, fascist slogans. Tokyo is notorious for its noise pollution; everyone, from fax-machine salespeople to fanatical rightists, exploits the aural smog as an advertising medium.

A trio of policemen stood in a small circle at the entrance to the shrine. They wore track suits and radio earplugs, wires running down their necks and under the collars of the polyester pullovers.

Ozaki didn't like what he saw. This group of middle-aged drunks, part of the All Japan Patriotic League, an ultranationalist umbrella organization with some 30,000 members headed by seventy-three-year-old fascist Rikio Kubota, was not going to change Japan or the world. They were soft. They were fat. They were slow. They were stupid. They were under police surveillance. In other words, Ozaki didn't want anything to do with them.

Ozaki had a small, shaved head and sharp pointed features, including a long, arching beak nose rare among Japanese. Sitting by himself at the concrete table, wearing shades against the dawn's light and smoking his thin, imported cigars—one of the few imported products Ozaki liked—Ozaki ignored the uniformed, middle-aged, rank-and-file rightists who sat around eating ice cream cones, nursing hangovers, or staring blankly at a bronze relief of the Battle of Port Arthur on one side of a stone column. He was here for a meeting with Noburo Isoyuki, a powerful lieutenant of the far right. (In fact, Noburo was a lieutenant in name only; he had long ago taken over the day-to-day operations of the All Japan Patriotic League, leaving Kubota, the elder patriarch, to formulate ideology and policy.)

Ozaki wore a Matsuda suit with Issey Miyake shoes. (He wore only Japanese designer suits.) He checked his Seiko watch and put out his cigar. They shouldn't keep him waiting like this, even if he was the younger man. It was rude and unprofessional. Punctuality, after all, was one of the traits that made Japanese great. And punctuality was also of utmost importance to all men of action. (Hadn't Mussolini made the trains run on time?) But these specimens, the drunken, ice cream–eating fatsos now sitting at the benches around him, were not men of action. He had doubts the man he waited to see, Noburo Isuyuki, was a man of action, considering he presided over this rabble and this rabble couldn't even get to the shrine in order, much less recapture the Northern Territories.

A dark blue Mercedes limousine pulled onto the gravel drive and slowed next to the column of sound trucks. A power

window lowered and Noburo's sunglassed face could be discerned as he greeted the sound truck drivers, who jumped from their seats startled and bowed back to their *sensei*. The car came to a stop across the street from where Ozaki sat. Noburo's chauffeur, a giant of a Japanese man with a round, wide-eyed, childlike face hurriedly stepped from the car and opened Noburo-sensei's door. The men sitting around Ozaki stood up and bowed as Noburo walked across the street, his wooden *geta* sandals making his walk appear tentative, as though he were wading a stream. Over his sandals he wore a generously cut Western-style suit. Noburo did a half-bow back to his men and then bowed a little deeper to Ozaki, who stood and crisply, deeply, bowed back. The chauffeur, who had been walking alongside Noburo, broke away from him and went to the concession window.

"Kubota-sensei will be glad you came," Noburo told Ozaki after he had taken a seat on the bench opposite him.

"I came because of him," Ozaki said. He presented Noburo with the gift-wrapped box and sat down again. It was true: if it weren't for the high regard in which he held the elderly Kubota, he would never have bothered with this meeting.

"I'll tell him." Noburo fished around in one of his jacket pockets for a moment and came up with a silver cigarette case that he popped open and held out to Ozaki. Ozaki declined and extended a lighter for Noburo. Noburo's face was tan and fleshy with a thick, flat nose that had a trace of gray hair coming from the nostrils. As Noburo inhaled, the nostrils indented a little.

"Your organization has been doing very good things," Noburo said as he exhaled. "We have been hearing good things—well, it's obvious. You have been doing good things and you are now an important and integral element in the movement. We—Kubota-sensei and others—wish you would work with us, together, as part of the family. Japan is, as you know, a family—"

"Yes," Ozaki said.

"And as such a family, we should all be together. We have,

after all, the same beliefs, the same values, the same samurai spirit—"

The chauffeur returned and when Ozaki saw him up close he understood why the chauffeur had seemed childlike. He was retarded. Ozaki saw it in his eyes, which were nearly crossed as he licked his ice cream, in the intent expression of his face as he concentrated on lapping up his ice cream before it melted and ran down the cone.

"Take this to the car," Noburo said to his chauffeur, holding up the gift box Ozaki had presented him with. "And stay there."

As the retarded boy took the box, Ozaki marveled at his size; his hand nearly covered the top of the box, which was capacious enough to contain four one-pint cans of *wasabi*. He was a giant, over two meters, and thickly built. Ozaki wondered if he was fast or coordinated, but that would hardly matter—no one could take this fellow down without a firearm, sword, or bow.

Noburo continued. "Your people are organized, they stay in line, they follow orders, they present a sharp image. We like that."

"Thank you." Ozaki nodded.

"We're asking you for a few favors. Small favors. Things we need done that we can't do ourselves." He nodded to the huddle of policemen. "These are tasks you could perform. It would be admirable."

"I'll think about it," Ozaki said. He stood up and brushed some imaginary dust from his trousers. "Tell Mr. Kubota he has all my respect and best wishes."

When he walked away, he saw the retarded boy again, only this time the boy seemed to be staring wide-eyed at him from beneath his blunt, inverted-bowl-shaped haircut. His head turned to follow Ozaki as he walked.

Ozaki listened as one of the trucks, probably to test the sound system, played the Kimigayo, Japan's national anthem, at earsplitting volume so that the high notes on the koto sounded like a train horn. Then the music abruptly stopped when the truck started its engine and the driver forgot to put the tape back on.

* * *

According to the National Police Agency, there are about 840 right-wing groups with a total of 120,000 to 150,000 members in Japan. The most visible components of these groups are the sound trucks. While the *uyoku* (far right) occasionally promote one of their own for office (rightist leader Akao Bin was a perennial candidate for the Diet until his death in 1990), for the most part they function more covertly in the political system, both as behind-the-scenes pressure groups and as the political arm of the Yakuza.

In their first capacity, the *uyoku* serve to gut-check mainstream conservative politicians and bureaucrats who, though reluctant to appear as ultranationalists, promote a reactionary and conservative agenda. Asao Mihara, Sokuichiro Tamaki, and former prime minister Yasuhiro Nakasone all favor strengthening the military and revising the constitution. (The so-called PKO bill, which allows Japanese troops to participate in United Nations–sanctioned actions, was actually opposed by many rightists, who believe Japanese troops should not serve as part of any international operations but should act unilaterally.) Nakasone's controversial 1985 official visit to the Yasukuni Shrine, where some war criminals are buried, was a bone thrown to the militarist far right. Other government policies also seem geared to placate ultranationalists; for example, the use of taxpayer money to sponsor the religious *daijosai,* the Shintoist Imperial Ascension ceremony, and the royal wedding of Crown Prince Naruhito and Masako Owada, and the rewriting of textbooks to exonerate Japan from World War II atrocities.

Mainstream politicians heed the *uyoku* because of the immense wealth and influence of several avowed rightists who, though careful to avoid publicizing direct links with the *uyoku,* have expressed identical views. Prominent ultranationalists Yoshio Kodama and Ryoichi Sasakawa, who once proclaimed, "I am the world's richest fascist," both have been kingmakers in Japanese politics. And since, until 1994, there was no law limiting the size of campaign contributions, politicians are well aware of the influence wielded by men like multibillionaire Sasakawa.

In addition to the financial carrot, there is a potentially lethal stick for those who offend the ultranationalists. In 1989, the right-wing Seiki-Juku, or Common-Sense Party, tried to assassinate Mayor Hitoshi Motoshima of Nagasaki in retaliation for his saying that Emperor Hirohito bore "some responsibility" for World War II. Since recovering from a bullet in the back, Motoshima has been ousted from the Liberal Democratic Party and is now fighting for his political career. Mainstream politicians shun him and seek thus to drive him from office; his political opponents have exploited his severed links with the party, claiming he will be unable to obtain federal financing for building projects. Not a single politician rallied to Motoshima's defense after he was shot.

The standard *uyoku* response to charges that they seek to curtail freedom of speech runs along the lines of this statement by Toyohisa Eto, chair of the All-Japan Youth Federation: "Freedom of speech is a good thing, but people like Mayor Motoshima must not abuse that privilege."

As political organizations, the *uyoku* are exempt from corporate taxes. That exemption encourages criminal Yakuza groups to seek tax shelters by calling themselves political parties, and invariably their political views are ultranationalist. The links between the *uyoku* and Yakuza can be traced to the nineteenth century, when early ultranationalist groups such as the Dark Ocean Society used Yakuza thugs to steal elections and threaten politicians. Today, the rank-and-file *uyoku* who ride the sound trucks are also frequently employed as strike-breakers and in the construction industry, both mob-controlled rackets.

During the late eighties and early nineties, ultranationalist leaders, caught up in the frenzy of the bubble economy and a need for more money to finance their operations, increasingly worked with criminal gangs in extortion rings. Typically, a Yakuza gang and *uyoku* group targeted a cash-rich politician, bureaucrat, or corporation by bombarding the residence, ministry, or corporate headquarters with earsplitting rightist screeds and embarrassing, though sometimes true, allegations. Then the

Yakuza stepped in, offering the politician or corporate chief a mediation service that eliminated the rightist scourge but cost anywhere from $50,000 to $5 million (for the politician with some clout the cost could be a few political favors; for a corporate head the trade-off might be for some insider information). The take was then split between the Yakuza and *uyoku* group. This scam was worked to perfection by Susumu Ishii, former head of the criminal group Inagawa-kai, and the *uyoku* Nippon Kominto group during Noboru Takeshita's run for prime minister in 1988. Yukio Hori, author of *The Right Wing in Postwar Japan*, asserts, "Nearly every major corporation is extorted from by the *uyoku*."

Yokichi Ozaki frowned upon this kind of money-for-favors right-wing activity. The *uyoku*, he felt, had been subverted by a few men who were getting rich by discarding the honor and nobility of the movement. Ozaki often quoted his hero Tsunetomo Yamamoto, the eighteenth-century author of *The Way of the Samurai*: "It is a wretched thing that the young men of today are so contriving and so proud of their material possessions. Men with contriving hearts are lacking in duty. Lacking in duty they will have no self-respect."

Ozaki adheres to the standard rightist views: the emperor should be restored to prewar status; Russia should return the Kuril Islands; communism must be fought at all costs; Article 9 of the Japanese constitution, limiting the military to self-defense, should be abolished (in fact, he believes the constitution should be scrapped altogether). He also insists that the Japanese are "a pure nation, homogeneous, and should not mix with other peoples."

"We are a family," Ozaki explains. "That is why it does not make sense to have a constitution protecting personal liberties. Like any family, there must be a balance between freedom and obedience. When this balance is disrupted, there will be conflict."

"Intermarriage is detrimental because Japanese people are the best people in the world," says Ozaki, "Intermarriage is one

of the first steps in the breakdown of the Japanese family, a family in which the emperor is to rule like a stern father. Japanese people are superior in their souls, in their intellect, and in their toughness."

Ozaki divides intermarriage with different races into a hierarchy of categories: "Marriage with Chinese or Koreans is more desirable than with other Asians. And marriage with other Asians is still better than marriage with Westerners. At least it should stay Asian. Western people should not intermarry with Japanese—that will taint the purity." Other races, apparently, are not ranked.

"Japanese people are unique," Ozaki declares. "If you go to Kyoto, and go through the temples, you hear the footsteps, the rustle of the wind, the smell of the incense and fresh cedar wood, these things can only be appreciated by Japanese people."

Ozaki's organization, Seikokai, the Society for Purity and Justice, is a group of ten hard-core rightists between the ages of sixteen and twenty-five passionately devoted to restoring the emperor to his divine status, raising Japan to great power status and to martial arts, particularly *kendo* (swordsmanship) and *kyudo* (archery). Their zeal borders on fanaticism and, at times, crosses the line to outright terrorism. Ozaki admits his group has resorted to kidnapping, extortion, and assault to achieve its goals and to raise money for what he considers good causes: right-wing pamphleteering, civil disturbances protesting the visits of Russian diplomats, and legal defense funds for men accused of political assassination attempts or attacking corrupt or leftist politicians' campaign headquarters. "We are not getting rich," Ozaki is quick to point out.

Few of Ozaki's crimes are ever reported to police because victims fear Seikokai's reputation for harsh retribution. Ozaki and his organization are known in *uyoku* circles as true believers who do not mix money and politics and will not participate in a protest or sound-truck operation solely for profit. Ozaki and his boys are pure fascists, real men of action, unlike the drunken bums he had seen at Yasukuni Shrine that morning.

"The movement loses its vitality and effectiveness when our muscle is rented out to the highest bidder," says Ozaki of the many *uyoku* who make their living by working extortion scams with the Yakuza. "I know we need money. I know the various faction leaders always need to pay their cadres. I have to confront those realities myself. But what's going on now is that we are losing sight of our goals, the movement is shifting from being a political one to a financial one. The movement is mirroring Japanese society as a whole, which values money above honor, nobility, and purity. The movement's only strength is in its discipline. Nonpolitical crime is a contradiction and has no place in the movement."

As Ozaki rode in a taxi back to Tokyo Station, he already knew that he wanted nothing to do with the offer Noburo had made that morning at the shrine. Noburo's motives weren't pure—they never were. He was using the movement to get rich just like the rest of the compromising faction leaders. He already had acquired, Ozaki noted, a house in Sendai where his wife and children stayed, another in Tokyo, and numerous cars, including the Benz 500 in which he had arrived at the shrine. (He also, Ozaki had discovered, kept several mistresses around town.) All of Noburo's numerous perquisites were financed by *uyoku* extortion. Ozaki wondered if Rikio Kubota was even aware of Noburo's mistresses and other excesses. The old man would never put up with that kind of impurity. But Kubota was an old man—a true believer, certainly, but old and unable to monitor his whole organization.

As the cab rolled up on the redbrick facade of Tokyo Station, Ozaki recalled with disgust all the impurities he had witnessed that morning—at Yasukuni Shrine, no less, the resting place of some of Japan's greatest war heroes. The band of overweight rightists breaking ranks to order ice cream, the disordered lines of trucks, and the retarded boy who chauffeured Noburo. That was the greatest impurity. That a boy whose appearance betrayed his own stupidity and inferiority should drive one of the most powerful men in the movement was an insult to

Ozaki's sensibilities. And Noburo, in the midst of this squalid display, had the audacity to ask Ozaki to cooperate with him on what would certainly be an extortion operation.

In the open-air station, as he waited on Platform 8 for the southbound Tokaido line with the rest of the late-morning rush-hour crowd, he resented Noburo's imperiousness. An 8:15 meeting had required Ozaki to take the first train of the day up from Chigasaki. But for the old man's sake, for Kubota's sake, Ozaki had come.

It was the old man who had taken Ozaki into the movement when he had graduated from Waseda University. Ozaki had never liked college—the dirty dormitories inhabited by leftists and liberals had bothered him and struck him as being utterly un-Japanese. The professors, those who expressed any political views at all, were liberals and former Communists, many of them participants in the campus unrest that rocked Japan in the sixties. Ozaki had not found a single professor who shared his extreme nationalist ideology, which was a combination of martial discipline and overt ultranationalism. Ozaki's only joy during college was the *kendo* club, where he excelled as a swordsman. There, while his ideological bent wasn't shared by his coaches, it was tolerated and even encouraged as long as it made him better with the sword. And it was through the *kendo* club that he began attending seminars on Tsunetomo Yamamoto's *The Way of the Samurai* and on seventeenth-century nationalist Yamaga Soga where, for the first time, he heard the elder *uyoku* patriarch Rikio Kubota speak. Ozaki was enraptured by the simple, clear, straightforward opinions expressed by Kubota and began to hang around with the All Japan Patriotic League and even to ride in the sound trucks as they blasted Tokyo out of its torpor. It had seemed a noble calling then, one that even Tsunetomo Yamamoto or Yamaga Sogo would have approved of, and a necessary calling as he saw the Japanese around him sinking into an impure morale morass that was defeatist and of foreign provenance. Ozaki, while he had never been poor, was the child of a factory worker father

who was widowed when Ozaki was six. He was raised by his father's unmarried sister, who encouraged Ozaki to study—he had always been diligent—and otherwise left him to do whatever he wanted in the dingy back alleys of Chigasaki, a beach town eighty miles south of Tokyo.

Waiting at the station for Ozaki was his sergeant at arms, Jiro, who wore narrow, rectangular sunglasses and read a *Shonen Jump* comic book. While Ozaki was the president of the Society, Jiro was its best swordsman—he was a tremendous athlete who excelled as a surfer as well as at the martial disciplines. Jiro was Ozaki's right hand; he was bigger, stronger, and faster than Ozaki, and with his leathery tanned skin and short, blunt-cut hair, he looked like a warrior. Ozaki, despite his fanatical devotion to *kendo,* was less of a swordsman than Jiro. Ozaki could take a thousand practice strokes a day for two years while Jiro frolicked in the water on his surfboard and he would still not reach Jiro's level of competence with the sword. Frustrated, he still marveled at Jiro's ability and admired his easy confidence and humility. In *The Way of the Samurai* it was written that at the highest levels of study a man has the look of knowing nothing. Jiro had that look.

"Well?" Jiro asked.

Ozaki laid it all out for him: Noburo's request, the drunken columns of men, the retarded boy. Ozaki related that he had already decided to reject Noburo, despite his loyalty to the old man who was his nominal boss. He noticed the surfboard jutting from the back of the jeep and the wet suits in a heap next to Jiro's and Ozaki's *kendo* bags on the backseat.

"You were already in the water?" Ozaki asked.

"Big swell," Jiro explained. "Coming in from the south. And it'll be better tomorrow."

Ozaki hadn't been surfing since he had gone away to college. He gave it up when he became serious about *kendo.* He felt he could not devote himself to the nation, swordsmanship, *and* surfing. Jiro saw no such contradictions and blended a professed

love of country, the sword, and surfing (and baseball, soccer, and windsurfing, for that matter) without any doubts about the propriety of such a mix. As long as Jiro showed no signs of fatigue during morning *kendo* training sessions, there was nothing Ozaki could say about his surfing before the workouts.

They drove through Chigasaki away from the ocean, the sweaty smell of the *kendo* gear filling the jeep.

Chigasaki is divided into two distinct areas: Oceanside and Cityside. Oceanside, for obvious reasons, is the more expensive neighborhood and also the site of the town's few designer boutiques and pricey restaurants. The boardwalk along Shonan Beach extends from Chigasaki all the way up to Enoshima and other Tokyo resorts and is an extension of those popular summer haunts. Chigasaki kids spend much of their youth on the beach—Jiro and Ozaki did—and the quality and pace of life there is far removed from Tokyo's hectic bustle. Chigasaki is a beach town with all the connotations that implies: tanned girls in bikinis, boys in wet suits, kids on skateboards, and hazy, briny morning fog. Oceanside is the heart of the local surfing scene with six surf shops; it even hosts one major contest a year.

Cityside is Chigasaki's working-class neighborhood where Oceanside's resort employees can rent modest apartments and still be within walking or biking distance of the sea. Ozaki grew up in Cityside, about twenty minutes from the beach by bicycle. But it was on the beach that he became friends with Jiro, whose family was from Oceanside and ran several sporting goods shops and two surf shops. (Jiro's older brothers were legendary as the area's hottest surfers; they made frequent trips to Bali, Australia, and Hawaii and were rarities in Japan in that they were genuine big-wave surfers.) Ozaki and Jiro had been close since sixth grade. Ozaki had always been the more aggressive of the two, although Jiro seemed to pull off effortlessly the bottom turns and cutbacks that Ozaki executed only with strength and concentration.

And though Ozaki had taken up *kendo* first, Jiro, once he came to it, took to the sport quickly, reaching the lofty fifth *dan* rank in half the time it would take Ozaki.

Jiro pulled into the dirt parking lot next to the *kendo dojo* (club). The club was housed in an old, converted warehouse to which had been added a hastily constructed, traditional facade of paper screen doors and wooden lintels. Over the entrance hung the *kanban* with the club's name. Ozaki admired the club's austere decor. The club, Chigasaki's most rigorous and conservative, was known for its approach to *kendo* as combat rather than sport. The club scored well in intra-prefecture competitions, especially in exercise sections, but rarely won the competitions outright due to what was believed to be excessive nervousness on the part of the club's swordsmen. (Jiro had won the demonstration section two years running.)

After Jiro and Ozaki had changed into *hakama* (divided skirt), *keikogi* (jacket), lacquered breastplates, and wire helmets that resembled chrome catcher's masks, they took their practice strokes in the main hall. As Jiro took his cuts, stepping forward and bringing the wooden practice sword down to the exact same point with each blow, Ozaki watched him. Glimpses of tanned thigh were visible for a moment through the side of Jiro's pleated skirt. As Jiro brought the sword down, the heavy fabric shifted and reminded Ozaki that Jiro was flesh and blood beneath all that protective gear. Jiro, at the end of each stroke, would be motionless, ready to parry or exploit a gap, to bring the sword up or forward. Perfect form, the body still resonating with the movement just completed, yet still a blank, the void of motionlessness between movements.

"Like the string of the bow after the arrow is released," Ozaki said.

"What?" Jiro said, suddenly losing that perfect form as he turned to listen to Ozaki.

Ozaki, suddenly embarrassed, quickly resumed his practice strokes, displaying sloppy, undisciplined form.

The Seikokai met in an abandoned factory adjacent to a warehouse owned by Jiro's parents. Years ago, before the recession, workers in this factory stenciled resort names onto inflatable rubber rafts. The paint sprayers and silk-screen machinery

had all been removed and sold so that the only vestiges were bolts protruding from the concrete floor and a few deflated raft carcasses piled in a corner. The factory was about the size of a three-car garage and had low ceilings from which dangled wires left behind from long-ago-removed light fixtures. The only live cable in the building was strung unbeknownst to Jiro's parents from their warehouse. The room was lit only by a desk lamp in the corner that left much of the room in shadow. Ozaki preferred meeting in restaurants—the Denny's up the coast near Fujisawa was perfect—but occasionally he liked to congregate in the factory. This place had more lore, hinted at illicitness and secrecy, and was therefore useful when rallying the Society or explaining strategy.

As the members filed in, some in the green jumpsuits that were the Society's casual uniform and others in street clothes, Ozaki stood before the lamp smoking one of his thin cigars as Jiro sat napping with his back against the wall. The Society members were mostly working-class kids like Ozaki—he was the only one to have gone to college—and most of them could be counted on to keep their mouths shut. They weren't thinkers, Ozaki had long ago concluded, and therein lay their great strength. These were men of action, and little more. They would support each other and the group, and by extension the nation. They would act without hesitation, Ozaki believed. But Ozaki suspected that the other eight members of the Society—excluding Jiro and himself—could possibly be swayed by other *uyoku* like Noburo.

The Society was organized around Ozaki and Jiro as the core with the other members reporting personally to Ozaki. He was chairman and the group's undisputed leader. Physically he wasn't the biggest of the members, nor was he the best fighter or swordsman—Jiro held both those distinctions—but Ozaki made the important decisions. Ozaki had founded Seikokai upon returning home from college and deciding he didn't want to enter the corporate world, that he instead preferred working in the movement. He had dabbled in the local chapter of the All

Japan Patriotic League but found their behavior and style contemptuous, so he came up with the idea of forming a youth auxiliary that would complement the senior ultranationalists. But he quickly took the group underground and split from the movement's mainstream because he was offended by the flagrant corruption and excessive greed he had seen firsthand. He would form a movement that couldn't be bought. For his followers, his resolve gave him an almost messianic appeal.

As Ozaki lectured the Society in the factory he was reinforcing the idea that the Society's way was the only way, was, indeed, the way of the samurai. They were the true believers and the other *uyoku*—those in it only for the money—were vain and vulgar. Impure. The troops didn't seem terribly concerned with Ozaki's peroration; he wasn't being specific about Noburo's request to use the group and his decision to turn down that request.

"We cannot be compromised," Ozaki explained, "not for personal gain or material wealth."

Even Jiro seemed uninterested in Ozaki's speech. Though he nodded a few times, he kept his eyes closed.

Ozaki's concern was that Noburo would decide that if the Society wouldn't cooperate with his request then he would simply eliminate Ozaki. Before Ozaki could respectfully tell Noburo to go fuck himself, he needed the assurance that his troops would stand behind him, and only him. He would certainly need their support if powerful rightists elements came down from Tokyo to take care of business.

"We need to be one," Ozaki said. "Above all, if we stick together, then nothing can go wrong."

He then quoted from *The Way of the Samurai*: "Being a retainer is nothing other than being a supporter of one's lord, entrusting matters of good and evil to him, and renouncing self-interest. If there are but two or three men of this type, the fief will be secure."

The members in the darkened room gazed around at each other in confusion. Jiro opened his eyes and stared quizzically

at Ozaki. Ozaki, noticing the blank, confused expressions, hastily added: "From *The Way of the Samurai*. It means that we have to act together, as one cohesive unit and of one mind."

But it had been a mistake to attempt further explanation, it was a sign of weakness, of less than absolute confidence. If he had simply been oblivious to his troops' incomprehension and in the spontaneity of his speech continued on, that would have been better. To back up and justify himself was calculating, admitting he cared what the members of Seikokai thought about him. He should have simply charged forward. He had been self-conscious where he should have been natural and unstudied; he had acted like the antithesis of the warrior.

Seikokai, the Society for Purity and Justice, during its first year, had kept squalid, cramped offices in Chigasaki paid for by the All Japan Patriotic League. (The Society's sound truck, a modified Mitsubishi van, was also a contribution of established *uyoku* leaders.) Most *uyoku* groups have corporate-style offices from which they publish pamphlets or work the phones to stroke cooperative politicians and harass uncooperative business leaders. Mercedes Benzes, BMWs, and Jaguars proliferate outside these offices and many *uyoku* chiefs like to deck themselves in pricey imported suits and furnish their workspaces with plush leather-upholstered appointments. (Very few *uyoku* leaders, despite their insistence that the emperor and prime minister should wear traditional Japanese kimonos, don traditional garb themselves.) At the central offices of the very well-heeled groups, the atmosphere is more like an efficient small business than fascist movement: ornate, brass Chinese character nameplates are emblazoned next to the entrance, female secretaries answer phones and tap at word processors, attractive receptionists take coats and offer tea. Every *uyoku* office has large, framed photographs of past emperors lining the walls and gives special prominence to the present Emperor Akihito. (The Tokyo offices of Seiki-Juku, the group that took responsibility for shooting Nagasaki Mayor Motoshima, also has a framed letter from the Dalai Lama thanking them for contributing a hundred blankets

to the Tibetan relief cause. *Uyoku* groups often forge such un-
likely connections and claim any prominent internationally
renowned anti-Communist as an ally.)

After a year, when Ozaki decided to split off from the move-
ment, he moved to new offices for which he never paid a day's
rent and from which he was finally evicted. The Seikokai group
was currently without offices and the boxes of paperwork, the
two word processors, and the Imperial photographs were piled
in Ozaki's tiny apartment next to a closed bicycle shop.

This was the apartment Ozaki had moved into upon gradu-
ating from college. Ozaki, Jiro, and two other members of the
Society had paid a visit to the middle-aged landlord a few days
after Ozaki had moved his possessions in. They initiated a long
discussion with the landlord about Shintoism, the Emperor,
Japan, *The Way of the Samurai,* and how devoted Ozaki was to
working for these causes. The Society suggested the landlord
could contribute to the cause by letting Ozaki do his work in
peace. The landlord got the message and never asked him for
rent again.

When Ozaki returned to his apartment that evening after
the meeting, he found in his mailbox an express-delivered, rice-
paper-wrapped greeting card tied in gold and silver string with
an envelope attached to it. Written on the white cardboard in
heavy-stroke Chinese characters—the kind of writing favored
by sumo wrestlers, actually—was a brief greeting from Noburo:
TO OUR GLORIOUS AND NOBLE FUTURE. LONG LIVE THE EMPEROR.

Inside the envelope was ¥1 million in a hundred ¥10,000
notes.

The attempted payoff so enraged Ozaki that he immediately
stuffed it in a rough envelope with his business card attached
and returned it overnight express from a local Lawson's conve-
nience store. The crudity of Noburo's methods offended him.
The thought of Noburo, his Mercedes, and his retarded driver
repulsed him with its decadence.

The assumption that he would cooperate for money was
absurd and misinformed; he would never have split from the

organization in the first place if it were money he wanted. We are samurai, Ozaki thought proudly as he walked from the convenience store, and even if we have to starve we will never appear hungry. Our pursuit is not money but the glory of Japan. And if Ozaki was not committed, then who in this decadent society would be? He resolved to go at dawn tomorrow to a shrine to Amaterasu, the sun goddess, before going to the *kendo* club.

The open-air shrine was nestled between two tacky white-concrete resort hotels across the highway from the ocean. There were several willow trees on the grounds, but otherwise the only vegetation was a row of shrubs near the white wall on the property line. The muddy grounds before the altar were covered by discarded wrappers, cigarette butts, and empty cans. Bare tables stood in disarray next to the stone path that led to the vestibule. Scattered on the tables were losing lottery tickets that the ocean breeze gently pushed farther inland.

A traveling carnival had been through the shrine the night before and left its mess behind for the priests to clean up. The shrine received a fee from the carnival—the carnivals were Yakuza-run affairs—and as part of the deal the monks would have to pick up after the bottle-toss games, lotteries, and bean cake stands packed up and moved on. They had yet to attend to the job, and while Ozaki paid tribute the place was still a shambles.

When he finished his meditations he crossed the street and watched a giant morning swell begin rolling in against the nearly deserted beach. A group of surfers, the tops of their wet suits hanging from their bodies, stood near a jetty of square, concrete blocks. They didn't look like they'd been in the water; instead they talked and periodically pointed toward it. As Ozaki followed their gaze he saw there were already a few surfers in the water, so far out he hadn't noticed them at first, their black wet suits making them almost invisible against the dark, glassy water. He watched as one of them attempted to take off on a powerful wave as big as a mini-van and was late and then sucked over the top of it, falling after his board into a massive

frothing cake of white water. It was a mean swell. The waves were big and fast and the hundred-foot sections were closing quickly, unforgiving for unskilled or hesitant surfers. Big waves like that took confidence, Ozaki remembered. He had never been any good in water like this.

Then he saw another surfer take off, slide cleanly down the face, bottom turn neatly, carve along the glassy front of the wave, ride up closer to the top, then down, then cut back up and then— unbelievable—ride along the top for a moment as the section closed and drop back over the white water in a manner that actually had him airborne for an instant. Then he pumped ahead of the white water before getting back into the cradle of the wave and kicking out. The surfers on the beach were hooting, and even the few other surfers farther out had stopped their paddling for position and were looking inland. That had been the ride of the day, and it had been Jiro.

When he came out of the water, Jiro shook his short hair out quickly and walked up the beach past the crowd gathering there. The day's first non-surfers had begun to arrive: fishermen lugging tackle boxes and beach chairs and boxes of Kentucky Fried Chicken. It was still low season, early spring, so the tourist crowd would be light. A few families coming down from Tokyo to visit Sea World up the coast, maybe some couples looking for a romantic walk along the beach.

"You're becoming as good as your brothers," Ozaki told Jiro.

"No." Jiro shook his head again. "There's not enough consistent surf in Japan for me to get better."

Ozaki didn't say anything. One of the things that he had always disliked about surfing was its foreign origin.

"I think I'm going to go with my brothers to Bali," Jiro said. "Next month. If I have the money."

Ozaki was shocked. "Bali? Why leave Japan?"

"Surf." Jiro looked out at the water. His round black eyes, rough, tanned complexion, and thick, chapped lips seemed to be intentionally turned away from Ozaki. "I've been thinking, maybe you should take that offer from the big boys."

"What?" Ozaki hadn't even told him about the envelope bulging with cash he had received in the mail last night.

"Yeah." Jiro watched another surfer screw up a big wave. "Maybe it's a good offer. You'll have a future, a career in the organization."

"What do you mean 'you'?" Ozaki was saying. "It's us, not me. It's the Society."

"Yeah," Jiro said, "sorry. Us."

"It's a bad offer," Ozaki said. "You know that. It's not what I've been working toward."

Jiro walked across the sand a few steps to a staircase that climbed a short retaining wall separating sand from the paved boardwalk. Seagulls flew overhead in small flocks.

Jiro set his board against the retaining wall and unzipped his wet suit top, struggling to slip his arms from the tight rubber sleeves.

"Did you ever think that maybe the reason all the other *uyoku* do things is for money?" Jiro asked when he had freed his arms from the suit. "Maybe that's what they do. Maybe that's what the movement is really about. All the patriotism and fanaticism are just the means to make a living."

Ozaki shook his head. "Do you know what you're saying?"

Jiro rolled his wet suit down along his tanned body. As the neoprene slipped down, his muscled chest and taut stomach came into view. Standing there, in the first morning sun, Jiro looked like some kind of sea creature shedding a skin and undergoing a metamorphosis into a different, cleaner, more perfect form, as though he were becoming a man right before Ozaki's eyes.

"Yeah," Jiro said, "I know what I'm saying. The point of it all *is* the money. All this other stuff is the way we make it. If the big boys in Tokyo are doing it that way, then how can we not do it that way?"

"That's wrong," Ozaki said. "We do what we do for love of country, not love of money."

"How long can you keep believing that?" Jiro asked. "How long can you go on like this? There's a reason the Tokyo boys

do it for the cash, and that's because doing it for any other reason is childish."

"Childish?"

"To do something only because you believe in it is childish. Yes." Jiro slipped the wet suit down his legs, revealing a pair of shimmery blue-and-silver surfing trunks. "And if you don't take the money, they'll be after you."

"So what?" Ozaki said defiantly.

"I know you're not frightened," Jiro said. "But if they want to get you, they'll get you. Be smart—take the money while you can. Get rich. Get a good life."

"That's the worst life I can imagine," Ozaki said.

Jiro removed his legs from the wet suit one foot at a time until it lay in a black, wet, twisted heap at his feet. "By the way," Jiro said, "the other guys think we should take it, too."

This was not a democracy, Ozaki reflected. Even if the other members of Seikokai shared Jiro's views, it was Ozaki's decision to make. He was the leader and they would have to fall in line behind him. (But how did Jiro know about the envelope? This was a disturbing question that Ozaki couldn't answer. Or had Jiro been speaking generally? Jiro knew there had been discussions between Ozaki and Noburo, and there was an implied offer there, but not the specifics. Had Jiro specifically referred to the envelope? Ozaki couldn't remember.)

That afternoon he had a terrible *kendo* practice. Usually, his quickness allowed him to bring the sword to defensive positions, parry, and then counterattack before the attacking swordsmen knew what was going on. Today, his grip was too tight and consequently his sword speed was sluggish. He couldn't concentrate and achieve the empty-headed oneness with the sword so important to succeeding—the empty-headed oneness that Jiro brought to any sport he took up.

Ozaki recalled a day two years ago, just after he graduated from college, when he was still relatively new to the movement. He had attended a rally in Hibiya Park protesting Mikhail Gorbachev's visit to Japan. Amid the thousands of rightists and

hundreds of banners proclaiming loyalty to the emperor, demanding the return of the Kuril Islands, rejecting Korean claims for war reparations, and insisting that Japan should have become more involved in the Gulf War were hundreds of casually dressed women and children eating boxed lunches and enjoying a day in the sun. The speakers that afternoon had been prominent *uyoku* from all over Japan, including Ozaki's hero, Rikio Kubota. Near the front and standing at attention in disciplined columns and raising their hands above their heads to shout hearty banzais were nearly two thousand uniformed, hard-core fascists. Ozaki had stood among them, staring rapt at the stage while keeping a stiff, dignified posture. As the afternoon sun beat down and a strong breeze whipped the numerous fluttering banners and the sound trucks driving in a continuous circle around the park kept the police and government surveillance teams at bay, Ozaki had believed this movement would truly change Japan, would throw out the impure foreign influences, restore the emperor, and return Japan to military greatness. This samurai spirit—a good warrior, after all, was worth ten men—could be the foundation of a revolution that would transform Japan. Ozaki was completely caught up in the spirit of the movement, in the infinite possibilities that seemed suddenly within reach, in the drama and passion of a life devoted to duty to the emperor, in the sense of purpose he felt at the rally that day. That had been before he discovered the corruption and greed that had subsumed the movement. He now saw his own role in the movement as a heroic and valiant effort to restore the purity that would make it effective.

As he toweled himself off in the dressing room and packed his *kendo* armor and practice sword in the black duffel bag, he realized that now he was alone. His best friend, the man closest to him in the whole world, was advocating an impurity he could never have anything to do with. He would ask Jiro to leave the Society. Or, if the Society seemed to be taking Jiro's side, he would disband the Society.

* * *

The dark blue Mercedes limousine idling before Ozaki's building was out of place in the working-class neighborhood and drew curious glances from the locals as they walked past on their way to the market or bus station. Ozaki saw it in the early evening light as soon as he turned the corner; the narrow street made the massive, dark blue sedan seem even more immense silhouetted against Ozaki's white building. It was Noburo's car. Ozaki kept walking down the unevenly paved street, intentionally not changing stride or in any way showing that he had noticed the car. The driver's door opened and Noboru's retarded bodyguard stepped out. He walked slightly hunched over, Ozaki noticed, but even hunched over he was gigantic. The bodyguard seemed to be listening to a voice coming from inside the car. Because the vehicle was between Ozaki and the bodyguard, Ozaki couldn't tell if the bodyguard was armed or not. He unzipped his duffel bag and wrapped a hand around the leather grip of his wooden practice sword and continued until he was alongside the automobile. The bodyguard walked around the front fender, his blunt-cut hair bouncing as he strode and his round eyes totally vacant. (Empty-headedness, Ozaki noted.) At the front right headlight, the retarded bodyguard held up a hand like a traffic cop. Ozaki changed course, stepped wide of the bodyguard, but kept walking. When the retarded boy reached out to stop Ozaki, Ozaki pulled his practice sword and swung down quickly at the bodyguard's outstretched arm. Ozaki heard a snapping noise and wondered if he had broken the bone. He took a neat step back and his back foot landed in a small plot of flowers the landlord cultivated next to the street, and for a second he lost his balance. He managed to steady the sword above his head in position to strike again. As the bodyguard came forward, keeping his injured left arm at his side, Ozaki brought the sword down, but he couldn't get much power behind it because of his unsteady stance. The retarded bodyguard was able to take hold of the sword and turn it so that Ozaki's wrist nearly broke; Ozaki was forced to let go. Ozaki had been disarmed by an unarmed man—perhaps the ultimate disgrace for a *kendo* expert.

The passenger door nearest to Ozaki opened and Noburo stepped out.

And from the other side of the car emerged Jiro.

Jiro didn't say anything but gestured for the practice sword. The retarded boy, nursing his left arm, obliged and Jiro acted as though he was inspecting the sword while Noburo spoke.

"You have been removed," Noburo said. "By orders of the old man himself in Tokyo. Here is a letter from Rikio Kubota explaining that your services are no longer required."

He lay the letter atop Ozaki's duffel bag, which in the tussle he had dropped next to the car.

"You're a *ronin*," Jiro said, using the word for a samurai without a fief. He held the practice sword beside him.

"The Society is Jiro's now," Noburo said.

The retarded boy winced as he held his arm and looked back to Noburo as if he didn't know what to do.

"Wait a minute," Noburo told him. He turned back to Ozaki. "You're done, you understand?"

This impure creature had disarmed him, Ozaki shamefully reflected as he watched the retarded boy gingerly attempt to bend his arm. Ozaki stood silent, too embarrassed in his ignominy to say anything. That he had been defeated by such a bad specimen of the species—a retard!—was intolerable. That Jiro had seen this sad spectacle left Ozaki flushed with shame. Ozaki noticed his legs were trembling.

"Do you understand?" Noburo repeated.

Ozaki tried to steady himself. His landlord peered out from behind a slightly opened door.

"He understands," Jiro said. He cocked his arm back as if to throw the practice sword over the roof of the car back to Ozaki but then thought better of it and slid it onto the backseat.

"Come on," Noburo told the retarded boy, who had been turning his head from Ozaki to Noburo, always checking with Noburo to see what he should do. "Let's go."

The retarded boy flashed Ozaki a final glance, this one not laced with hatred but mere wide-eyed curiosity. "Bye-bye," the

retarded boy said in Japanese-accented English. And he waved with his good arm.

As the Mercedes drove off, Ozaki's shame and humiliation left him with only one option. It didn't matter that Jiro had taken the practice sword, because for what Ozaki had in mind, only a real sword would do.

X

JACKIE

THE HOSTESS

For a hostess, the dream is a recurring one. One huge deal, a gigantic payday that will enable her to retire in her early twenties and return from Tokyo to America or England or Sweden a rich, successful businesswoman. Achieving the dream always means confronting the question of trading sex for money.

Deborah, from Vancouver, says she has never had sex with a customer for money. Laura, from Warren, Michigan, says she is paid a thousand dollars monthly by a Japanese man who sleeps with her once a month. Eve, from Gothenburg, Sweden, says she won't do it and never will. Vickie, from Surrey, England, slept with a customer when she was drunk and accepted the fifty-thousand-yen tip he gave her. Jo, from Perth, Australia, actually went to a hotel with a customer before she backed out. Annie, from Lakeland, Florida, says she would consider it if the money were good enough. Heather, from Oxnard, California, says of course, if the money were good enough. Marie-Anne, from Paris, says she has thought of it but hasn't yet. Samantha, from Roberval, Canada, is dating one of her customers in an affair that started when he took her on a cruise through the Caribbean and paid her five thousand dollars for her time. Amy, from Aachen, Germany, says Japanese men disgust her. Susan, from Dallas, says fuck no.

Jacqueline Burke sits with her legs crossed on a gray foam sofa in her Tokyo apartment. Sunlight streams in through two windows and bathes her slightly tanned skin and golden blond hair in rich, creamy yellow. She's conscious of the effect. For the past eighteen months, this gold has been her fortune.

California-girl looks that had been a dime a dozen in Los Angeles are exotic here. And exotica, she has found, commands a price. In Huntington Beach, Jackie, twenty, had been a $300-a-week waitress. Here, because of her shapely physique and pouty lips, she's a first-class hostess at Casanova, a hostess bar in Roppongi, her salary at the top of the pay scale. In addition, she earns tips and her customers give her gifts. All kinds of gifts.

She is dressed for work in a black Moschino skirt, black tights, red Alaia jacket, pearl-shaped gold necklace, Chanel watch, diamond ring, emerald ring, and pearl earrings. All of it, excluding the tights, was given to her by customers.

"Once your regular customers start to like you, you can get them to keep giving and giving," Jackie says as she unwraps a pack of Marlboro Lights. "But if you want to get stuff you like, then you'd better start telling them exactly what you want or you'll end up with five Chanel handbags."

She smokes and looks at one of her rings in the light. A diamond as big as a peanut. "But it's funny. You don't really like wearing the stuff. Some diamond worth five grand and you only wear it when you go to the club so the customer thinks you really like him and then maybe he'll get you another one." Jackie laughs. "And you'll probably not even like to wear that either."

"I keep thinking that this time I'm gonna make a shitload of money, a big deal, and get out. Usually I always blow it. After three months hostessing I take my twenty or thirty K and blow it traveling or in Thailand and come back to Tokyo broke.

"To be a good hostess, you've got to be a good businesswoman. I have to resist the temptation to go to Thailand or Goa or some tropical paradise like that. I've got to be a businesswoman."

She wiggles her fingers, the fat diamond and emeralds glittering, and smiles, "This stuff is for beginners."

In Tokyo deals are done, alliances formed, and mergers forged in dimly lit hostess bars. With hostess bars in every community and hundreds of thousands of girls in the business, hostessing is a multibillion-dollar industry. For the salaryman, the hostess bars still serve as a respite from the confining office, as an oasis of scotch-and-waters and pretty women where business negotiations can be carried out in a relaxed environment.

"It's where we let our guard down," says airline executive Takeo Hideoka, a regular hostess bar customer in Tokyo. "We have some drinks and can speak frankly. I still do as much

business at the two or three bars I frequent as I do at my office. I don't see the bar as a particularly sexual place—although I have met mistresses at hostess bars. But it's a business place." He laughs. "If you eliminated the hostessing industry," he says, "the Japanese GNP would probably decline by fifty percent."

Hostessing is rooted in the geisha tradition and is, in some aspects, an ingenuous modern incarnation of that more artful manner of entertaining men. Where the geisha embodies old Japan with rigorous training, sake, kimonos, samisen playing and fan dancing, the hostess is modern—no special training, but plenty of bourbon, Gaultier outfits, karaoke singing, and disco dancing.

In male-dominated Japanese society, the business of child rearing and managing a household is still relegated to the wife. The coquettish or flirtatious roles that had traditionally been played by geishas now belong to hostesses, who emerged in the twenties as the *jokyu*, or "cafe girls." Since then, the hostessing industry has thrived.

A hostess pours drinks, cajoles her customer into ordering overpriced snacks, and generally panders to his ego by laughing at his jokes or attentively listening to laments. Sex might or might not be a part of the package. For a hostess to sleep with a client, says manager Michiko Nagisa of the Yamazakira hostess bar in Roppongi "is totally up to her and is totally her business." It always comes up however, sometimes with huge sums of money at stake.

The Asian Laborers Solidarity organization, an advocacy group for foreign workers in Japan, estimates that there are 70,000 to 100,000 foreign hostesses in Japan. Most of them are from neighboring Asian countries; about 10,000 are European and at least 2,000 are American. The average American hostess stays in Tokyo for about two years, saving some money before moving on to see the rest of Asia or returning to the United States.

Since the early seventies, as Japan's fixation with Western trends and imports extended to Western women, Europeans and Americans have increasingly replaced Japanese hostesses in the plush booths beside tipsy corporate executives, gangsters,

politicians, art dealers, and the scions of some of Japan's oldest and wealthiest families.

"Blond women are a status symbol for Japanese men, who have long been intimidated by foreign women," says hostess-turned-journalist Rie Sekiguchi. That the women now serve Japanese men, she says, can be taken as a symbol of Japan's ascendancy.

"I've never done it. But I don't see what's wrong with taking money for sex," says Jacqueline Burke as she inhales her Marlboro Light. "But there has to be something attractive about the guy."

Jackie is short at five feet three inches, too short to be a successful fashion model, and she knows that. ("I hate models," she often says. "All they are are pretty faces and ugly attitudes.") And Jackie's beauty is miles away from the emptiness that is so often at the center of a fashion model's two-dimensional appeal. Her lips and the slight frown of her mouth, which at first glance suggest an air-headed pout, are really the clenched expression of a thoughtful, calculating person. Her hair, height, and manner—the way she's careful about her cigarette ashes and smooths her skirt when she shifts her legs—create a soft, modest impression, but her steel-blue eyes are always appraising and making judgments. When she talks, she watches for clues to see how you are reacting, what you are thinking. When you talk, she squints as she thinks about what you are saying.

There is still a lot of Huntington Beach in Jackie. Her vocabulary is an odd combination of beach slang, pidgin Japanese, and British colloquialisms she's picked up from fellow hostesses. She says *gnarly* instead of frightening, *shabu* instead of speed, and *snog* instead of make out. She is at ease with her sexuality the way only attractive girls who went through puberty in micro-bikinis on California beaches are. She takes her looks for granted; so for granted, in fact, that she is now coming to terms with the idea that they may be a commodity, as salable as being able to program a computer or hit a fastball three times out of ten.

"My mom once told me that every girl wonders inside if she could be, you know, a whore," Jackie says as she exhales smoke. "She said when I came to Tokyo, this would be my chance to find out.

"What I want is to get one of my customers to finance a hotel in Cancun. Right on the beach. Beautiful. With bungalows, white sand, palm trees. Paradise. I know the exact hotel—I stayed there for the first time with my mom when I was thirteen. I've got pictures."

Jackie snuffs her cigarette in an empty teacup with caricatures of Japanese prime ministers on the side. When asked who is on the cup she shrugs and says she doesn't know. She uncrosses her legs, stands, adjusts her skirt, and shuffles across the tatami floor to her bedroom. She returns with a few dozen photographs of clear blue water, cloudless azure skies, deserted white sand beaches, a fair approximation of tourist brochure paradise, and the exact opposite of murky, smoggy, congested Tokyo. In one of the photographs is Jackie, topless, wearing sunglasses and lying on a towel.

"There isn't another hotel for twenty miles. So we're talking about miles of exclusive, private beach. I can buy the whole thing and make the changes I want—like renovate the rooms, add stables and horses, make it more like Club Med or something only groovier. I can do everything I want with $250,000."

Jackie shares a four-room apartment in the upper-middle-class Setagaya ward with two other hostesses, Liza and Deborah, and Steve, an Englishman who works as a blackjack dealer at a casino/strip club in Roppongi.

Jackie and Liza met when their parents joined a commune in Oregon headed by a famous Indian mystic. The two friends moved to Los Angeles when "the ranch," once home to three thousand faithful, dissolved in the mid-eighties. "We had a great time at the ranch," Jackie says of her girlhood. "But we never learned to do some pretty basic things—"

"Like spelling or long division," interrupts Liza, walking into the room. Liza, a strawberry blond about two inches taller than Jackie, brushes her hair. She wears a pair of flannel pajamas.

Under her arm she carries an application for California State University at Fullerton. She has already taken the high school equivalency exam and the SATs and her dream is to go to college back in the States.

Jackie and Liza, who is also twenty, woke up at one P.M. Deborah, from Vancouver, Canada, who is studying at Tokyo American Community College, had been up and out by noon. ("Dawn patrol," Jackie had moaned when Deborah's alarm went off.) Jackie and Liza had partied the night before at a club near Roppongi, doing lines of coke off the toilet tank and eating hash brownies baked in the nightclub's kitchen. They didn't get to sleep until well after dawn.

The first thing Jackie did after she looked in the mirror at one P.M. was to rouse Liza, the makeup specialist in the apartment, who supervises the long makeup process essential for hostesses. After morning tea and cigarettes they start with Clinique day cream, eye cream, loose transparent powder, black Chanel eye pencils, and matte eye shadow from a theatrical makeup company. When the eyes are done, they use Elizabeth Arden Lip Fix and a Lancôme lip liner—brown for Jackie and pink for Liza. Then red Shu Uemura lipstick for Jackie. Chanel coral for Liza.

They finish with the pill.

Jackie, made up as the blond bombshell Japanese men pay so much to sit beside, leans against the kitchen table and flips through her address book, as she does every night, looking for selected customers' phone numbers. For each customer who comes into the club and "nominates" her—asks for her by name—she is paid an additional ¥1,500 ($14). For a *dohan* (dinner date) where the customer takes the hostess to dinner and then to the club, she receives a ¥5,000 ($45) bonus. The more nominations and *dohan*s she accumulates, the more likely she can demand a sizable raise.

She punches the digits and speaks in halting Japanese to the customer's secretary or in English if the customer himself answers on a cellular phone. She alternates from a low sexy

voice to a more girlish tone depending on the patron, but she asks them all to come tonight. "There's a party," she assures them. Every night is a "party" at Casanova.

Jackie calls her best customer, Junichiro Shigematsu, last, laying it on especially thick for him.

"For three months since I started working at the club, this guy Shigematsu—he's in construction—has been coming in maybe two nights a week and always asks to have me at his table," Jackie says as she closes the address book. Liza stands by the stove, putting on a pot of water for tea.

"He has given me, so far, one Chanel bag, one Cartier wristwatch, a Tiffany diamond pendant, a diamond bracelet from Harrods, and two diamond rings from Paloma Picasso. He's good with the brand names."

Liza asks if she wants more tea. Jackie says yes. Green or black, Liza asks. *"Ocha,"* Jackie replies, using the Japanese word for green tea.

"Each gift has been a little more valuable than the last one," she smiles. "And the duration of his hand's stay on my thigh is a little longer than last time, or his hand is, like, infinitesimally closer to my pussy. But this is a game, with rules, and he knows them and I know them. If he goes too far I get up and go to the loo."

Japanese customers know the rules: no groping. Junichiro Arai, manager of the Grand Mois hostess bar on the Ginza, lays down the law: "It's the girl's job to handle the situation politely. But if that fails, she can get help and one of the waiters will talk to the customer. But that kind of problem is rare."

Shigematsu is a real estate speculator who specializes in taking over the mortgages of properties that overleveraged developers would otherwise have to default on. In exchange they must give him a fifty percent equity share in the real estate. Once you have Shigematsu as a partner, he's never going away. He's that kind of guy, and he's connected to even worse kinds of guys. (The only good thing about having Shigematsu as a partner is your tenants will never give you trouble again.)

Jackie estimates his net worth at "something with a wagon train of zeros." He is fifty-seven, married, and has two children.

Shigematsu has brought a few of his friends into the club and introduced them to Jackie. He shows Jackie off at times like that—pats her on the thigh, tries, for the benefit of his business associates, to make it look as if theirs is the traditional mistress-patron relationship.

"The Shigematsu situation is going critical," Jackie says. "The size of the next gift is going to require more than just a peck of gratitude on his cheek; I've told him about my hotel plan. He knows what I want. And to get it, he wants me to become his mistress, which grosses me out, because the guy is, like, repulsive. It's not an ethical thing—the guy's just gross."

"But I want to do it. I have to," Jackie says. "At least for a while, at least to get the firm off the ground."

Liza sips tea and says, as though she's heard it a million times, "Jackie's Hotel by the Sea."

Jackie and Liza came to Tokyo because they had heard, from a hostess who had just returned from Japan, that there was big money to be made on the west side of the Pacific. They met the woman at a swimsuit model audition for a calendar company, and when the model found out the job paid only $500, she told Jackie and Liza that if they really wanted to cash in, go to Tokyo. "It sounded crazy," Liza says—the woman described men paying $800, $900, just to talk to them. "But she gave us a phone number and the name of some clubs. She also said we could get some modeling work. But since we've been here, the hostessing has kept us busy."

Others hear about hostessing while they are on vacation in Thailand or India. In the early nineties, as Tokyo became the world's newest boomtown, the word went out along the low-budget and student-travel grapevine: come to Japan and cash in. Although there is currently a glut of job seekers in modeling and hostessing, women of all nationalities—including American, English, French, German, Swedish, Finnish, Australian, New Zealander, Dutch—still fly into Tokyo daily looking for work as

hostesses. (Hostesses must have work visas, but the actual enforcement of that rule varies. The basic equation is the prettier the girl, the less likely she needs the proper visa.)

In other cases, women who answer employment agency ads in American newspapers to work in Japan as "dancers" or "entertainers" frequently find themselves hostessing. Some complain and return to the States. Others decide to stick it out. Laura, a brunette from Warren, Michigan, came to Tokyo four years ago to work as a "dancer" in an Akasaka club. "I walked into the place and saw it wasn't big enough to swing a cat," Laura says as she waits on a subway platform for an Akasaka-bound train. "So I knew I wouldn't be dancing. At first, the job freaked me out, but I got used to it. And the money is sweet."

Some women never get used to it. The U.S. Embassy takes up one case a year of a stranded woman who wants out. In a typical case, a woman was flown from San Francisco by unsavory employment agents, put up in a pricey hotel and encouraged to order room service. When she wanted to quit, her club manager informed her that she owed $7,000 for the hotel bill and plane ticket. The consular section of the U.S. Embassy arranged for her ticket out of Tokyo.

"It can be very hard on the girls," says manager Arai. "If they don't get regular customers or good tips, the job is not that lucrative. I'll help a girl find a place to stay occasionally. But Tokyo is expensive, and they have to start practically from scratch. I wouldn't want my daughter to be a hostess."

Complaints about the emotional hardships of the job are more common than complaints about mistreatment or bad management. "I began to really hate men," says Laura, twenty-four. "I was repulsed by them, especially by Japanese men. They were so pathetic and sexist, thinking they could have everything because of money. It's degrading."

It's no wonder that she and other women begin to see men as fat wallets from which to extract as much money as possible. Expensive dinners, designer outfits, jewelry, and even trips abroad to Saipan, Hawaii, or Paris with customers are measured in terms of dollar value.

As the value of the gift escalates, the customer is more likely to demand carnal satisfaction. At that point, the job enters a gray area bordering on prostitution. Every hostess, at some point in her career, is tempted by a combination of entreaties and swanky gifts to sleep with a customer. As Jackie says, "Some guy offers you an apartment, money, and basically will subsidize your whole life. And if he's not bad-looking you'd have to be the prudest girl in the world not to consider it." Every hostess has a story about the largest gift she has heard about: condominiums, $200,000 in Mitsubishi stock, Ferrari cabriolets.

Rebecca, from rural Devonshire in England, received the Ferrari. The car was the final installment in a long seduction by a real estate developer obsessed with the short, lithe, sharp-featured Briton. He had already given her a diamond pendant and a membership in an exclusive health club. He made it clear she would have to sleep with him to get the car. Rebecca describes him as "too weedy, a thin old man." But she lusted after the black Ferrari. And now she's the only twenty-year-old blond in Tokyo with a $120,000 car parked outside trendy Tokyo nightspots. But it didn't get her out of the game: she still works at the Shy in Roppongi.

A few hostesses have graduated. Penny, twenty-six, has made a successful transition from hostessing to dealing art. She is curating a show by a promising young British painter at her stark, modern gallery near Roppongi.

"Hostessing was how I made my connections," says Penny, a dark-skinned Lebanese-American whose hair flows in long, black waves. "When a friend called and told me he had some Warhol lithos for sale, I decided, why not? Ask the customers. I sold three in a week. My commission was fifteen percent of $150,000. You do the math."

After a few such deals, she built a clientele of undiscerning buyers eager to please her. "I had ambassadors, foreign ministry officials, top guys from Fuji Bank, all kinds in here. And they'd pay top yen for almost anything. They liked the tax write-off. Things have changed of course, the market isn't like it

used to be. If it gets any slower, I'll have to make a decision—leave town or go back to hostessing."

At 12:30 on a Friday night, the Connection, Casanova's house band of mustachioed Filipinos, has launched a cruise-ship cover of the B-52's hit single "Love Shack." The band, not even bothering to feign enthusiasm, keeps the music quiet so as not to interrupt the various conversations in progress. The dance floor is lighted from beneath and a mirror ball glitters overhead. Giant bronze palm trees strung with white Christmas lights stand between plush, red velour booths. The waiters officiously attend to those booths, asking every five minutes if a patron would like another drink. The cost to the customer for an hour and a half, including all the liquor one can drink, is ¥35,000 ($318), but that's before extras such as buying the hostesses drinks or a "snack" of popcorn or potato chips. When a customer enters and is given a table, the manager sends several girls to come sit with him.

The final cost for a few hours entertainment can reach the four figures in dollars with a minimum of effort by the customer, who will most likely write off the evening as a business expense.

Jackie sits with her patron Shigematsu, whose mottled skin, thick glasses, and slim physique make him look older than his fifty-seven years. His bodyguards, two beefy men in blue suits, sit one booth over with two other girls. Shigematsu has ordered his regular bottle of twelve-year-old Glenlivet Scotch and the Island Paradise snack platter: two sliced, grilled chicken breasts floating on a sea of flavorless blue gelatin. Connecting the two breasts is a miniature bamboo rope-bridge strewn with Tater-Tots. The monstrosity is symbolically topped off by a tiny golf-pin flag on each chicken breast. It costs $200.

Golf is a common icebreaker between foreign hostesses and Japanese customers, but Jackie and Shigematsu are beyond that kind of small talk. Shigematsu keeps professing to Jackie that he is in love with her and that he wants to consummate

that love. Jackie is eager to consummate the financing for her hotel. They make a date for lunch next Saturday.

During the Connection's low-octane version of Michael Jackson's "Thriller," two blue-suit-clad Nomura executives are led onto the dance floor by two hostesses. The Japanese men dance in a manner evocative of the Ickey Shuffle, thrusting their arms forward and back, palms upward.

Why do Japanese men, some of them quite handsome, want to pay for the company of women? "I don't think these guys ever get to just sit and talk with girls," Liza, who works in a different club, explains. "Japanese men don't do a lot of simple socializing with women, even the good-looking guys are sort of inept." Liza has gone out with several of her customers, including a long-term relationship with one of them. "We slept together for about three months. But because he was still living with his family and he was uncomfortable at our place, we always stayed in hotel rooms. You get kind of sick of that after a while."

When Casanova closes, after the hostesses help the customers into waiting chauffeur-driven Lexuses, Mercedes Benzes, and Nissan Presidents and bow as they drive off, Jackie takes a taxi to meet Liza at Metro.

The drinks are free for well-connected girls like Jackie and Liza, and the music, not the cruise-ship stylings of the Connection, but real, kick-ass stuff by Pearl Jam or hip-hop from Ice Cube gives Metro the authentic good-time atmosphere Casanova tries but fails to achieve. The crowd is comprised of hostesses, English teachers, a few bankers and brokers, models, and out-of-uniform marines on twenty-four-hour furloughs from the Yokosuka and Atsugi U.S. military bases south of Tokyo. Hostesses are at the heart of the young expatriate scene in Tokyo. On an average night out, at bars like Metro, about half of the foreign girls who come in are hostesses.

Anything feels possible at Metro: fights, love connections, or drug deals. The hostess bar, on the other hand, with its contrived festive air, leaves nothing to chance: a meeting with a pretty girl is guaranteed.

Liza and Jackie sip Planter's Punches and smoke cigarettes. Adrienne, a French topless dancer who works at a strip club nearby, comes in and tells the girls she's got Ecstasy for sale.

"How much?"

"Ten thousand a hit."

"Too dear," Jackie says, nipping at her sickly-sweet drink and feeling Adrienne's black Katherine Hammet jacket. "Nice."

"Thanks." Adrienne sets her shoulder bag stuffed with her sequined dance outfit down on the bar. "All right," Adrienne says, "three for twenty."

Jackie buys three. She and Liza each swallow one. Jackie saves the other capsule for Mark, the Canadian who Liza describes as Jackie's "flavor of the minute."

Tall with long, brown hair and chiseled, gaunt features marred by crooked teeth and a long nose, Mark wears a silver bracelet on one arm and a string surfer bracelet and Tag Heuer watch on the other. He is a bartender at Deja Vu, another bar catering to the foreign crowd.

He kisses Jackie on the cheek, takes his Ecstasy and swallows it by sipping from Jackie's drink.

Jackie and Mark hug each other for a moment by the bar, gazing into each other's eyes, as Ice Cube raps "Dead on Arrival."

By 4:30 A.M. the crowd is dancing to Belgian techno music spun by a Japanese DJ wearing sunglasses and a Kangol hat. Jackie and Mark dance a little, they drink and laugh and feel good about each other and about themselves. It's moments like these when Jackie doesn't worry about getting out of hostessing and into her own business. That Mexican stretch of beach eight thousand miles away doesn't seem that important right now.

Until Shigematsu, the real estate speculator, walks into the club with his bodyguards and sees Jackie. She spots him as he walks over to a reserved booth. Pulling away from Mark, she mouths "One minute" and goes over to Shigematsu's table.

"Come on," Mark calls to her. "You ain't working."

As Jackie and Shigematsu dance on a crowded floor, the strobe light makes even his awkward steps look okay, and Jackie, wishing the song would end, looks over at Mark, trying

to catch his eye and smile and let him know that it is all business. Just business.

"We made everything clear." Jackie says when she returns from her Saturday lunch with Shigematsu. "The whole deal. Bank transfers. Lawyers. I have to start looking into Mexican water rights. That guy is in love with me. He couldn't stop telling me over and over again at lunch. He's even considering putting me in his will."

Liza, who sits at the kitchen table trying to decipher a financial-aid application form from Cal State says, "You need a lawyer."

"He *is* a lawyer." Jackie opens her Chanel bag and extracts a pack of cigarettes and lights up. "But you're right, I need a lawyer."

Steve, from the next room, shouts, "My cousin's a lawyer."

"Yeah?" Jackie says.

"In Scotland," says Steve.

Jackie ignores him. "I have to begin researching the amount of beach access required per guest and the amount of square meters required per horse. It's a maze."

Shigematsu has agreed to capitalize Jackie's development corporation for $250,000 if she will become his mistress. They will meet for dinner this Thursday and then retire to a pied-à-terre Shigematsu keeps in the Aoyama section of Tokyo.

Shigematsu picks her up in his Mercedes at nine on Thursday night. Jackie has arranged with the club to take the night off. She and Shigematsu dine without his bodyguards at a French restaurant in Tokyo's most famous hotel. They talk about golf, of all things. After dinner, in Shigematsu's car, Jackie asks to see the papers certifying that a bank transfer had been made into the Mitsubishi Bank account she has established for her corporation.

Instead, he hands her a small box wrapped in gold paper. She unwraps it and finds another diamond ring. When she thanks him and asks him about the bank transfer, he laughs

and waves her off, saying she shouldn't take things so seriously. They would, after all, know each other for a long, long time.

Jackie split ten days later to Koh Samui, an island off southern Thailand, taking $15,000 she had saved in tips and salary. She hocked her diamond rings before leaving Tokyo for about 20 percent of what they were worth.

While Jackie was in Thailand, Liza received her letter of acceptance from Cal State Fullerton for the fall semester.

Jackie returned from Thailand broke. She resumed hostessing in Tokyo.

XI

MOTO

HOMESTAY

Moto is speaking:

March twenty-third. The second time the silver-gray Toyota Surf drives by—with two guys in it who look like dicks, college guys, I don't know, just two guys I hate with haircuts like fucking Elvis Presley or those losers who dance to fifties music at Harajuku Park; I mean, just the kind of guys I fucking detest, who I can barely control myself around, you know? with pompadours, big, piled-up stacks of black hair, what the fuck kind of look is that?—I start paying attention to them.

Plus they're just driving around and around, going up Bunkamura Dori and then down Inokashira Dori past where we're hanging out; they're looking for girls or something or showing off that buffed-out four-wheel-drive piece of shit they think is so incredible that just sitting in it will pull some *saseko* [girl who will do anything], and it gets me pissed off. I start to feel like they're being disrespectful or something. I'm not territorial. Me and my friends, we're not a gang or anything, but that guy is the exact type I hate. Bad hair and a four-wheel-drive. Nothing worse in the whole world.

So I'm in a bad mood anyway. It's drizzling out, kind of light, pissy rain, like mist, and it's a slow Thursday night and the crowds wandering around in Shibuya are the usual bunch of college kids and high school kids who have nothing better to do. I feel lousy—those guys in the truck weren't helping—and me and Mako, who's my best friend, and his buddy Tai leave our usual spot where we hang out near Inokashira Dori and stroll through the middle of Shibuya, the brick-lined pedestrian street called Center-gai, and maybe half the kids are in school uniforms, carrying their little black bags. The girls licking ice cream cones and giggling. Some of the boys smoking cigarettes.

I feel shitty—you know?—pissed off about everything. But it's better here where there aren't any cars going by because that way I won't see those dicks in their stupid four-wheel-drive truck.

I got kicked out of Rikkyo High School three months ago for fighting. I'm eighteen.

My buddy Mako just came back from a homestay in San Jose, California, where his parents sent him so he wouldn't get in any more trouble. That's a popular thing among my friends' parents—the richer they are, the more likely that the moment they think they're going to have any trouble with their kid, they send him away on a homestay. The first choice is one of the programs in California or Australia. Then comes the east coast of America and so on. The worst place to go on a homestay—China. The programs have names like the Hayashi International Educational Voyages, My American Holiday, Seeing Lovely California the Takamatsu Way, or the Tanaka Rural Learning Experience. Some exist just to get problem kids out of Tokyo and the Japanese school system for a while. Kids simply vanish. It's better than going to a detention center or transferring to a bad school. Plus, the parents don't have to do any explaining to friends about why their kid isn't in school. Homestays are like a Japanese parent's problem solver. Your kid gets busted for drugs? Homestay. He has a gun? Homestay. Daughter keeps staying out all night? Homestay.

Lately, my mom has been bringing up homestays. She has some brochures from a company called California Learning, which for a few million yen will make sure I'm well provided for and placed with a good, stable family of white people in California somewhere. The pictures in the brochure make it look like a camping trip or something—people rafting in canoes, hiking in mountains, skiing.

Mako says his was a lot of fun. The parents who took care of him in San Jose were paid three thousand dollars a month, so he said he could do whatever he wanted. He said there were a lot of Japanese kids around—the homestay program gives you a list of Japanese kids who are over there. That's where he met Tai, even, and Tai's a good guy.

You know why?

Because Tai's dad is in the Ministry of Foreign Affairs. So you know what? When he travels with his dad Tai gets diplomatic immunity so he can bring back whatever he wants when

they go places. He's going to bring back a handgun, some bullets. A Glock, I told him, a Glock or a Tec 9, something really cool. So Tai's okay. Going to get us a gun.

Mako's my best friend. We've known each other since elementary school. He's taller than me, by about seven centimeters. But I'm more aggressive. Mako has short hair and wears a long leather car-coat, like a cop on TV. I have long hair, which I sometimes tie into a ponytail, and usually I wear a shearling leather jacket. I'm not short. I'm just a little shorter than average. Tai is about average height, with his hair cut almost short enough so you can see his scalp. But sometimes people say I'm short or that I get in trouble because I'm short. At Rikkyo, the P.E. teachers said with my body shape I would be a good soccer player. They're right. I'm a good kicker. Kick you in the fucking head. Got kicked out of school.

There are gangs around here. Groups. Little posses with cute names. Fly Boys. AMGs. Jasons. Aliens. You know what? They're all full of shit. They all got written up in magazines and there was a movie about them, about how there was this new street culture in Shibuya called the *shibukaji* [Shibuya Casuals]. Drugs. Break dancing. Gang fights. They made it sound like *West Side Story*. But you know what? I know most of those guys, went to school with half the AMGs, and they couldn't find you a Halcion in a fucking pharmacy. That's how dumb those guys are. Mako and I watched those shows, and read about them in *Brutus* magazine, about how they're selling drugs and all that, and we looked at each other and cracked up. What the magazines and shows didn't pick up was that just because a guy wears denim and a pair of Doc Martens doesn't mean he can get you any speed or a ten-milligram Valium. I know it for a fact. You know why?

Because Mako and I have been ripping all these guys off for the last few weeks selling them wack stuff and telling them its GHB or E or acid.

Here's what you do. Empty a gel-cap of Aptetinil-Depo, it's a kind of ethyl-amphetamine that can be sent through the mail

into Japan. Grind it up with a mortar or even between two spoons. Add niacin, caffeine, vitamin B12 and, if you've got it to spare, some Valium, and stuff it back into the capsule. Call it E and sell it for seven thousand. And those *shibukaji* will take it, feel something—the combination of speed, niacin, and caffeine is certainly a noticeable, if not powerful, combination—and those guys think they're getting off. Then we take the money and go get drunk, take a few speeds or some Fiorinal or Valium, get really high and have a great fucking time. Those guys in the gangs are a bunch of losers. That's why Mako and I don't belong to any one of the *shibukaji* gangs. That's why we're special. And that's why when we watch TV shows about Shibuya's street culture we just laugh. Those idiots would snort detergent and think that because their nose hurts like hell it must be good stuff.

You see, there's demand on the streets, the shows got that right. But there's a limited supply.

You can go to the Yakuza, but these kids aren't really connected, or you could go to the Iranians at the park, but everyone's afraid of the Iranians.

So that leaves us. Me and Mako, and now Tai.

We walk up Center-gai, toward Häagen-Dazs where some of the AMG OBs [Old Boys—older, retired members] are hanging out in the drizzle, getting their leather and moussed hair all wet and they nod to us because they know that we got the juice, we got stuff. Right now, I'm telling you, there's no one that's got more respect in Shibuya than us.

What's up? says Mura, who's like twenty-two and has absolutely nothing going on in his life. The reflection from the Love Burger sign across the street makes his face look red.

Not much, I go.

And he goes, Are you holding?

Yeah.

GHB?

I nod. You know the deal, I tell him.

This is really funny because everyone is talking about this new drug, GHB. I don't even know what it stands for. But everyone wants it. So one day when Mako and I had made a batch of gel-caps and were looking to sell some, somebody said what they really wanted was GHB. So we went home, emptied the gel-caps into bits of tinfoil and came back and said, here it is, GHB. And they bought it and said it was cool, better than E. Can you believe that shit? GHB is the hot stuff right now. Everyone wants it. Don't even know what it's supposed to be.

So he gives me ¥20,000.

And Mako gives him two hits of GHB wrapped in foil.

Later, I say to him. And we walk away from Center-gai, toward Inokashira Dori and we feel so good it's got to be better than really being on GHB, whatever that is.

You see Tai, we're telling him, you see how easy it is.

It's beautiful, he marvels.

The traffic up ahead is backed up where the pedestrians spill into the street and everyone's trying to hail a cab because the drizzle is turning into rain. Traffic's stopped. Then it goes. We're threading our way across the street and there are those fucking guys again in their four-wheel-drive asshole-mobile. They're weaving between cars, playing some EPMD at ten on their sound system, and I'm in a bad mood again.

One of them, a guy with the beginnings of a mustache and an earring in one ear, gives me this look that makes me freeze for a moment. Not like I want to hit him, but a feeling I don't understand.

Something like fear.

March twenty-sixth. When I was in school I had this best friend. Big fat kid named Tomo who was so shy he couldn't even talk to a girl but who I have known forever. His parents are friends with my parents, that kind of thing, so I saw a lot of him. We grew up together, played computer games, and traded comic books, and I always stayed friends with him even when I wasn't in school with him anymore, after I got kicked out. Tomo

is good at math, super-comfortable around computers—better with them than with people—so he's going to go to a good college. Still, even a good college sounds so boring to me; I mean, I see those guys, college guys, coming down from Todai in their preppy outfits and what do they want to do? Pick up the girls we're going out with. That's the joke—they want the girls we already have. So what's so great about college?

That's what I ask Tomo about when I stop by his house. That and I got to talk to him about something. His mom recognizes me through the video monitor at the door and buzzes me in and she asks over the intercom about how my parents are doing and I say my mom's great and my dad's in Malaysia playing golf. (My dad is always somewhere playing golf. Malaysia. Singapore. Hawaii. California. If there's a course, then he's there. I've never set foot on a golf course.) Tell them to please come and visit, she says.

I go down the hall to Tomo's room and he's in there playing with some kind of busted circuit board, pushing a soldering iron down on some yellow and red wires, the smell in the room is of smoking metal, and it's a strong, pungent smell. Tomo's room is all books, comics, computers, and busted circuit boards; he loves playing with computers, which is cool because he doesn't really have any friends besides me so it keeps him occupied, you know? Poor guy's got to do something besides jerk off.

Haven't seen you in a while, Tomo says, looking up at me and blinking. He's removed the soldering iron from the circuit board but the iron's still smoldering, sending a thin column of smoke straight into Tomo's eyes. He wears contacts—weird vanity on his part, since he doesn't go anywhere but school and home—and his eyes are welling up with tears because of the smoke. He puts down the soldering iron and bends over to unplug it from the power strip at his feet, and then he sits back and rubs his eyes with the collar of his shirt.

No, I say, I've just been hanging out.

Shibuya?

Yeah.

There's nowhere to sit down in his room but on his bed. which looks kind of gross but I sit there anyway, at the foot of it. Tomo turns back to his circuit board, which I can see now isn't busted at all but is just meant to be irregularly shaped, it's a slot-board, one that can be slid into a video game and played.

I ask Tomo, You fixing that?

No, he says, just switching it around. Going to make it faster. It's Street Fighter Two but I'm going to make it faster.

Cool.

He nods.

How's school? I ask.

Fine. Passed the entrance exam for Hitotsubashi.

That's something, you going there?

He nods.

I smile and go, So you're going to be prime minister someday? Or in charge of the Foreign Ministry?

Like half the government comes from Hitotsubashi, and suddenly I imagine Tomo, much older, in a bad suit with a receding hairline and he's president of some company or even prime minister or something, just because he does so fucking well in school. There's no stopping you as long as you keep getting the highest score on tests. What they should do, actually, is give a giant test to everyone in the country and whoever gets the highest score on that gets to be prime minister. Make it a really hard test, it would save everyone a lot of trouble.

Tomo shrugs. He inspects his circuit board closely and tugs at the wires a little bit to see if they'll stick.

From where I'm sitting it looks like a fine job but Tomo doesn't look that happy and puts the circuit board down on his desk, atop a copy of *Circus Sexus*, which is one of the porno comics Tomo likes.

Hey, Tomo?

Yeah.

Can you set us up with some cellular phones? Me and Mako were thinking it would be cool to have some mobile phones, then

we wouldn't have to run around so much or just one of us could be out in the street, you know, walking around and the other one wouldn't have to be there.

Tomo thinks this over for a moment. He says, What you would have to do is get the phones—

We have phones.

Okay, then the problem is activating them.

That's where we thought you'd help, Tomo-sama.

He says, The only way to do it is to patch into an existing number, but it wouldn't last very long, because as soon as someone found out you were making calls on their account, the account would be closed.

How long would each account last?

Maybe two weeks, a month at the most. But each time you change, there would be a chance you could get caught, because you would have to tap into another account. For cellular phones, Tomo explains, the dream situation would be to steal two live ones and then not have them reported—

That's impossible, I point out, and besides we already have phones.

Tomo agrees.

I'm starting to get pissed off at him. All I want is to have two phones activated for a few weeks. No one would catch us and we can try it out, see how the system works.

I say in a cool, serious voice to Tomo, Could you activate two phones?

Yes.

Fine. I reach into the inside pocket of my shearling jacket and take out two phones, one Shintom and one Novatel. We took the phones in a trade for drugs from a few punks last week.

Tomo looks them over and smirks. These aren't good phones, he complains. Not much talk time. Short battery life. Just ten memory locations. Only sixty-four numbers—

Who cares? I ask.

He shrugs. I'll see what I can do.

I scan his room and take in Tomo himself. He's a fat ugly guy with bad skin and he's going to one of the best colleges in

Japan. I ask him, You ever think about doing anything besides studying and jerking off with computers?

What's wrong with studying and computers?

I don't know. Nothing. Just, don't you want to live a little?

Look, he says to me, wiping his eyes again with the collar of his shirt, you play around on the streets, getting loaded and fighting, and I'll play with computers and study and I'll see you at the finish line. Then we'll decide who wins.

I have nothing to say to that.

I'll call you about the phones, he says.

March twenty-seventh. I saw those assholes in the four-wheel-drive again. They were definitely checking out me and Mako. I even pointed them out to Mako, but he said he'd never seen those guys before. They're just a couple of assholes in a truck, Mako said, don't worry about them.

But still, I feel like they're keeping tabs on me, like they know what I'm doing and are intentionally checking on me. They're a little older and the one with the mustache looks like he's about twenty. Whenever I see them I get in a bad mood.

But I just walk away. When I see that truck I just walk away because it's becoming like a bad luck sign or something.

You're just jealous because you can't drive, Mako says.

Is that it? No way, I just hate these guys.

March twenty-ninth. We got the phones today. Tomo called me and told me to come over there and I picked them up and they worked fine, better than any walkie-talkies I ever used. So now me and Mako can talk to each other, even when we aren't around each other, and we don't need to carry any stuff around. Me and Tai just go around, and then kind of take orders, and collect the money and then Mako comes around with the drugs. This way we're never caught short. But, if we are, Mako can cut it up at home to make a smaller batch go further. Plus, if we ever have any trouble, like someone trying to get heavy on us, we can phone for backup.

And, it's really cool having a cellular phone—it's real, big-

time, James Bond stuff. It feels really cool to be standing around in front of Octopus Army or somewhere with a bunch of little *chimas* [girls] and then hear the chirping cellular ringing and then flipping open the phone and answering and everyone looking at you. That's a good feeling, like you really are somebody.

March thirtieth. I'm walking up Center-gai with Tai and we've just made up a huge batch of powder. Mako has it at home and he's watching *Terminator 2* on video and waiting for me to call him (actually, we only needed one cellular phone because one person always is at home, but this way, if we need two, we can get them, and also this way one of us can go out). Over by the Love Burger I see four guys I recognize as part of the NBAs, another Shibukaji gang, these guys are a little older than some groups, and I know Kohji, he went to the same high school as me, only two years earlier, and he's a pretty cool guy, pretty tough. I once watched him beat the crap out of some little faggot in a school uniform right in front of the Arby's. Kohji knocked the kid over and was kicking him in the face with his Gorilla boots while the kid was just laying their trying to cover up. It was a crowded day, raining a little, and people were gathering around to watch, so one of Kohji's friends, another NBA guy, grabbed Kohji from behind and led him away. Kohji was laughing while he stomped away from the bloodied kid.

Tough guy, Kohji. I still don't know why he beat up the kid.

What's up? I ask them.

Kohji smiles at me and his eyes are really red, like maybe he's a little drunk or something. Nothing.

You want anything? I ask.

He shakes his head. We're fine, he says.

I find this very disconcerting. Kohji always wants something, and his guys are always good for buying a few hits of our Ecstasy or something.

Okay, take it easy.

And on the way up the street, up to where the NFL experience and the Dr. Jheekans and all the arcades are, I'm telling

Tai I can't figure it out, that Kohji always wants something. And Tai says that maybe Kohji figured out it's all crap.

Kohji? Figuring that out? Nah.

The Jasons also don't want to score.

Neither do the Fuckers. I can't figure this out.

I call Mako on the cellular and I can hear John Conner in the background and I tell Mako about the NBAs, Jasons, and the Fuckers all not wanting anything and he says he can't believe it and I agree. Then as I'm standing in front of the NFL experience, near the elevator bank, I see the four-wheel-drive go by again and the guy is staring at me again.

Who is this guy? I say into the phone.

And Mako says, Who?

It's those guys again, I tell Mako, the guys in the Toyota Surf.

And then Mako asks me how much money I have because he wants to order a pizza, and I tell him nothing because I had to pay Tomo for working on the phones and I still owe him ¥20,000. Mako says he doesn't have any money either because he had to pay for the Aptetinil-Depo so we could make the Ecstasy and now we can't move the E, so what the hell are we going to do about eating?

Tai, I say, you have any money?

He nods. A little.

Enough for a pizza?

What's that, like three thousand?

About.

Tai nods his head.

Go ahead, I tell Mako, order the pizza, we're not getting shit out here tonight.

April first. We haven't been selling shit for the last two days. Mako sold two hits to these girls near the Parco Number Three building, but he said that was like trying to convince two virgins to fuck a donkey it was so hard. He says if selling this stuff is getting that difficult we had better find something easier, because this is turning into a bitch.

The usual guys, the Jasons and AMGs and the Fuckers, all the little Shibuya gangs the media wrote so much about are suddenly not buying anything from us anymore. They've just stopped, and when I ask them what's up they just say they don't need anything, you know, the economy, the recession, the bubble's burst, and I'm thinking no way, that is not a good reason for anything with these idiots.

And then one evening I'm in Taco Time with Kohji, the hard guy who's in charge of the NBAs, and I'm eating these little fried potatoes they sell and I can't even buy a Coke because I don't have any cash and I keep bugging Kohji to tell me what's up, why isn't anyone copping any more drugs. I'm thinking about chucking it all in and going on a homestay or something because I don't see any future in this anymore. Then Kohji takes a bite from his teriyaki chicken taco and while he's chewing it he looks at me and begins talking, the cheese and shredded cabbage and chicken skin all mixing up with his braces so that it looks gross.

You don't get it, do you? You guys were selling crap, bullshit, did you think you could keep doing it forever? I was dumb, but I know now. We're getting better stuff, the real thing, and that shit you sold us was just crap, all fake. You were ripping off your friends, you asshole.

Kohji finishes chewing and swallows.

Nobody's going to buy anything from you. There's real stuff around now. Good Ecstasy for eight thousand a hit. One hit and you really get spun out, not like that shitty speed or whatever it is you were passing off. I got your number. I should beat the shit out of you myself, drill you, really fuck you up. And I would if I didn't know you so long. I'm doing you a favor not beating the shit out of you. Give it up, you're finished.

He swallows the rest of his taco and some teriyaki sauce runs down his cheek and I hand him a napkin so he can clean it off.

Who is it? I ask.

Some guys, two guys, they drive a Toyota Surf around. I see them around a lot, and they're always holding.

* * *

As soon as I leave the place I call Mako on the phone and tell him about what's happened.

It's those guys, I tell Mako, those guys in that fucking Toyota four-by-four. I told you, I told you. We should find those guys and nail them. Hurt them. Make them wish they'd never heard of Shibuya or even read a fucking comic book about it. If I had a gun I'd blow them away. Where's Tai? When's he going to get that gun? That's what we need. A Glock, put a fucking hollow-point through his chest and then shoot his tires out. I mean, who do they think they are moving in on us like this? It took us weeks to set all this up and now some guy in a truck with a bad haircut thinks he's going to take it over. I'm going to kick him in the liver. I'm going to stick him with a knife. With a fucking *katana* [sword], a clean thrust right up under the short rib—

Mako interrupts me: Did Kohji say who these guys were?

Nah. But who cares? They're always around. I know where to find them. They're not that—

Listen, come over here and we'll see about what to do.

Mako's got this actual-size poster of some black basketball player on his wall and it's over two meters tall and when you stand next to it you get some idea of how big this basketball player is. He got it when he was on his homestay in California and says that all basketball players are that big, which I don't believe. He also told me that all basketball players are homosexuals and that one has AIDS, which I do believe because I heard that on the news. When I was a kid I was a big baseball fan, loved the Giants, loved Kuwata, their pitcher, because he wore an oversized cap at this weird angle so that he looked like a, I don't know, like a misfit, kind of tough, like someone I would want to hang out with. And he was a great pitcher, had fifteen-win seasons, ERA under two, but then, once he had a bad season, the team made him wear a cap that fit and not at an angle so that he looked like any other Giants player and that bugged me somehow, like couldn't anything about the team be cool, or different, or at least not like everything else. Like Komada, this

big first baseman I hate who hit about fifteen home runs a season but acted like he was a big power hitter. I hate his big, fat, smiling head and the way he trots out to take his position and the way he looks all earnest and interested when he's taking batting practice. I hate all his good-natured enthusiasm. Drives me crazy. Reminds me of everything I hated about high school—we were all supposed to be enthusiastic and quiet and obedient and not complain when everything is absolutely fucked up from start to finish. It was a bitch fitting in. Actually, I'm sick of baseball and so are all my friends; who cares anymore about this game? As far as I'm concerned this game might as well be played by faggots, because that's how interested I am in it.

Tai and Mako are playing Street Fighter Two on Mako's computer when I walk in and they hardly pay any attention to me.

I got a winner, I say, and sit and start flipping through old *Be-Bop High School* comics, which is really boring, and the game between Tai and Mako will probably never end because the two of them are about equally as good, which means they've mastered the game by now—who hasn't?—and then it occurs to me that what we need is Tomo's speeded-up circuit board. So I take the phone and call Tomo and his mom answers and asks how I'm doing and I say fine, and then she asks about my dad and I decide to fuck with her and say he's playing golf in Siberia but she doesn't notice and buzzes up to Tomo to pick up the phone. And when he does I can hear he's playing Street Fighter Two in the background.

What's up? I ask.

Playing a little Street Fighter Two.

The speeded-up one?

Yeah.

How is it?

It's not so good. It's kind of the same as the old way, only you just have to push the buttons faster.

That's it?

Uh-huh.

Maybe I should get one anyway, I wonder out loud.

You still owe me for the phones. When are you going to pay me for the phones?

Don't worry.

I hang up and finally Mako turns to me and shrugs.

We talk for a while about what to do because it looks like there's no way of getting any more money out on the streets, unless we can get rid of those guys in the four-by-four. And even if we do, we can't go back to selling our old stuff if this new stuff really is that much better, because even though all these kids out on the street are a bunch of poseurs and idiots they still won't buy what we're selling anymore.

I tell Mako and Tai that it looks to me like we've got no choice but to find those guys in the Toyota four-by-four and threaten to beat the crap out of them if we don't get cut into the action.

It's our place, I point out, we created this market. This is our thing.

April third. So we spread out, Mako and Tai with one phone and me with the other, and prowl Shibuya starting at about four in the afternoon when the gangs all start hanging out. It's a nice day, the sun is still up over the Tokyu department store building and is bathing the whole Shibuya crossing in orangey light so that you can't see the videos on the Axis video monitor over the intersection. It's the first day when you don't really need a coat, and even I have to admit that it's great walking around in just a sweater and jeans and not having to worry about my cellular phone getting wet. I'm wearing sunglasses and I'm waiting at the light to cross the street diagonally and I'm checking out these cute high school girls next to me who are giggling and covering their mouths with their hands and looking at me sidelong.

I go, How're you girls doing?

And they look at me like I'm a drug dealer, which I am, or at least was, and giggle some more and then the light changes and they cross.

Fine, fuck them, I think. Who needs two losers like that?

There are always lots of girls, that's the great thing about Shibuya. And there are love hotels right up the hill, hundreds of them.

As I'm walking across the street and thinking how I wouldn't mind meeting a girl—it's been a while, okay, it's actually been months—something flashes gray on my periphery and I turn and see the Toyota Surf making a right onto Koen Dori. There they are.

I flip open the phone. Mako answers.

They're here, I tell him.

Where?

On Koen Dori, driving toward the Seibu buildings. Meet me in front of Seibu One.

I run the rest of the way across the street, dodging pedestrians and start trotting down Koen Dori, keeping abreast of the Toyota Surf as it slows down in heavy traffic. The same two guys are in the truck, the driver with his stupid Elvis hair. These are the guys who are taking our business. These losers. I was so right to hate them from the start. They've got the sun roof open and the Blue Hearts "Train Train" record is playing, which really bugs me because it reminds me of high school. I see Mako and Tai standing in front of the Seibu, looking down the road at me and I point over my head at the Toyota. They look at the truck and then back at me, and then the bad music and the stupid hair and the big truck and their cutting into our trade all get to me and remind me of everything I hate and I tear across the street, weaving between cars stuck in traffic, and before the two jerks even know I'm there I'm opening the driver's side door and I throw a punch at the driver. The blow doesn't really connect solidly because I'm throwing upward and my fist glances off his head and hits the sun-roof pane and I think I've even cut my hand, but I can see the guy is shocked and is already trying to unbuckle his seat belt, which is one of those over-both-shoulders-ultra-secure ones, so he only has to push one button and all four belts disconnect from the center. He's faster than I thought he would be, and after I've thrown a left that sort of glances off his chest he has begun reaching for the door, which I

can't understand because there's no way he can shut the door as I'm standing between the door and the car, and then he pulls his hand back in, and he has something black and boxy the size of a cellular phone in it and he holds that against my solar plexus for a second and before I can flick it away I'm zapped by ten thousand volts of stun-gun juice and I jump up and back, out of the door frame, and the gun sticks to me and he keeps zapping and I feel something deep in my chest, like something scraping my heart from the inside. I slump right there in the middle of the street, and as traffic starts to go I hear the honking of cars and can barely focus on the four-by-four driving away, and I can hear the music again, that stupid Blue Hearts crap, that singer going, "This isn't heaven, but it isn't hell either," and I can see the back of that guy's ducktailed head and I think I'm going to puke.

Come on, get up, you can't sit here, Mako is telling me.

He's standing over me, looking down the broken yellow line for oncoming traffic. People in cars driving by are looking at me funny. Some guy with glasses in a Nissan Fairlady. Woman with short hair in a Benz. Two taxi drivers. Tai and Mako wait for me as I unsteadily find my legs.

Did he hit you? Tai asks. Where did he hit you?

He had a stun gun, I say. He shocked me with a stun gun.

The traffic breaks and we walk to the curb. A small crowd of people is standing there watching, but I ignore them. Mako and Tai seem a little embarrassed about the whole thing.

Embarrassed? I think to myself, I'm fucking furious.

At the curb, I catch Mako and Tai exchanging glances.

You didn't see it? I tell them.

Mako hands me my phone, which must have fallen out of my pocket. Let's go, he says.

No, wait, I say, You mean you don't think I got zapped?

Tai goes, We didn't see anything.

I wasn't talking to you, I snap at Tai. I turn back to Mako.

We didn't, Mako says.

I shake my head. Fuck you guys, I tell them, and walk away.

It's nine o'clock before I finally calm down. The sting of the stun gun wears off pretty quickly, actually, and in about 'an hour or so I feel okay but a little frightened; I won't get zapped again. But the sting of my best friend not believing what happened to me, that makes me furious, gives me bad feelings, drives me to hate. I don't know who to hate, but I'm angry.

The open door must have blocked Mako's and Tai's view of what actually happened.

So maybe they think I'm a little stupid, that I shouldn't have acted so rash and quick in trying to jump those guys, but I thought my boys were going to watch my back and I had no idea they had a stun gun. Who knew? And acting fast is one of my strengths. I believe in showing no fear. I don't believe in hesitating. I mean, when combat is called for then it's called for so you might as well get it on. That's my attitude. And toe to toe, with people who are about the same size as me—and the pompadoured dick in the Toyota Surf is about my height—I'll slug it out with anyone.

I'm sitting in my bedroom, listening to my mother practicing her stupid piano lessons. It's repetitious and she makes tons of mistakes. She's been taking three lessons a week for a decade and she still sucks. When I came in she brought up the homestay program again. (You can go shooting, she said, they have rifle ranges in America.) I ignored her.

There's nothing on TV and I don't have any money to do anything so I go down to the kitchen for some food and there's bananas so I take some, and while I'm going back upstairs I hear my mobile phone ringing in my room and I think it must be Mako wanting to apologize or at least to make things right between us.

It's Tomo.

Where's my money? he asks. I want my money.

Okay, okay, I assure him, I'll get it. I've got about ten million things going wrong for me right now.

I want my money, he keeps repeating. Tonight. Or you'll have ten million and one things wrong.

I don't have it now, I explain. Give me a break. Me and the boys are getting some deals together, then we'll have it.

Tomo sounds really mad.

Look, I did the phones for you just like you asked. I did my job, now I have to be paid, I don't do this shit for free.

I thought we were friends, I say, not really meaning it but I have to say something.

Were, Tomo says, were friends. I'm going to college soon and I don't need this kind of crap. I did you a favor.

I hang up and I'm thinking, when did Tomo suddenly become all tough about everything? He's always been the loser, a guy I sort of look down on but hang out with anyway sometimes because I feel sorry for him and I've known him so long. I've always thought of being friends with him as kind of like charity work. And now he's giving me all kinds of yang about the money for the phones and that's the last thing I need to think about now.

April fourth. Now I'm in a good mood, and I feel like it's time to fix things up with Mako and let him apologize to me and then go straighten out these scumbags in the Toyota Surf and then see about making some money and getting Tomo off my back. I just want to get things back the way they were. I would even consider working with those guys in the Toyota Surf, even though for good reason I owe that guy a few shots.

On the phone, Mako just says hello. He doesn't apologize, doesn't even talk about what happened yesterday, he just says what's up, and when I tell him to get Tai and meet me in front of the Tower Records he says okay and is about to hang up, and I say in a half-hour and he says okay.

Maybe he's too embarrassed to say anything. I would be if I were him, considering that I risked my ass for our business and what happened was he and Tai find me in a heap. I decide that I'll be cool about yesterday. It's hard to admit you're wrong, I know that, so if I just let it go that would be nicer of me.

I get there first and am waiting a little up the street from the Tower Records in front of this stand where some guy we sort of know sells heavy-metal T-shirts. He used to buy drugs from me, but when I get there before Mako and Tai he ignores me. Like some guy selling bootleg Kiss T-shirts has so much going on he can't even say hello.

Sun streams down the narrow street, silhouetting the salary-men marching down the hill from the NHK building and the mothers with little kids strolling from the park. It was cloudy before, but it's warm when the sun's out, but the sun keeps going behind clouds and then coming back again fast so that the light is always changing, but it's better than rain or winter. A bunch of kids in school uniforms and yellow caps and thick leather backpacks come walking down the hill toward me. For a minute, as the sun slides behind some clouds again I'm nostalgic about being a kid, about how you're stupid and confused and insecure but in a nice and not frightening way, and then I remember that being a kid kind of sucked, I never knew what I was supposed to do. In fact, I hated it—short hair and that stupid uniform and all those times tables and long division. Awful.

And then there comes the Toyota Surf. I pick it out above the heads of the children as they pass me going downhill. The guy that zapped me is at the wheel and he sees me the moment I see him and he smiles this really mean, vicious smile that reminds me of the stun gun and I shiver once before I control myself, and then I realize that I'm afraid.

Where the fuck are Mako and Tai?

I take my phone, hit the auto-dial for Mako's number, push send, and nothing happens. I do it again, this time dialing his number myself before sending.

The Toyota double-parks. The guy with the pompadour gets out and his partner steps down to the street from the passenger side door. I hadn't noticed it before, but the partner is big, maybe six centimeters taller than me, and he looks older, like mid-twenties or something.

My phone's dead and I'm cursing and then I realize that

Tomo has called the numbers in to NTT, closed down the accounts, and shut off the phones. Fucking Tomo.

The pompadour steps over the guardrail and the only thing between us is the pedestrian traffic. He waits as his partner is caught in the center island. The T-shirt seller quietly moves to the other side of his little stand, and out of the corner of my eye I catch him smiling.

Mako and Tai aren't coming, it hits me. I'm alone. I run.

Maybe a homestay program is not such a bad idea.

XII

SNIX

THE OTAKU

Modern-day Tokyo is a society in symbiosis with the machine. Exactly where human beings end and technology begins can become confusing in a city that resembles, more than any other city on the planet, a neon-lit circuit board writ gigantic.

Grandmothers in kimonos bow in gratitude to their automated banking machines. Young couples bring hand-held computer games along for romantic evenings out. Workers on a Toyota assembly line vote their robot coworkers into the Auto Workers Union. A woman calls the Matsushita Denko kitchen design showroom to complain because her kitchen doesn't look like the model kitchen she saw in a virtual reality walk-through demonstration. "I was expecting more vivid oranges and pinks. Something more cartoony," she complains.

Voice-activated elevators. Cars that tell you to slow down. Houses that adjust internal temperatures themselves. Vacuum cleaners that alert you when it's time to clean. Toilets that know when to flush. CD to DAT to DCC to Mini-Disc. The march of progress, Tokyo-style. The most automated city in the world.

The cultural ground in Japan has always been fertile for new philosophies and ideologies to take root and flourish. There is no absolute, objective moral code. Confucian ethics, adapted from China, encourage an intricate but subjective morality. The concepts of *tatamae* and *honne*, meaning, respectively, public and private face, allow for different interpretations of truth and falsehood depending on context. There is no one reality. Instead you take your choice of what reality suits you. Japan has come to resemble *Total Recall* more than the oft-cited *Blade Runner*; truth is a memory implant: take a package trip to Paris where you will never speak to a non-Japanese and never eat any indigenous cooking. That other place, with the French people and heavy sauces, that's someplace for French people. Paris, for Japanese, is the implanted place, with Japanese people and sushi.

Compared to the United States and its relatively rigid Judeo-Christian ethical system, Japan is a moral donut you can fill with whatever pleases your fancy: Buddhism, Christianity, top hats, industrialization, fascism, the Beatles, pacifism, or

McDonald's. The Japanese have come to each of these with the fervor only a people without a strict, all-encompassing moral code could generate. The emperor is divine. The emperor is not divine. (Or again, maybe he is. No, he's not, etc.) Dianetics. Beaujolais Nouveau. Pyramid games. Air Jordans. Trends. *Turendo*. Booms sweep over Japan like the seasonal typhoons. The hula-hoop boom. The imported car boom. The Guns N' Roses boom. The Guns N' Roses suck boom. (We have already witnessed the disastrous effects of the boom mentality when the boom is a militaristic impulse to subjugate Asia or a sudden upsurge in the popularity of whale meat.)

And now, into this society so eager for a better boom, for a later trend, for a newer way of life, comes technology.

The computer boom.

Unlike hula hoops or tiramisu, the computer boom will have a lasting impact. In that sense, the computer boom resembles the Confucius boom of the seventh century or the Buddhism boom of the ninth. This is a boom that will leave as its residue a new way of being Japanese.

The computer has transformed Japan in different ways than it has the United States. America has the great computer visionaries like Jaron Lanier and Marvin Minsky. America also has the legendary computer entrepreneurs like Bill Gates and Steve Jobs. But Japan, unlike America, has become thoroughly computerized in all segments of society. Not only in banks, schools, factories, offices, and children's bedrooms, but in the psyche as well. Shintoism, a religion unique to Japan that is a mixture of animism and pantheism, is a "lite" faith devoid of heavy ritual or demanding liturgy. Worship is meditative, requiring contemplation of nature spirits and our oneness with these spirits. In other words, man and nature are one. Animistic religion precludes making a distinction between the human sphere and the sphere of nature.

Thus Japanese maintain a different relationship with their technology than the West. They simply view their PC or television as another object, like a rock or a tree or a kimono, which

is of nature and hence of themselves. One big Summer of Love between man and machine, because there is no man distinct from machine. This outlook, resembling particle physics put through a Tao of Physics food processor, has a proponent in University of Tokyo sociologist Volker Grassmuck: "The Japanese feel less at home with other people than with machines, materials, and information. They tend toward a sort of in-animism."

And no one will ride in-animism, or the meshing of technology and humanity, farther and harder than the Japanese. Real-life simulation games about child rearing, going on dates, cheating on exams, stamp collecting, and even games in which the object is to design successful, best-selling games (games within games) proliferate. Dogs and cats are viewed as inanimate toys, like Ultraman dolls or remote-controlled miniature four-by-four jeeps: when the dog is boring or annoying it can be discarded like an out-of-favor toy. (Every year the Tokyo metropolitan police department sets a new record for dogs destroyed.)

Virtual starlets are created. Yui Haga is a phantom comprised of different bodies and different voices. At concerts her face remains obscured and her voice is prerecorded. For television she is portrayed as an animated doe-eyed cutie. At a book-signing party for a recently published photo book, there were three girls at the autograph table. Fans could garner the signature of whichever of the three most closely resembled their interpretation of Haga-chan. Everybody knows Yui Haga doesn't exist. Therefore she can be all things to all people. She lives only as a media creation and Information Age phenomenon. Strip away the technology, and there is no starlet.

The line between reality and technology begins to blur. Or else it never existed. While individualism as practiced in the West throws up obstacles to technological proliferation, groupism as practiced in Japan encourages the march of progress.

The average Japanese is more comfortable with a new fuzzy-logic toaster than his preternaturally skeptical American counterpart. The new product has been made, tested, and approved by the powers that be and therefore must be kosher

(after all, Japan has the highest quality control standards on the planet). So slide the toast in and put it to work. And trust. Have faith: you and your toaster are part of the same group, part of the same big cosmic oneness. Yes, that's right, you and your toaster are one. So why shouldn't your toaster know that you like your toast light brown at 7:34 A.M. except on Sundays?

Though Japan is the only nation ever to have suffered the effects of man's most destructive technological achievement, the atom bomb, a sinister view of technology has never evolved to the extent that it has in the West, where technology, science, and the military industrial complex are sometimes viewed as an evil cabal in cahoots to destroy humanity. If technology in Japan has any moral imperative, it is as a positive influence. Television is ubiquitous, and the ranting of Western parents about children watching too much television would seem totally out of place in a society that watches more television than the United States. In Japan technology is seen as life-saving, like arthroscopic surgery. As helpful, like the bullet train. Or as adorable, like "Hello Kitty." Technology is your companion. Technology is your teacher. Technology is your friend. Technology is your livelihood.

Ultimately, technology becomes your reality.

This blurring of man and machine, of reality and what comes in over the VDT, is spawning a generation of Japanese kids who are opting out of the conformity of Japan, Inc., in favor of logging on to computer networks. They have been dubbed the *otaku* by the Japanese media, from the most formal way of saying "you" in Japanese, the implication being that there is always some kind of technological barrier between people.

The *otaku* came of age way back in the eighties with Paleolithic 186 computers and Neanderthal Atari Pac-Men as playmates. They were brought up on junk food and educated to memorize reams of contextless information in preparation for multiple-choice high school and college entrance examinations. They unwound with ultraviolent slasher comic books or equally

violent computer games. And then they discovered that by inter-
acting with computers instead of people, they could avoid
Japanese society's dauntingly complex Confucian web of social
obligations and loyalties. The result: a generation of Japanese
youth too uptight to talk to a telephone operator but who can
go hell-for-leather on the deck of a personal computer or work-
station.

First identified by Japanese lifestyle magazine *SPA!*, the esti-
mated 350,000 hard-core *otaku* are Japan's newest Information
Age product. "These are kids unlike any who preceded them in
Japan," *Lap Top* magazine editor Abiko Seigo says of the subcul-
ture of sixteen- to twenty-five-year-olds. "Where they are coming
from is a world where all the usual perspectives—such as whether
something is good or bad, smart or stupid, et cetera—are irrele-
vant because all of those things are judgments based on social
relations. If you don't socialize, you don't have much sense of
morality. The only thing that matters to them is data. How much
do you have and how much can you memorize."

That's hardly surprising, given the *otaku*'s years in schools
that emphasize rote memory over creativity and analysis. "Data
is practically worshiped in the Japanese school system," Volker
Grassmuck explains. "The exams test and reward those who
can process the most data."

Information is the fuel that feeds the *otaku*'s beloved dis-
semination systems—computer bulletin boards, modems, faxes.
There are *otaku* cliques devoted to *manga* (comic books),
weapons, monsters, videos, pornography, and teen idols. Mon-
ster *otaku* may collect the names of the various actors costumed
in rubber suits as Ultraman who were conspicuously shorter
than usual. Military *otaku* may know the tread width of the
German Pzk Mark IV tank and the velocity of the armor-pierc-
ing ammunition it fired. Everything—the blood type of comic
book artist Osamu Tezuka, the number of casualties at the
Battle of Midway, the age of pop star Miho Nakayama—is just
more contextless information, to be memorized, processed, and
stored in the brain or, more efficiently, on the hard drive.

Data, the newer the better, is status. Acquiring it may require *akisu* (hacking) into corporate data vaults or tapping into a fax line. (Among *otaku*, it is a matter of pride not to buy or sell information.) Their obsession with gathering may, at first glance, seem no different than the fanaticism of collectors of rare books or baseball cards. But it is as if instead of trading actual cards, card collectors were to trade only information about cards. ("Did you know that Hank Aaron had to pose seven times for 1970 Topps baseball card number 500 before they were happy with the shot and that the bat he was holding actually belonged to Eddie Mathews?") The objects themselves are meaningless to *otaku*—you can't send Ultraman or a German tank through a modem, but you *can* send every piece of information about them.

A dropout from the prestigious Keio University's mathematics department, Snix (a computer network sobriquet) used to be an idol *otaku*. Throughout high school and college he was obsessed with data about idol singers. But Snix wasn't interested in the successful idols, nor did he care that the music is repetitive and juvenile. He wanted all the information he could get about Chisato Moritaka—a cute-as-a-button up-and-coming idol. He needed to know the usual fanzine data such as her zodiac sign, blood-type, favorite foods, and what her father did for a living. But he delved much further for arcane and perverse info-bits such as her bra size (75-A), any childhood diseases she may have had (chicken pox and mumps), or which assistant sound engineer would have been used on the "Seventeen" single if he had been available. Snix scoured celebrity magazines, he accessed the Nifty Serve bulletin board that carried relevant information deposited there by other idol *otaku*, and he finally devised a way to hack into Warner Music Japan's mainframe with his own FM Zoom system and modem. There, in the Warner Music computer subconscious, he found a vault of previously inaccessible information about upcoming record store appearances and release dates for new singles, which made him an idol *otaku* hero when he sent it out over the com-

puter networks. The important point for Snix was not the relevance of the information, nor the nature of it, but that he had it and others didn't.

Throughout Snix's adolescence, his achievements in gathering data and hacking into mainframes, his technological expertise, were what he was praised for by other *otaku*. In psychological terms, his first positive reinforcements were messages sent to him on a computer bulletin board. Snix was a hot-shot idol *otaku*, renowned from Kyushu to Hokkaido for his ability to *akisu* data vaults and find factoids about his favorite idols. He thrived in the networks, was lord of the nerds. They were a subculture of kids, trading information, trivia, and corporate passwords in their bedrooms via modem while their parents downstairs thought they were studying. But they weren't studying. They were so immersed in the world of computer networks, cracking corporate security codes and analyzing algorithms, they could never come back. And all this just so they could be the first to disclose an upcoming record store appearance by idol-singer Seiko Matsuda.

A funny thing happened when these kids grew up: they had to make a living. For Snix it happened when the dean of the Keio University mathematics department called him into his office and said he should consider transferring to the night school. In Japan, this is the equivalent of being asked if you've ever considered joining the marines. Snix got the message and dropped out of college.

"That wasn't my scene anyway," Snix recalls. "A bunch of professors talking theory. I was into practice, into being on-line and breaking into a computer system and finding something that no one else had ever seen. The feeling you get when the screen blanks for a moment and then a program boots and you see the data falling in a neat, even row, like a waterfall, down the screen. How could I tell some dean what that felt like? How could I sit and listen to a math teacher talk about differential equations?"

But once out on his own, Snix had other worries. Like how could he make some yen?

"I was an *otaku*." Snix shrugs. "I only knew how to do one thing—get information."

It was time to put away childish things; he was done with idols. Snix went underground. His first job was to find out which questions would be on the entrance exams for various universities. Certain *juku*s (cram schools) had promised to reward him handsomely for this service. Ironic, because those same tests had given him so much trouble as a student, but he had never bothered to hack for the answers. He easily broke through academia's nonexistent computer security and found the test questions. His career took off. Snix found himself in demand by everyone from Yakuza thugs looking to tap into bank accounts to companies looking to gain an edge on the competition.

Snix's small Koenji apartment is a shrine to arcade-game and computer technology—a panoply of VDTs, circuit boards, battered decks, burned-out hard drives, busted joysticks, first, second, and third generations of everything from eight-digit LCD calculators to DCCs (digital compact cassettes). The door to his tiny apartment is quadruple-locked—a small slot like a doggy door allows delivery boys to drop off pizzas or *ramen* noodles and pick up their payment.

Snix dresses in standard *otaku* garb: jeans, a hooded sweatshirt, and either sneakers or desert boots. The elements of his wardrobe are all interchangeable, like some dingy, nerdy version of the Geranimals line. His hair is long, stringy, and greasy. Though he is twenty-five, his acne appears to be of a particularly resilient strain, and his diet of chocolate bonbons and potato chips doesn't help.

Snix laughs out loud as he reads a fax from one of his employers. He eats a chocolate bonbon with a pair of chopsticks instead of his fingers so as not to dirty his keyboard. The two Sharp fax machines behind him have been whirring and beeping steadily for the last hour. He turns from his keyboard to the machines every thirty seconds and strains to read the Japanese characters as they are fed from the machines upside down.

The fax that has him chuckling concerns a large insurance company. Snix has promised to deliver to his employer a list of the company's wealthiest customers. Snix's employer will pay him, for a list of fat cats, one thousand yen per name. So if Snix can *akisu* into the insurance company's computers and find a thousand people who pay premiums equivalent to one hundred thousand dollars a year, he will receive a million yen. His employer wants the names for a mailing list that he will sell to political organizations, right-wing fundraising groups, and investment brokers.

Snix is laughing because he did hack into the insurance company data bank and found, instead of fat cats, a list several hundred names long of Japanese women who have had silicon breast implants in the last two years. He wonders what a specialty skin magazine or malpractice lawyer would pay for that list.

Japanese computer security is still very lax. Computer hacking is a relatively new phenomenon and very little is being done to interdict *otaku* such as Snix who choose to exploit Japanese computer networks like ASCII and Nifty Serve and rummage around in privileged corporate or government mainframes. "It's a joke," says Hitoshi Yamaguchi of Sega Enterprises. "We're at the point the United States was at ten years ago in terms of computer security." For those *otaku* who are pioneering the criminal side of computer hacking, it's as easy as finding the correct password by running a standard dictionary search-and-match program for a few thousand *kanji* (Japanese characters).

When the job is done, Snix will give his employer one hundred sample names, occupations, addresses, and phone numbers from the insurance company's data vaults and give him the number of names he has for sale. His employer, a man known to him as Yoshida, with whom he communicates exclusively via fax, will check the list's authenticity and, if everything is in order, will deposit ¥1,000 per name into Snix's bank account via computer transfer. Snix will check his account through his home computer and when he sees that the money has hit his account, he will fax through the remaining names. No hand-

shake. No tedious and embarrassing face-to-face meetings. Just business. And money. And he never has to leave the house.

"I don't understand morality," Snix says, chomping on another bonbon. "This is my hobby and my living and everything about me. This is my world. This screen. This modem. There are simply no rules in computers, only games. I play games for a living. What could possibly be wrong with that?"

But for every *otaku* like Snix who can program and decipher passwords and auction off the results, there are thousands of harmless kids who just love gathering and passing on information. Very few elevate themselves to Snix's level of computer subterfuge. Most are obsessed with every piece of trivia regarding their particular field and don't get much further than happily reading computer bulletin boards.

"The *otaku* are an underground, but they are not opposed to the system per se," says Volker Grassmuck. "They change, manipulate, and subvert ready-made products and ideas, but at the same time they are the apotheosis of Japanese consumerism, and an ideal work force for contemporary capitalism. When you have a society where the best test-takers go to the top, and the tests are all fill-in-the-blank sort of things, then you end up with a society more comfortable with data than analysis. That's an *otaku* society."

Indeed, many *otaku* already have legitimate careers in technology-related fields as software designers, computer engineers, computer graphic artists, and computer magazine editors. Leading high-technology corporations say they are actively recruiting *otaku*-types because they are in the vanguard of personal computing and software design. And some *otaku* entrepreneurs have already made it big. Self-proclaimed "*otaku* mogul" Kazuhiku Nishi is the founder of the ASCII corporation, a software firm worth $500 million. "Lots of our best workers are what you might call '*otaku*,'" says an ASCII spokesman. "Maybe as many as 60 percent of our two thousand employees. You couldn't want more commitment."

Another company widely known as "the *otaku* company" is Gainax Corporation, whose ¥500 million animated fantasy film *Oneamisu Tsubasa* grossed more than ¥2 billion. (The film, about what the world would look like if pneumatic and steam technology had been developed instead of electricity and internal combustion, set off a craze for whimsically shaped steamdriven models.) Located in Kitchi-joji, a posh suburb to the west of Tokyo, Gainax creates adult animation and fantasy-roleplaying computer games. Founder and president Toshio Okada, a dropout of the Osaka Institute of Technology, boasts that all fifty of his employees are *otaku*. Gainax's offices are a mass of empty pizza boxes, piles of floppy disks, and dozens of game designers and graphic artists all bathing in the glow of their terminals, headphones on and one hand on their mouse, as they happily program, design, and engineer tomorrow's computer games. Employees like twenty-three-year-old Yohji Takagi, a game designer developing a role-playing game in which the player attempts to cheat on entrance exams to prestigious universities, love their work. And during his leisure time Yohji plays computer games—a variation of computer golf is his current favorite. Or he scans the Asahi Pasocon computer network for *otaku* data regarding his favorite subject: tropical fish. For Yohji, like most *otaku,* the difference between work and play is a matter of software.

"We *otaku* are the ideal information age work force," Snix believes, "totally at one with technology."

Snix taps his own chest. "Look at me. Maybe I am the future."

If Japan has a future.

When asked if he has ever had sex, Snix stares at the ceiling for about thirty seconds. He breathes deeply.

"That depends on your definition of sex," he says.

Intercourse with a human, male or female, he is told.

He shakes his head.

Taku-hachiro, a prominent *otaku* and author of the best-

selling *Otaku Heaven*, claims the *otaku* are largely uninterested in sex. He puts it this way: "I watch a lot of videos and read comic books so I know the mechanics of it, but I guess I'm frightened of it. I love to watch sex—and I love masturbation. But I'm terrified of skin contact with another person. You see, in the end, masturbation is really much better than sex. It's so much more . . . efficient."

Snix agrees with Taku-hachiro: "I get along with objects and data better than people. If it were possible to have sex with machines, then that would be more interesting."

The *otaku* may be the final stage in the symbiosis of man and machine. Their points of reference are all derivative of computers, mass communication, and media. And their technology-generated world is unfamiliar terrain, a new frontier where the morality and ethics of the old world no longer apply. Their behavior may serve as a warning of what awaits us in the cyberspace frontiers of technologies such as virtual reality, digital compression, and three-dimensional television. "There is no law out there," says Gabin Itoh, editor of the computer magazine *Log-In*. Itoh says that *otaku* morality meets virtual reality at "the final existential frontier. There is no reason to feel inhibited."

Taku-hachiro dreams that some confluence of virtual reality and digital compression technologies will allow him to have cybersex—sex with an object, in this case through some sort of sensor-laden, penis-reactive condom. (International computer networks such as CompuServe are already used as efficient and low-risk international smuggling routes for sexually explicit pornographic images. The police are only now beginning to crack down on this type of illicit commerce.)

Yet the *otaku* are divided over the significance of new technological applications such as virtual reality. Masataka Ohta, a computer researcher at the Tokyo Institute of Technology, feels it has great potential, especially in the area of arcade games and fantasy-role-playing games. Others, such as computer game *otaku* Yoichi Shibuya, believe that virtual reality is an attempt to

humanize technology, make it "softer," and he despises that sentiment. "We shouldn't make technology behave like we humans would prefer it; instead we should conform to technology. We already have a 'virtual reality.' It's in the bulletin boards and computer networks and mainframes. Just jack in and you're there—I don't need to wear some stupid helmet and pretend to walk around in some imitation kitchen. That's like having two TVs showing cartoons taped to my face."

However, the sales potential for ultra-real sexual, pornographic, or violent experiences via the computer is so great that computer engineers—free-lance *otaku* as well as corporate programmers—are furiously designing software that will satisfy an *otaku*'s "sexual" needs. Although some *otaku* wait—no doubt breathlessly—for the development of sexy technology they can plug into their underwear, black-market programmers already sell "seduction" and "rape" fantasy games through *otaku* networks. Last year, a software company in Osaka whose product was deemed "obscene" by the National Police Agency was raided, and their stock of pornographic games was confiscated.

The prospect of ultra-real pornographic or violent experiences in cyberspace is making some mainstream Japanese product designers consider the moral implications of what they are developing. An ethics department has been added to Sony's R&D division because of the potentially disturbing nature of three-dimensional television combined with digital compression and virtual reality technologies. "It could be psychologically damaging—and confusing for some people—if they're watching people being chopped up in three dimensions," says a Sony spokesman, "Or, even worse, if they're there, with them, doing the virtual chopping."

Hold on.

Is a murder committed in virtual reality—of a virtual person who is, for all intents and purposes real and tangible and impacting on your life—a real crime or a virtual crime?

"Chop her up," Snix says, "and let's see if anyone files charges."

ACKNOWLEDGMENTS

This book would not have been possible without the generous help and support of Yoshiko Tanaka and Michiko Toyama.

Thanks to the many people who shared their memories and experiences, on both sides of the law, in a culture where saving your ass and saving face are sometimes mutually exclusive. You said don't use your names, so I won't. But the list in my head is long and deep.

Gratitude to the many experts, officials, and journalists who took the time to meet with me and tell me what was what.

This book would have been difficult to write had not other foreign journalists and scholars written about Japan and shown the way. Of particular help were Ian Buruma's *Behind the Mask*, Nicholas Bornoff's *Pink Samurai*, James Fallows's *More Like Us*, David E. Kaplan and Alec Dubro's *Yakuza*, Edward Seidensticker's *Low City, High City*, and Rey Venturi's *Underground in Japan*.

Thanks to those Stateside who gave me breaks, encouraged me, and helped see this book through: my agent, Lew Grimes; my editor, Wendy Wolf; David Freeman; editors Victor Navasky, Richard Lingemann, John Homans, Donna Frazier, Myron Kolatch, and James Truman. In England, Sheryl Garratt, Kathryn Flett, and Michael Alcock. And in Japan: Kenji Nakagami, Kei Aragaki, Masa Endo, Osamu Kometani, Masa Sato, Taro Matsuoka, Nanae Tamura, Rie Sekiguchi, Sherry Yamaguchi, Osamu Ogawa, Yokichi Miamoto, Yukiko Chino, Steve Weisman, Toshiya Ohno, and Helen Kaye.

I would like to express special thanks to Christopher Seymour for his advice, generosity, and wit.

And thanks to Silke for putting up with me.

ABOUT THE AUTHOR

Karl Taro Greenfeld was born in Kobe, Japan, of a Japanese mother and an American father. He was educated and raised in the United States and returned to Japan in the late eighties. He is currently the Tokyo correspondent for *The Nation* and has contributed articles and essays to *Details*, *The Face*, the *Los Angeles Times*, and the *Wall Street Journal*, among other publications. This is his first book.